IMAGES
of America

LAKE COMPOUNCE

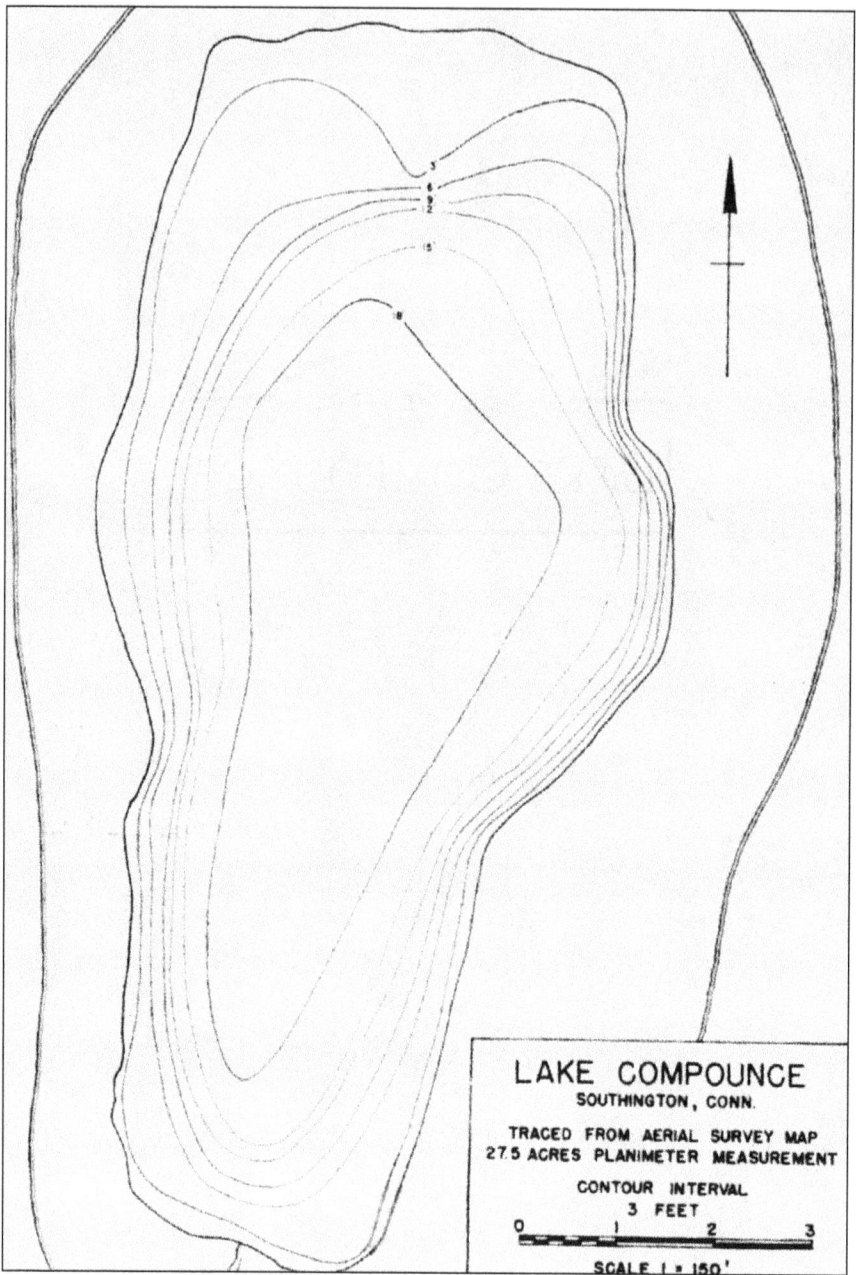

LAKE COMPOUNCE
SOUTHINGTON, CONN.

TRACED FROM AERIAL SURVEY MAP
27.5 ACRES PLANIMETER MEASUREMENT

CONTOUR INTERVAL
3 FEET

SCALE 1 = 150'

Lake Compounce is a natural lake located in Southington with a surface area of 27.9 acres. The maximum depth is 19 feet and the average depth 10.2 feet. The bottom is mainly sand, gravel, and mud. On October 19, 1919, game commissioner Frederick N. Manross and assistants stocked 3,600 fingerling salmon for the sport of fishing. The map above was done in 1959 by the State of Connecticut Board of Fisheries and the Game Lake and Pond Survey Unit.

On the cover: In this early-1900 picture, passengers are waiting their turn to ride in a steam-powered boat. In the background is the bandstand, and casino and the trolleys are on the right. (Courtesy of Tom Dickau.)

IMAGES
of America

LAKE COMPOUNCE

Lynda J. Russell

ARCADIA
PUBLISHING

Copyright © 2008 by Lynda J. Russell
ISBN 978-1-5316-3692-0

Published by Arcadia Publishing
Charleston, South Carolina

Library of Congress Catalog Card Number: 2007934954

For all general information contact Arcadia Publishing at:
Telephone 843-853-2070
Fax 843-853-0044
E-mail sales@arcadiapublishing.com
For customer service and orders:
Toll-Free 1-888-313-2665

Visit us on the Internet at www.arcadiapublishing.com

This book is dedicated to both the Norton and Pierce families and their descendants. It is also for anyone who came to the park and left with wonderful memories from a long time ago or just yesterday.

CONTENTS

ACKNOWLEDGMENTS

Spending time with J. Harwood "Stretch" Norton and his wife, Carrie, along with Ruth Sullivan Norton and Susan Pierce Segal, provided me with their personal family history and pictures that were so important for my research in putting this book together. I would also like to thank the following that provided sources of images: Tom Dickau, Ken DiMauro, Linda DiMatteo, Gary Potter, Peter Yalanis, Maryann Lemieux, Jerry Heresko, Tom Murrone, Tracey Blackman, Bob Montgomery, Linda Lubrico, the Greater Bristol Chamber of Commerce, the Bristol Historical Society, the Plainville Historical Society, the *Bristol Press*, the Bristol Public Library, the Elks Club of Bristol, and Lake Compounce. A final note of thanks to my husband, Chet, who has been part of all my books form the start.

The Bristol Historical Society will receive all the royalties from this book.

INTRODUCTION

Lake Compounce was originally occupied by the Tunxis Indian tribe, a small sect from the Mattatuck tribe. In the 1600s, the chief was Nesaheagun. John A. Compound, whose name varied in the English translation, was highly regarded by the tribe. The tribe's land consisted of several hundred acres adjacent to the lake. At this same time, the Norton family left England to come to America. The Nortons were among a party led by Thomas Hooker that finally settled in an area that became Farmington. In the third deed dated on December 2, 1684, Compound, along with 12 tribal members, transferred the title of the land to the Colonial settlers. This area became known as the Farmington Southwest Society. When this land was distributed in 1722, the lake, now known as Lake Compounce, and the adjacent land became the property of Samuel Steel and Thomas Orton, both prominent proprietors of Farmington. In 1779, their property became part of the town of Southington when it incorporated. This land changed owners several times until December 7, 1787, when it was purchased from the estate of Daniel Clark by Ebenezer Norton, a descendant of John Norton, one of the proprietors of Farmington.

Gad Norton, grandson of Ebenezer, inherited both the farm and Lake Compounce. For a long time, only an occasional fisherman, family members, and neighboring children knew of this quiet place. With the new invention of the electric telegraph, Samuel Botsford, a scientist from Bristol, persuaded owner Gad Norton to allow him to do a series of experiments, including blowing up the lake. Advertisements on handbills announced a scientific exhibition at Lake Compounce to be held on October 6, 1846. When the day arrived, many families came along with men in the field of science. Music was played and refreshments were served. Seating was provided for the women and children. The program went well until the last event, the blowing up of the lake, which failed. The people enjoyed themselves that day and came back, bringing others along.

Gad Norton built picnic tables and from a cart path built a road. In 1847, rowboats were placed on the lake and a tenpin alley was built. The road was opened around the lake, and an outdoor bandstand was built. In 1851, Gad Norton and Isaac Pierce became partners. Together they developed a park that became known as "America's Pioneer Playground." The boathouse was added that year, and in 1854 the Pleasure Wheel was added.

On September 9, 1875, a sheep roast, a popular southern-style barbecue, was given by Norton and Pierce to the legislators in appreciation for changing both of their residences from Southington to Bristol. The lake remained part of Southington. This became the start of the annual event known as the Crocodile Club.

The casino was built in 1895 with a ballroom upstairs and a dining room below. That same year, the Bristol and Plainville Tramway Company started bringing people to the park. Other trolley lines started coming from New Britain, Meriden, and Southington. Advertising in the *Bristol Press* hailed the park as a place factories, clubs, and family reunions could come to. The carousel was added in 1911 and the Green Dragon roller coaster added in 1914. On July 27, 1928, the new Miss America came to the lake and crowned the new Miss Compounce, Sally Whittle of Bristol.

In the 1930s, the casino was expanded, adding a roof, sidewalls, and a music shell. Many big bands played, including Tommy and Jimmy Dorsey, Glen Miller, Cab Calloway, Count Basie, Harry James, and Benny Goodman. In 1944, the famous Gillette railroad train was added. In 1929, Chris Craft speedboats replaced the rowboats. Local entertainers Tex Pavel, Colonel Clown, and Slim Cox and the Cowboy Caravan performed on the lakefront stage in the 1950s.

Lake Compounce remained under the ownership of Pierce and Norton Company Inc. until 1966, when Edward G. Pierce, grandson of Isaac Pierce, sold his interest to the Norton family. The Nortons continued to operate the park until 1985 when they sold it to Stephen Barberino Sr. and his son Stephen Jr. and J. D. "Chuck" Arute. They sold their majority ownership to Hershey Entertainment and Resort Company. New rides were added along with restoring the park to open in July 1986. In 1988, Hershey sold the park to Joseph Entertainment Group of Milwaukee, Wisconsin. In 1994, Funtime Park of Ohio became the next owners. The State of Connecticut pledged an $18 million economic grant to help turn the park into a regional tourist place. When Funtime was bought out, the Barberinos looked for new buyers for the park. Kennywood Entertainment Company of Pennsylvania bought the park in 1996. Lake Compounce now covers 332 acres with 44 rides, including four roller coasters, a water park, and two water rides. As Gad Norton had a vision in 1846 to turn his family's property into an amusement park, it is also important to Kennywood Entertainment as it continues to add new attractions and improvements for families to come and enjoy the United States' oldest amusement park.

One

THE NORTON AND PIERCE FAMILIES

This copy of the original deed was written by John Standly on December 2, 1684. Jon A. Compaus (also known as Jona Compoune or John A. Compound), along with 12 members from the Tunxis tribe, owned a tract of land called Mattatuck, now known as Waterbury and Farmington, and signed this deed to Farmington proprietors. John Norton, a descendant, helped lay out the Mattatuck boundaries in 1684.

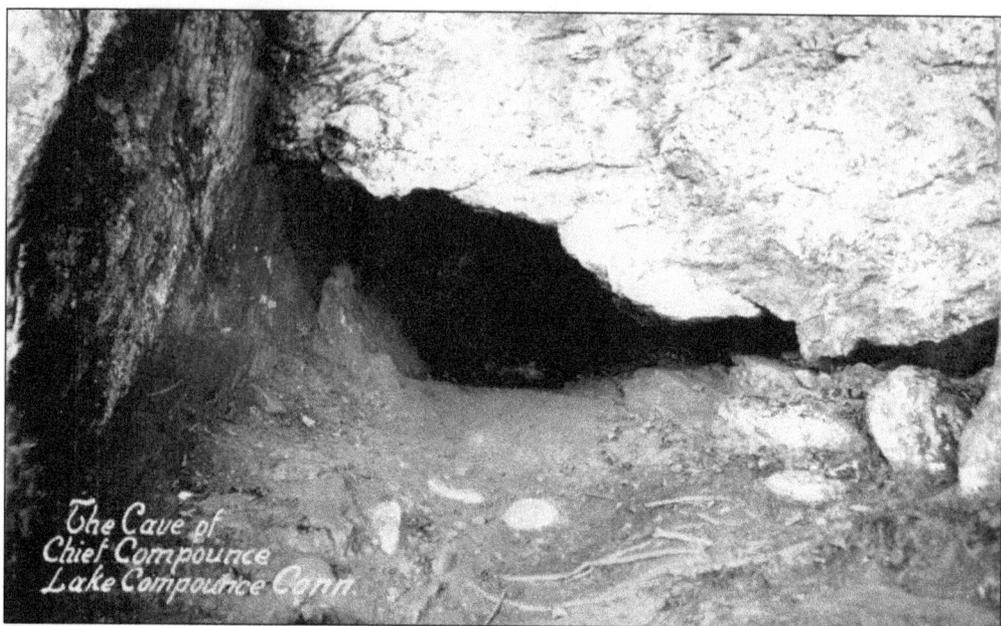

The Cave of
Chief Compounce
Lake Compounce Conn.

Caves such as this, also known as papoose houses, were the abodes of the Tunxis Indian tribe. They were sometimes large enough for several families to live in. This cave became an early attraction for the park.

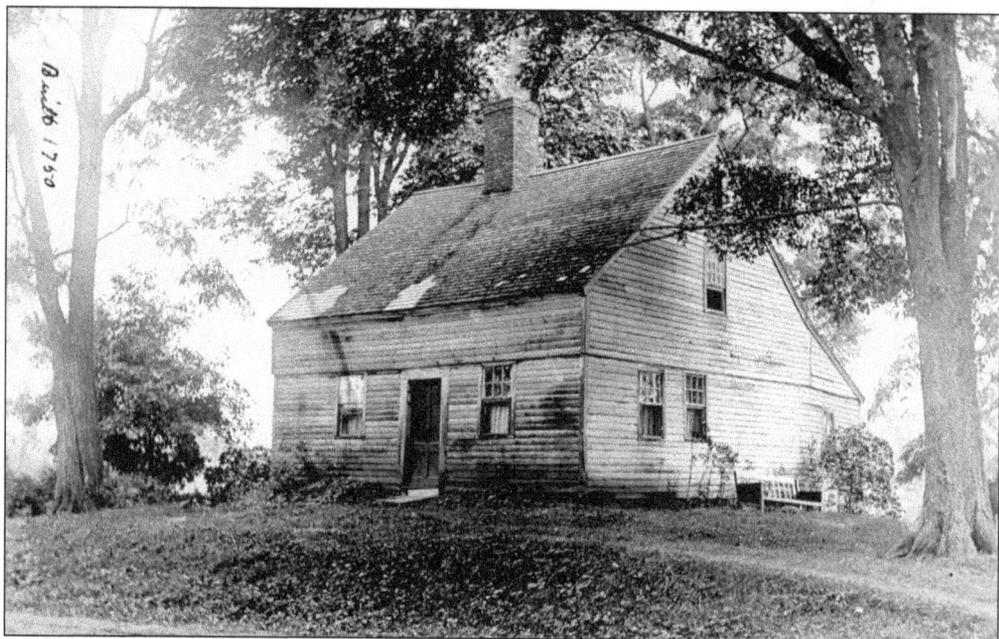

Built 1750

John Norton, a descendant of the original 84 proprietors of Farmington, lived in this 1750 home that was located on Lake Avenue. From the apples he grew, Norton built a cider mill so he could produce his cider to sell. The house was located across from the Lake Avenue Cemetery and no longer stands.

10

Gad Norton, son of Parish Norton and Betsey Royce Norton, was born in Southington on October 24, 1815. He was one of six children, five brothers and one sister. His great-grandfather Ebenezer Norton was the first to settle in this area. Gad was married to Mary A. Wiard. They had two sons, Gilbert and Marshall. Gad served as selectman for Southington in 1850 and again in 1874 and 1875. The Norton families were farmers, growing tobacco and corn. They also had cider mills and sawmills. They enjoyed swimming and fishing in the lake. On October 6, 1846, an experiment with electricity brought many people to enjoy the lake, picnicking, and music. The final experiment failed, but Gad saw an opportunity to promote his property by building picnic tables, opening up the pathway to go around the lake, and adding buildings and rowboats. The start of a summer resort would grow to become "America's Pioneer Playground." Gad died on May 4, 1898, at the age of 83.

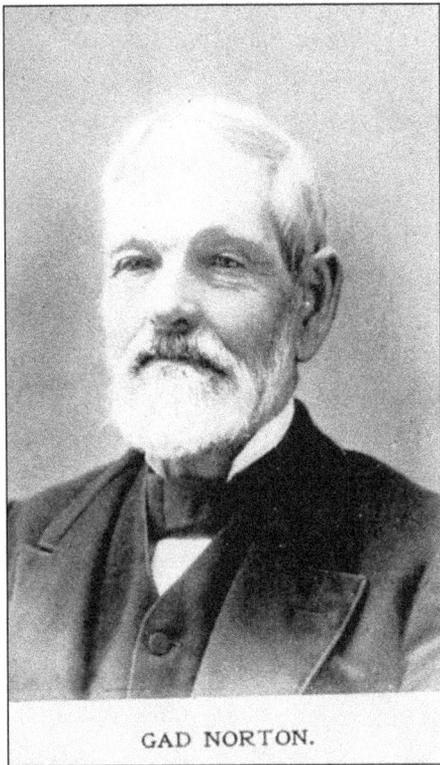

GAD NORTON.

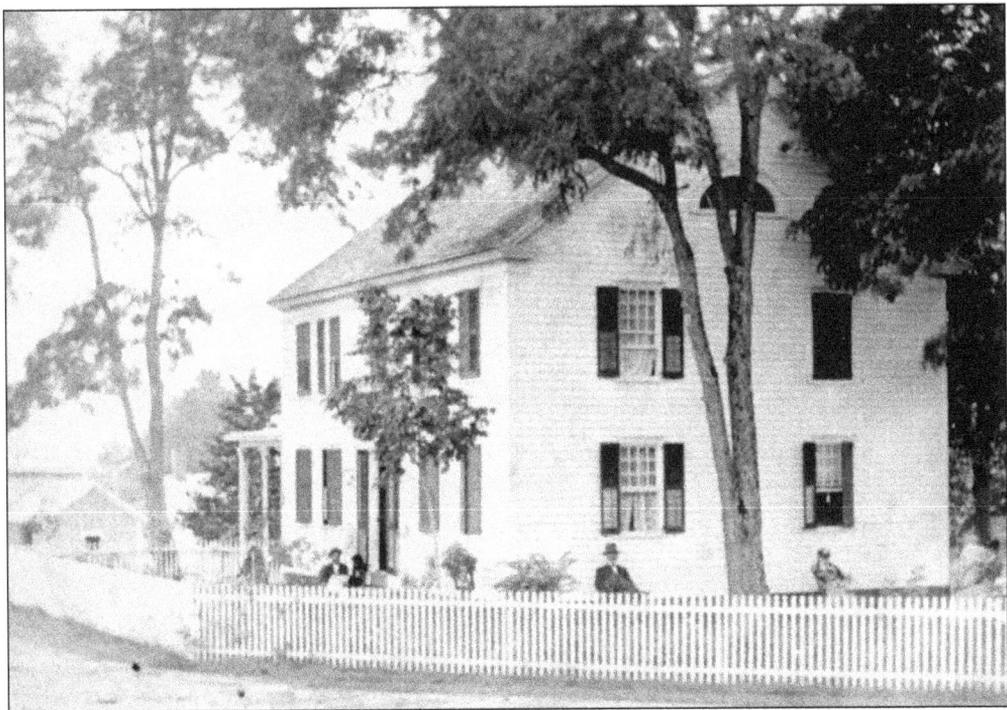

This home was where Gad Norton was born and lived all his life. It stood overlooking the park and lake below. The Norton families lived here over 200 years. The home was torn down in 2006.

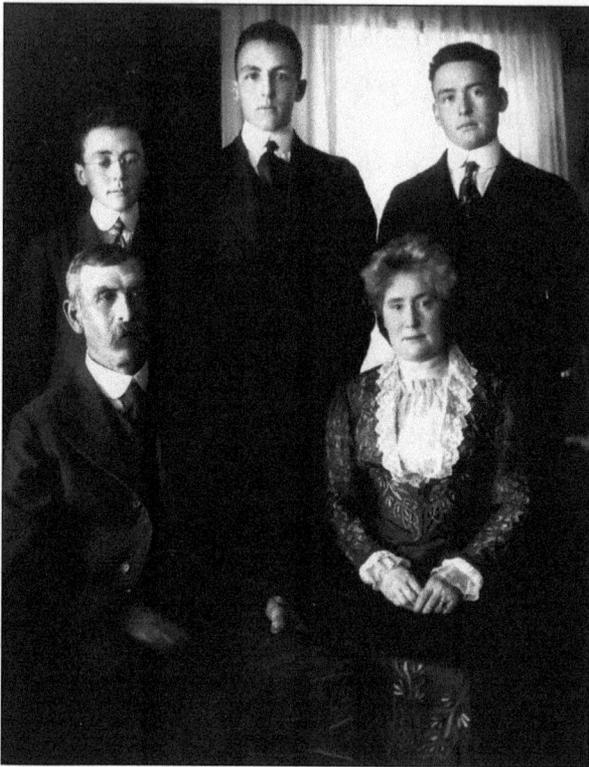

Gilbert Norton, and his wife, Nellie Scattergood Norton, are pictured here, with their children, from left to right, Percy Lamont, Julian Harwood, and Irving Wired, behind them. Gilbert was the son of Gad Norton and Mary A. Wiard Norton. Gilbert continued maintaining the families' lumber mill and sawmill and raising tobacco and corn. After World War I, Gilbert's three sons took over in the managing of the park instead of the farming their father did.

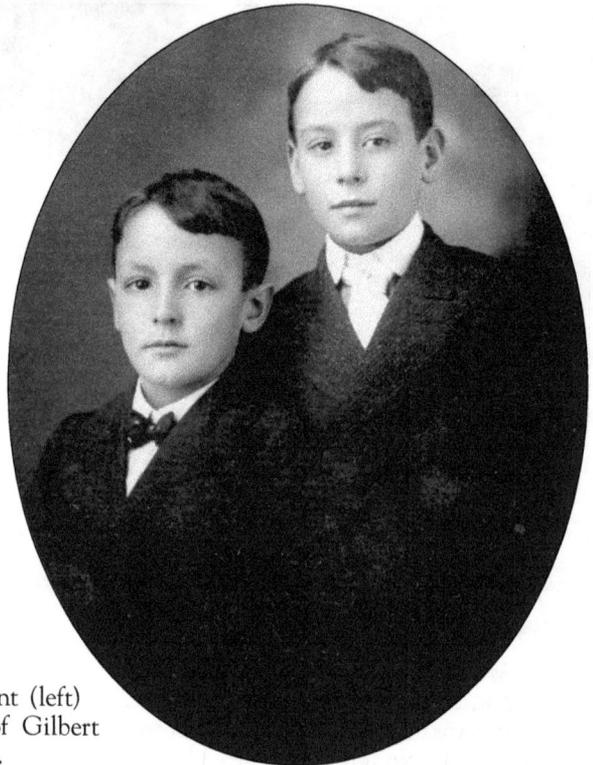

In this family picture are Percy Lamont (left) and Julian Harwood Norton, sons of Gilbert Norton and Nellie Scattergood Norton.

Percy Lamont Norton was born in 1894. He was the grandson of Gad Norton. Percy and his brothers, Julian and Irving, along with their families, continued the ownership of the park with the Pierce families. Percy was married to Christine French Norton. They had four children, William, Janet, Kenneth and Patricia. Percy died in 1952, and Christine died on December 4, 1988. They are both buried at the Lake Avenue Cemetery.

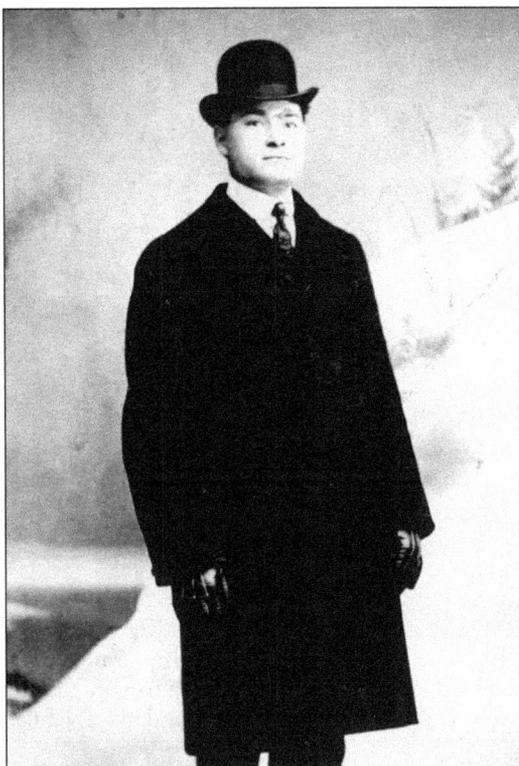

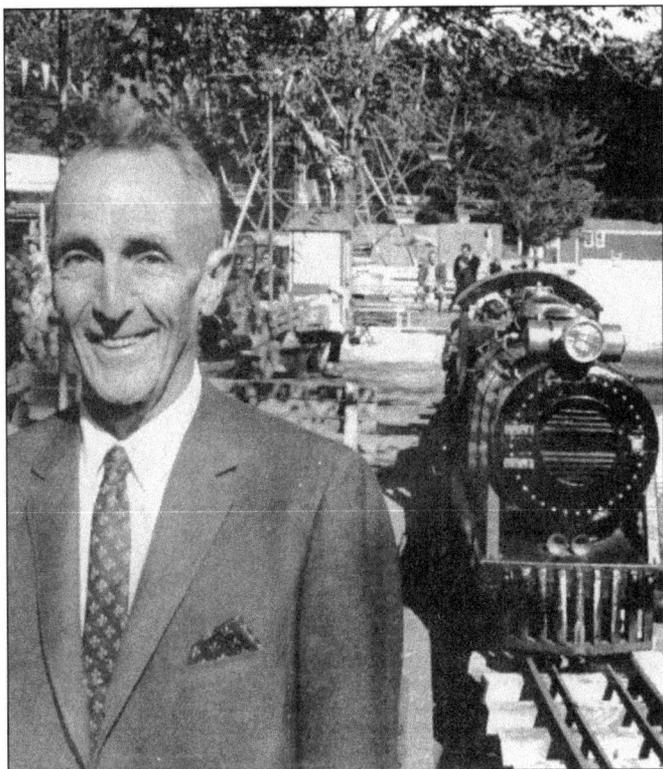

Julian Harwood Norton, son of Gilbert Norton and Nellie Scattergood Norton, was born on September 26, 1895. He attended local Bristol schools and then left to finish his education at Connecticut Agricultural College, later known as the University of Connecticut, to learn more about farming. After college, he served in World War I. He returned to Bristol and married Norberta Smith. Julian, along with his brothers, took over the management of the amusement park. Julian and Norberta had two children, J. Harwood "Stretch" Norton and Mary Louise Norton Albahary. In this 1968 picture, Julian is next to the famous Gillette train. He died in 1975 at the age of 80.

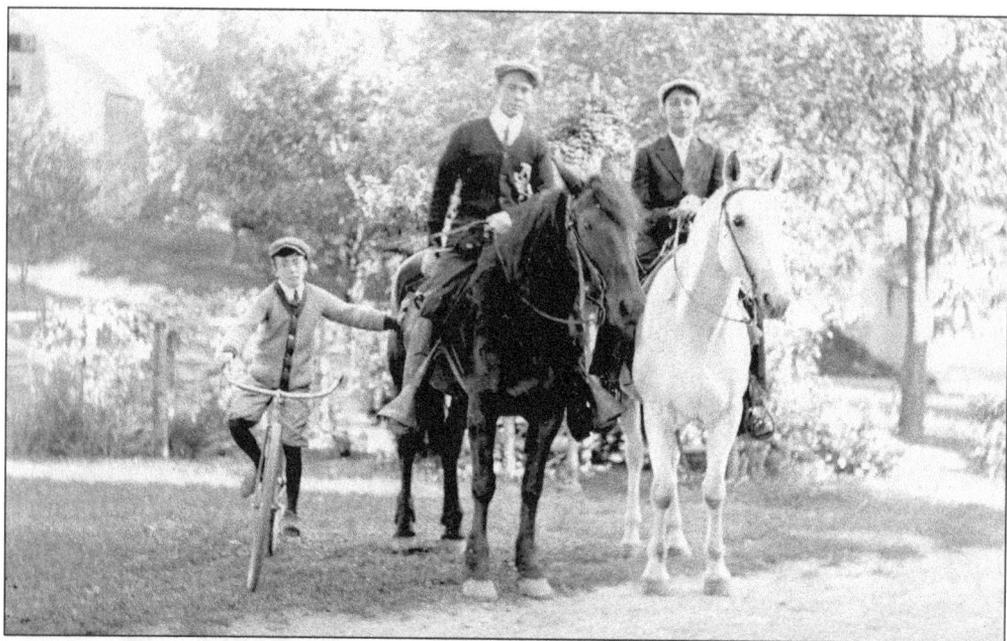

The three grandsons of Gad Norton are pictured here. From left to right are Irving Wired on the bicycle and his brothers Percy Lamont and Julian Harwood on the horses. This picture was taken at the Norton homestead on Lake Avenue.

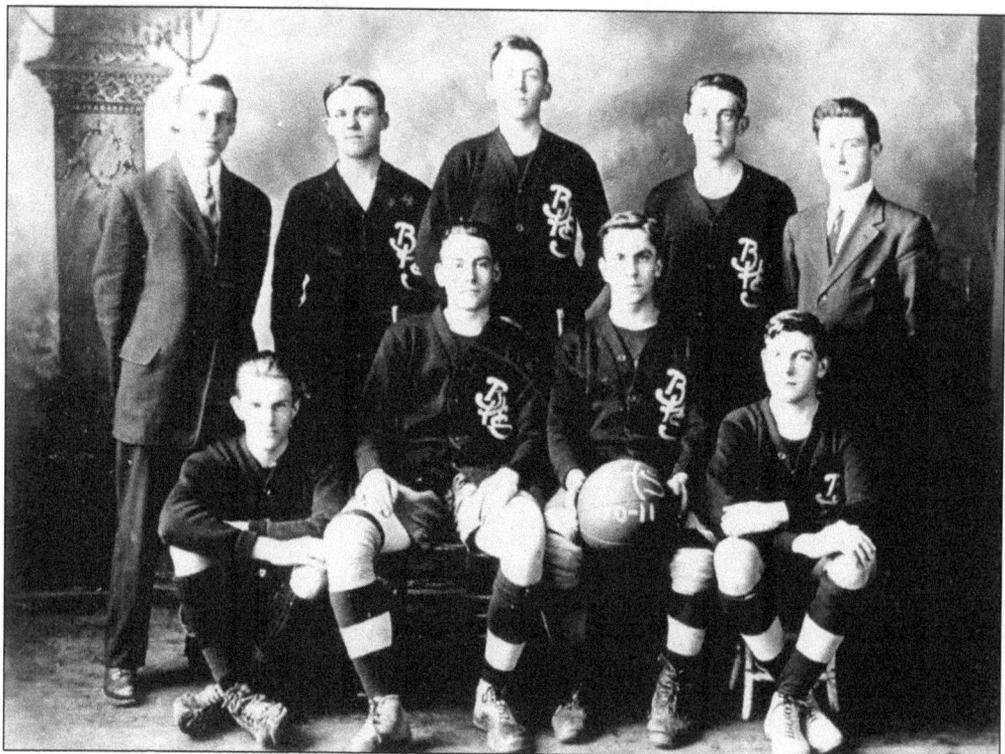

In this Bristol High picture, in the first row, second from the left, is Percy Lamont Norton, who was the coach for the team.

Isaac Pierce was born on November 28, 1815, in Bristol. He left home in 1833 to live in Greenville, Alabama, working with his cousin until 1842 when he decided to come back to Bristol. In 1849, he left Bristol for the gold rush in California, but he returned to Bristol in 1850. In 1851, he formed a partnership with Gad Norton. He married Catherine Degnan of Bristol. They had four children. Along with running the park with Norton, he served in the state assembly in 1861 and again in 1868. He died on July 28, 1897, at the age of 82. Both Isaac and wife Catherine are buried in the Lake Avenue Cemetery.

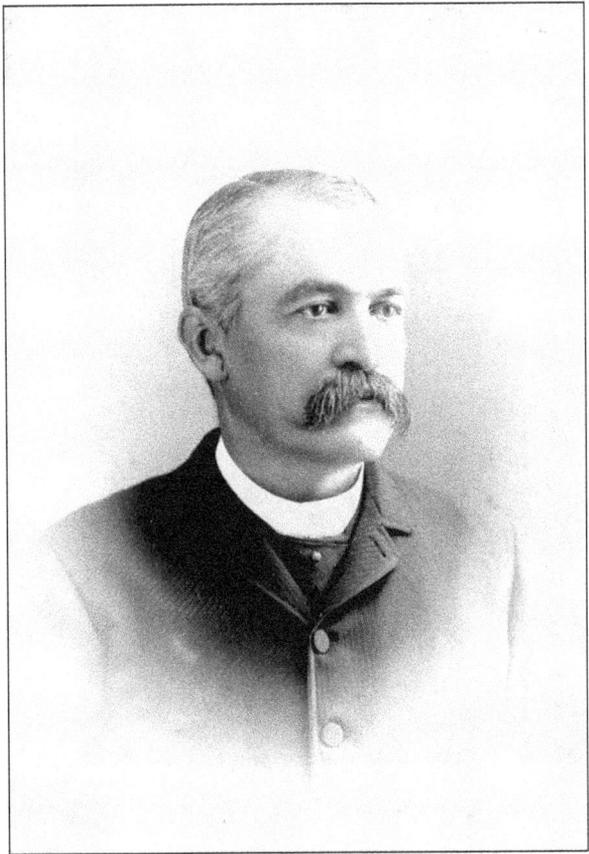

This was the home of Isaac Pierce that was next door to Gad Norton's home on Lake Avenue. The house was torn down, and all that remains today are the barns to the right in the picture.

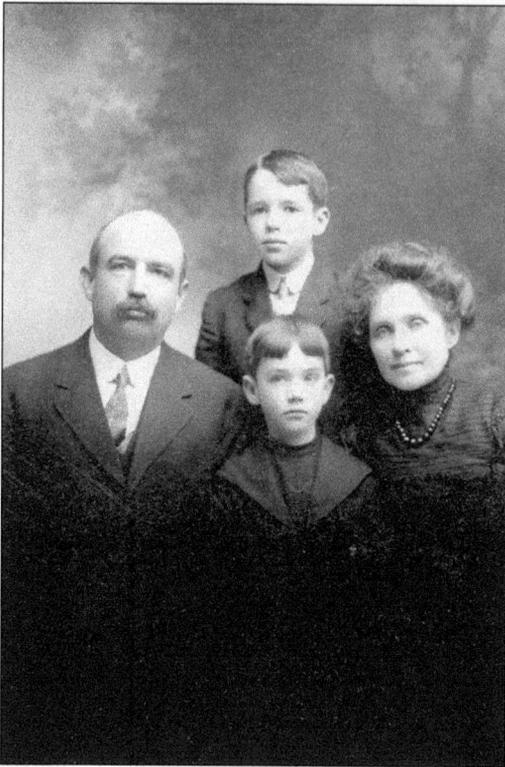

In this family portrait are Isaac Pierce's son I. Edward Pierce and his family. Clockwise from left are I. Edward Pierce, son Julius H. in back, wife Josephine, and son Edward G.

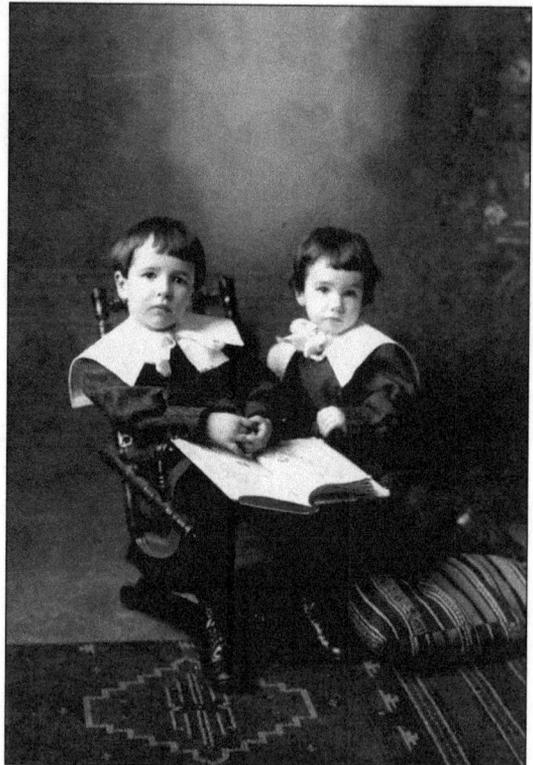

Taken in 1904, this photograph shows Julius H. (left) and Edward G. Pierce, children of I. Edward and Josephine Pierce.

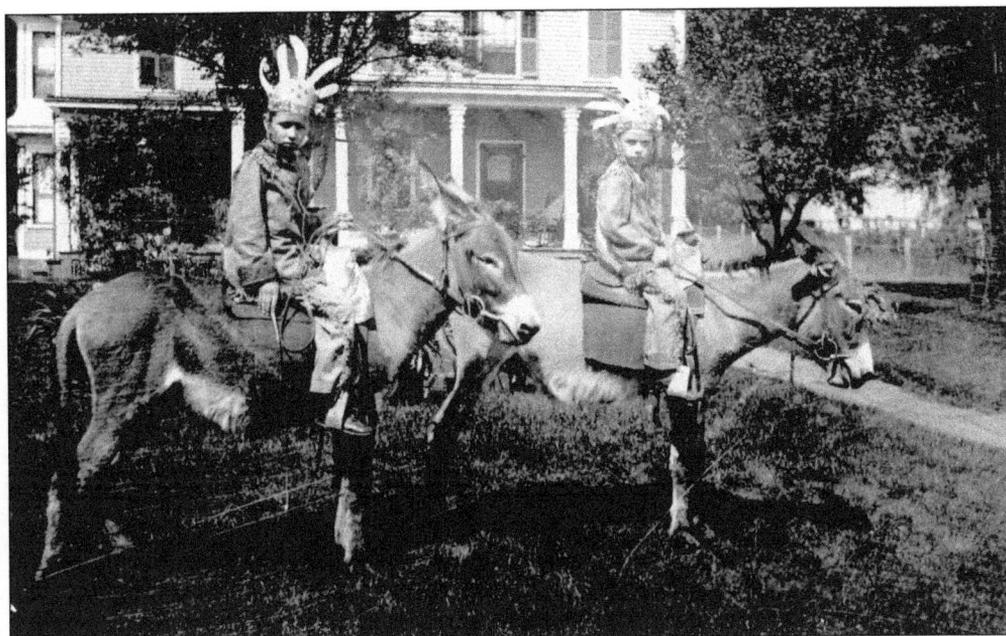

Julius H. Pierce (left) and his brother Edward G. Pierce are in front of their home in 1908. Their pictures later became postcards to promote the park.

This picture was taken at the Pierce homestead on Lake Avenue. Sitting on burros named Jack and Jill are Edward G. Pierce (left) and his brother Julius H.

On the far end of the lake, there were three cottages built by different families: the Nortons, who owned the park; Carl Mason, who owned C. V. Mason Insurance in Bristol; and Claire Phennig, who was a city engineer for Bristol. This cottage was the one owned by the Norton family and was where various members of the family lived, including Irving Norton's son William and his wife, Ruth Sullivan Norton, when they got married in 1944 until 1952. The cottages later were used by musicians who played at the lake. They no longer stand today.

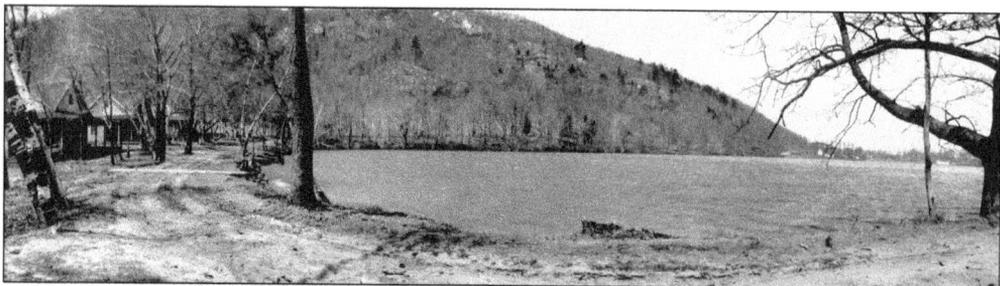

This 1907 view called "East Mountain" shows the three cottages on the left. The cottages were a great distance away from the park area.

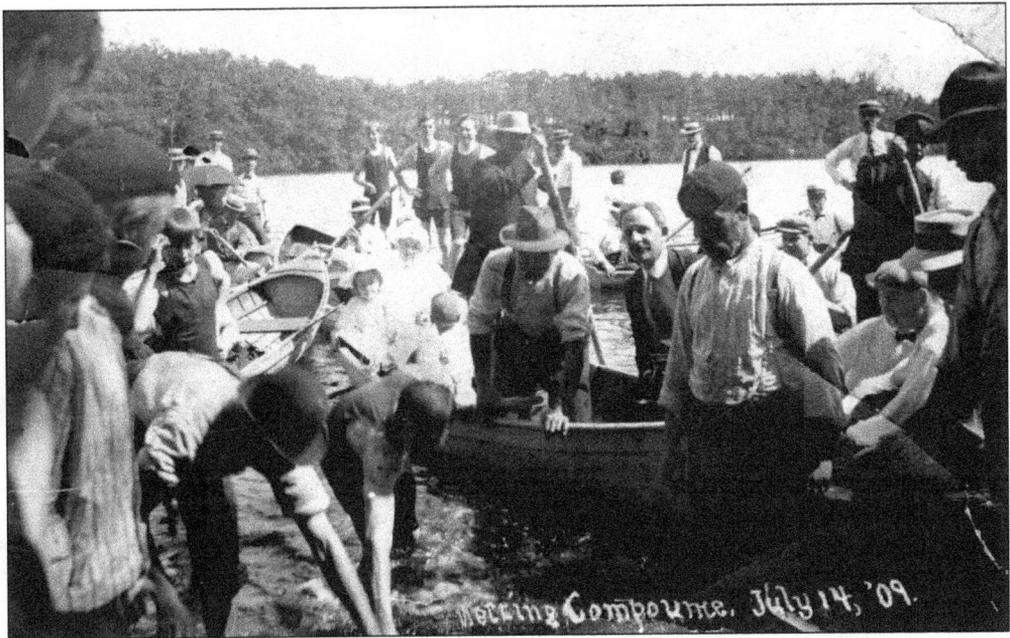

In this July 14, 1909, picture, the men are taking off the fish from the nets. Yellow and white perch, common sunfish, smallmouth bass, calico bass, catfish, pickerel, bullheads, and golden shiners were the types of fish caught in the lake.

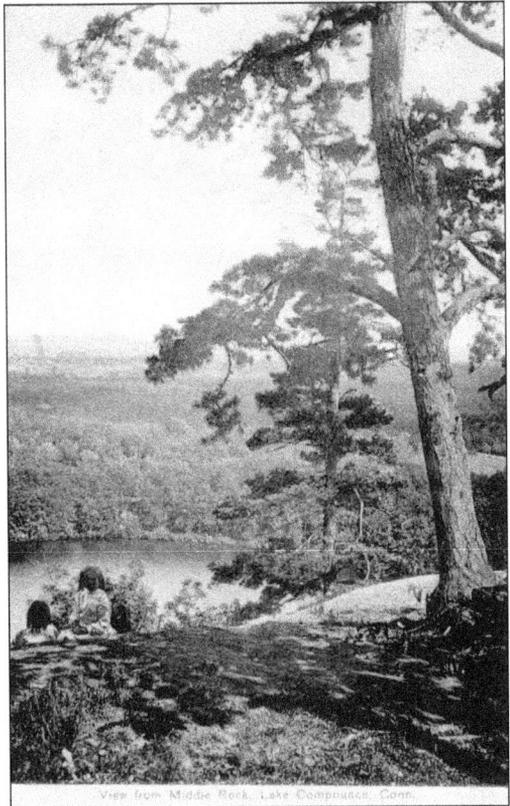

This 1906 view from the area called Middle Rock looks southeast at Lake Compounce, below to the left.

This 1908 picture features Lake Compounce and its surroundings during a quiet moment in time before the development of the area.

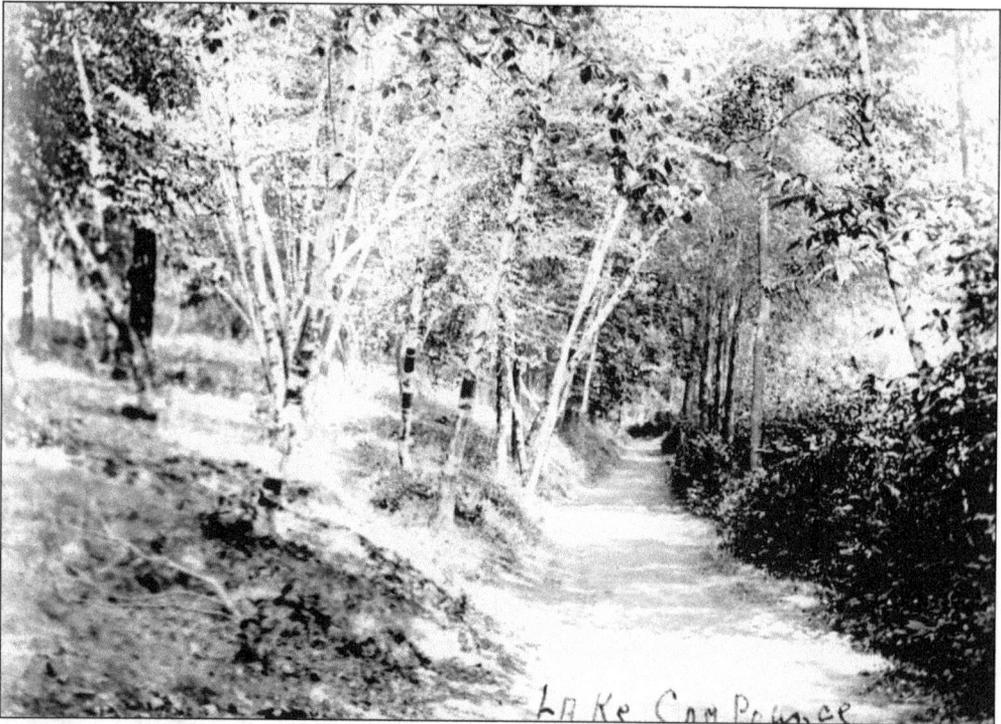

Seen here is an early rustic view of a cart path with white birches on either side of the road, which the horse and buggy traveled on to get to the park.

Two

AMERICAN PIONEER PLAYGROUND

This is the handbill advertising the blowing up of Lake Compounce on October 6, 1846, by Bristol scientist Samuel Botsford. Many traveled to witness the event. The experiment failed, but those who came enjoyed the beauty and charm of the place and soon brought others. Gad Norton turned the cart paths into a road. The next year, the tenpin alley was built and rowboats were added.

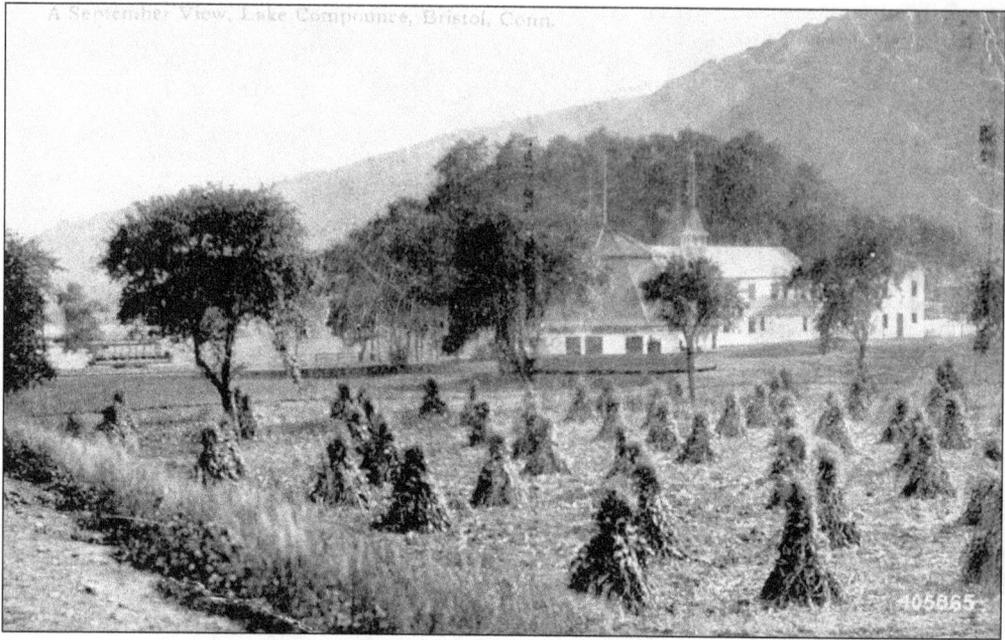

The Norton families were originally farmers who raised tobacco and corn. The Pierce family also raised tobacco. This September view shows the cornstalks with the carousel and the casino on the right and the dirt path on the left. Later this would become a ball field and then the parking lot for automobiles.

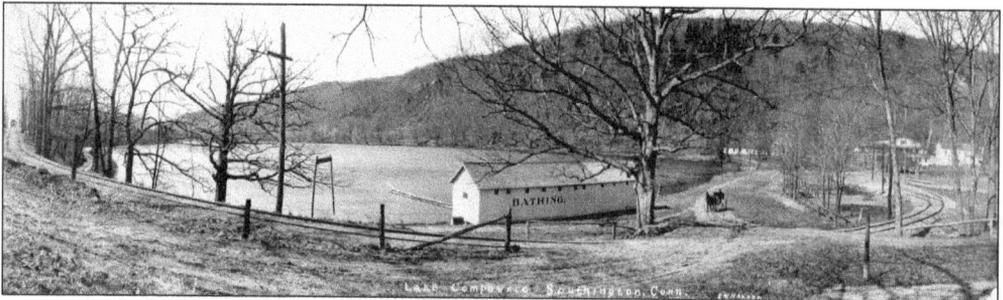

This July 1907 picture shows the bathing building with the tracks in place for the trolley cars.

The building on the left is the tenpin bowling alley, and on the right is the boathouse in this 1870s picture. This area was known as the Northern Corner.

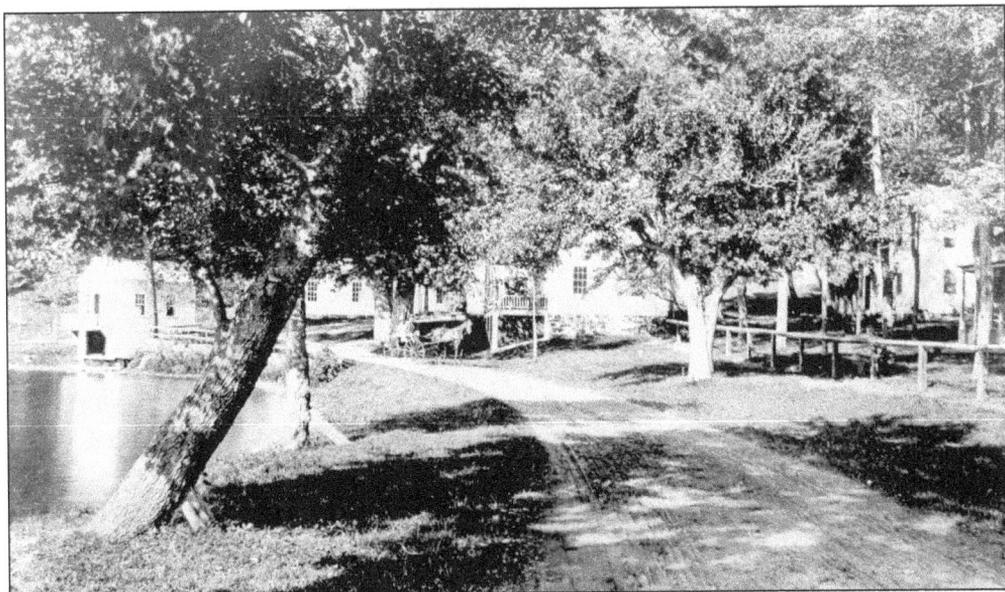

This early-1895 picture shows a horse and buggy, which was the only way that families traveled to the lake before the trolley started. The boathouse on the left was built in 1851. The building on the right is where the laundry was done.

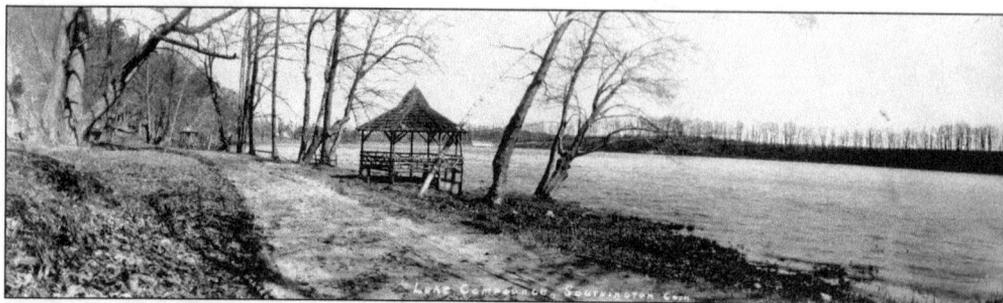

This rustic summerhouse was one built by Gad Norton and used by families for picnics. This was one of many built around the lake.

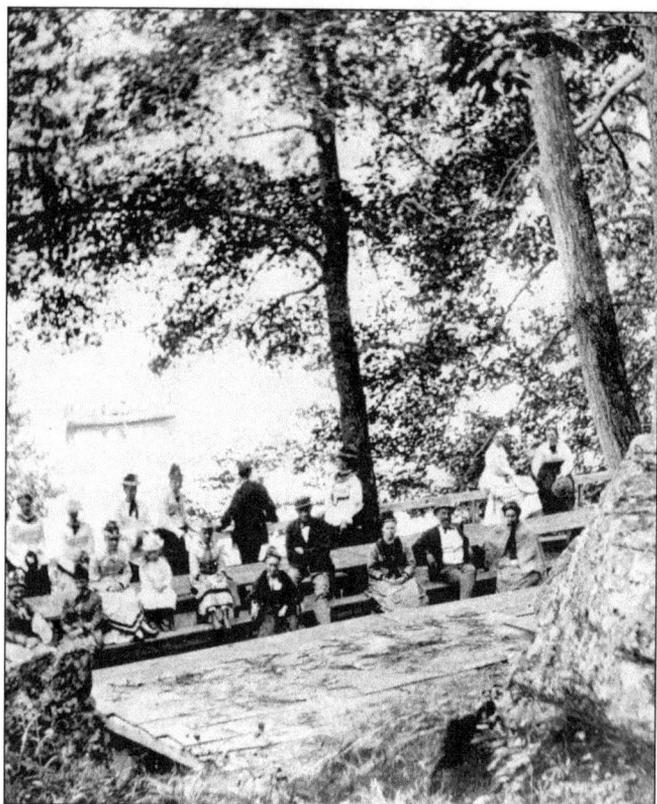

Wooden benches were put up by the park along the pathway. In this picture, people are sitting by the lake.

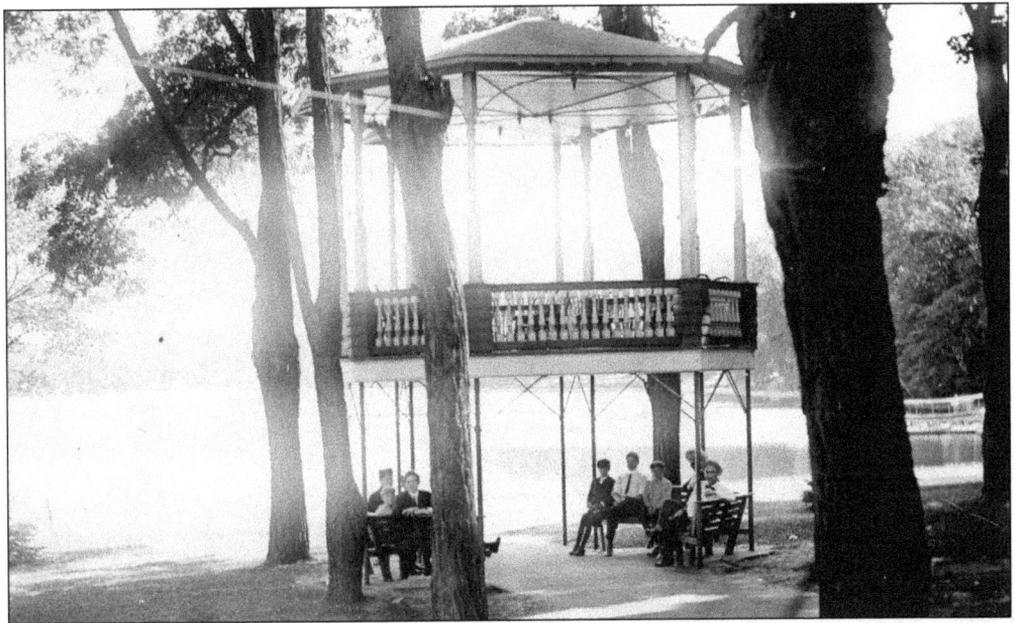

The first outdoor bandstand was put up by Gad Norton in 1847 so bands could play near the lake. When the band played, a ladder was put up on the second level. This picture was taken around 1910 and shows people sitting on the benches below.

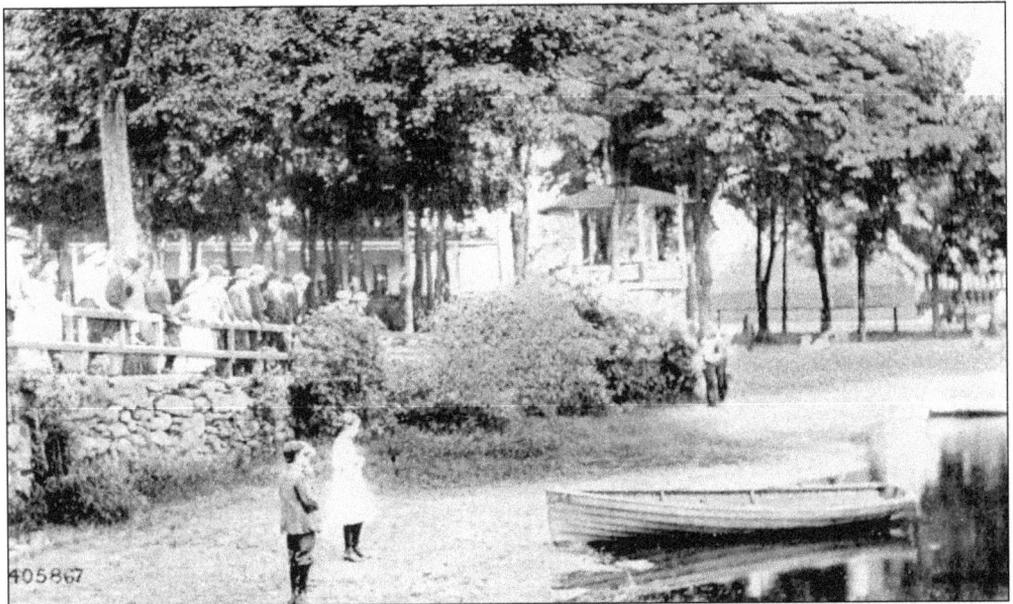

The rowboats were added to the lake in 1847. This 1909 picture shows people standing next to the railings with children by the shore. The trolley cars are on the far right.

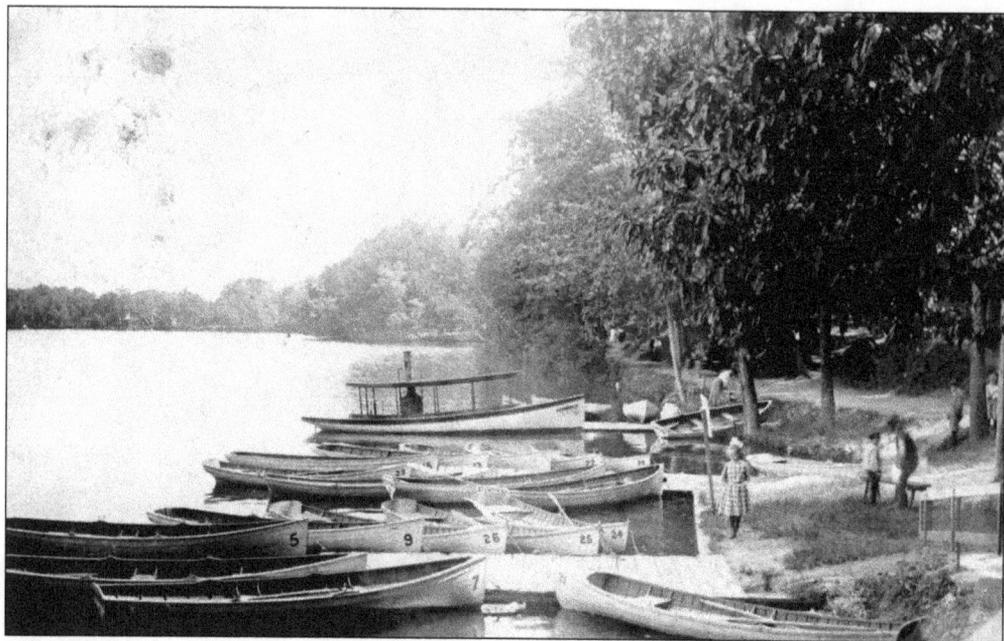

Taken at the dock area, this 1907 picture shows all the numbered rowboats sitting by the shore before they are taken out.

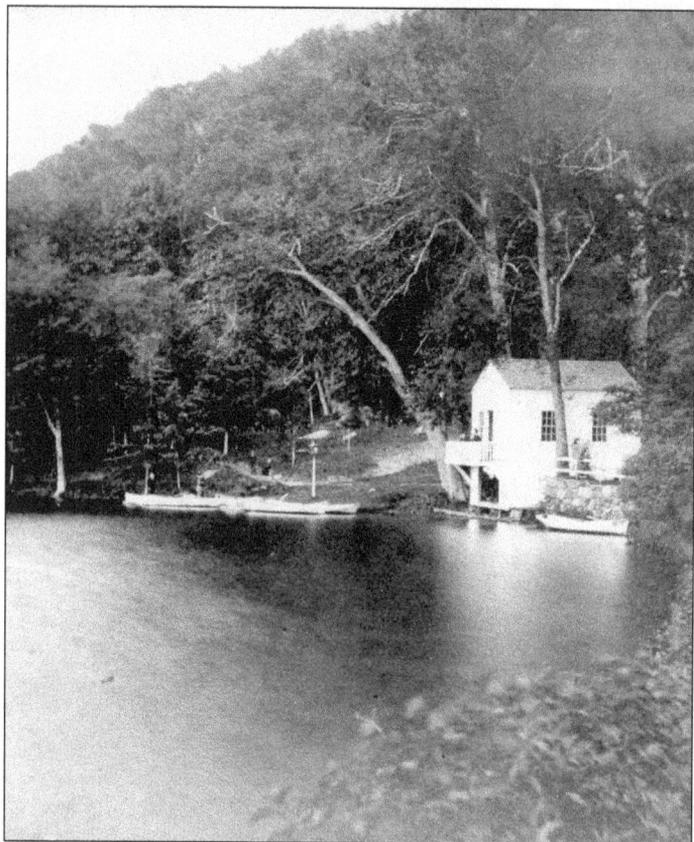

This stereoscopic picture of the boathouse was taken by Herbert N. Gale, a well-known photographer from Bristol, in the late 1890s.

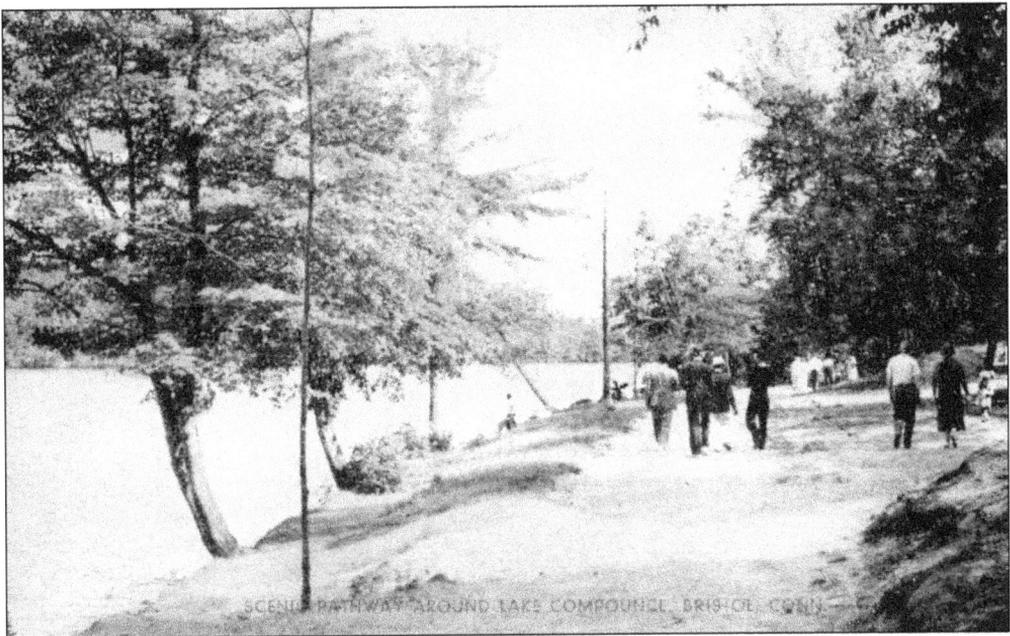

Visiting the park and taking a stroll along West Drive was how some enjoyed the park, as seen in this postcard, postmarked 1907. Others could stop along the way and sit on the benches that were built near the water.

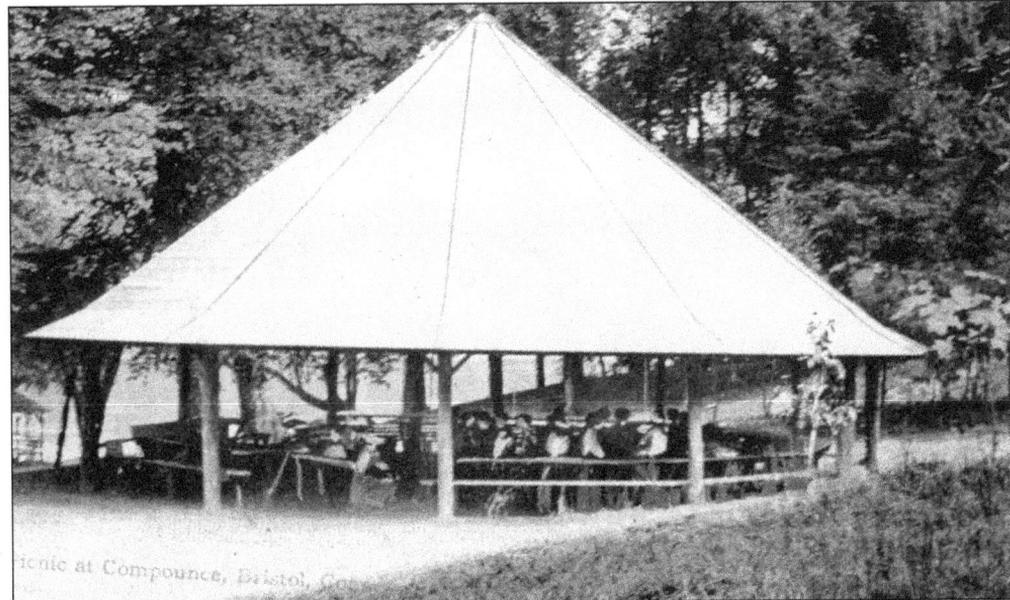

After 1865, Lake Compounce became known as a picnic park. Families brought their picnic baskets and used these tent-covered tables located by the lake.

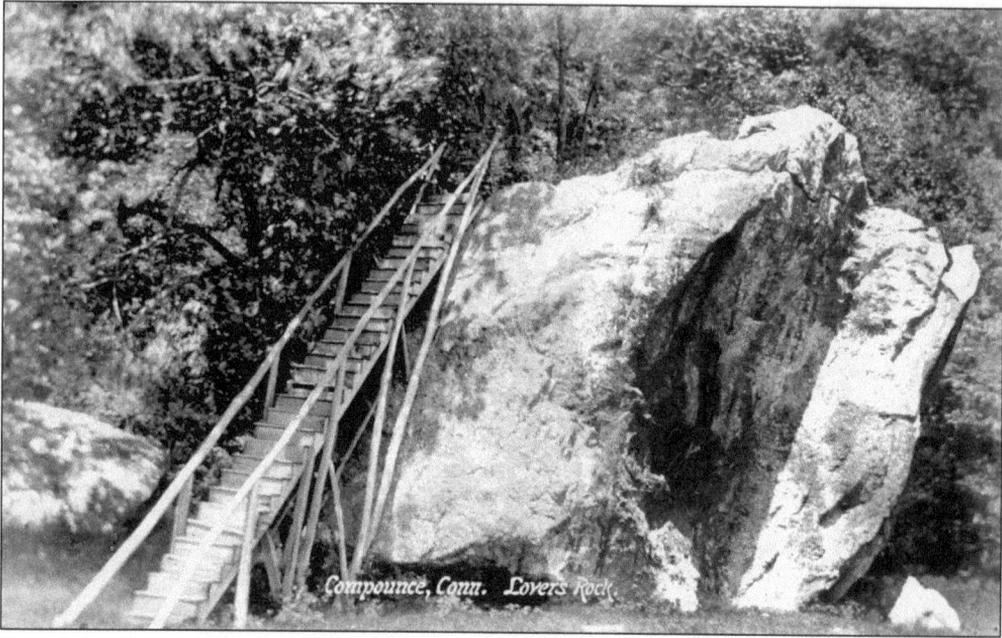

From Lake Drive, a path led to Lover's Rock. Made of granite, this rock is 35 feet tall. Wooden stairs were built and put next to it so people could climb to the top of it. This picture is from 1905. Lover's Rock is still at the park today, located out near the corporate picnic area.

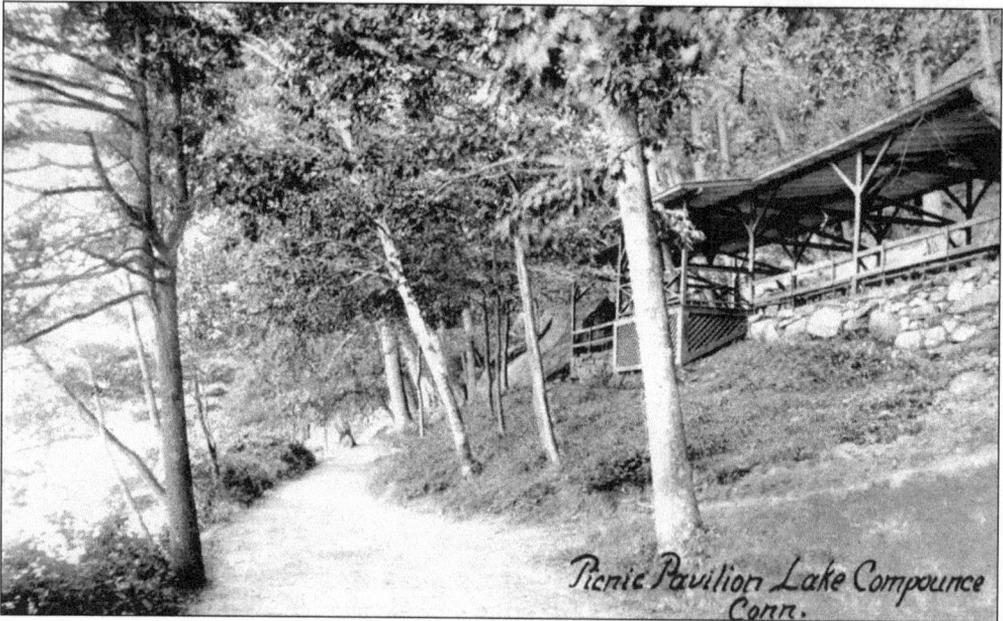

A more modern picnic pavilion was built along the pathway known as West Drive.

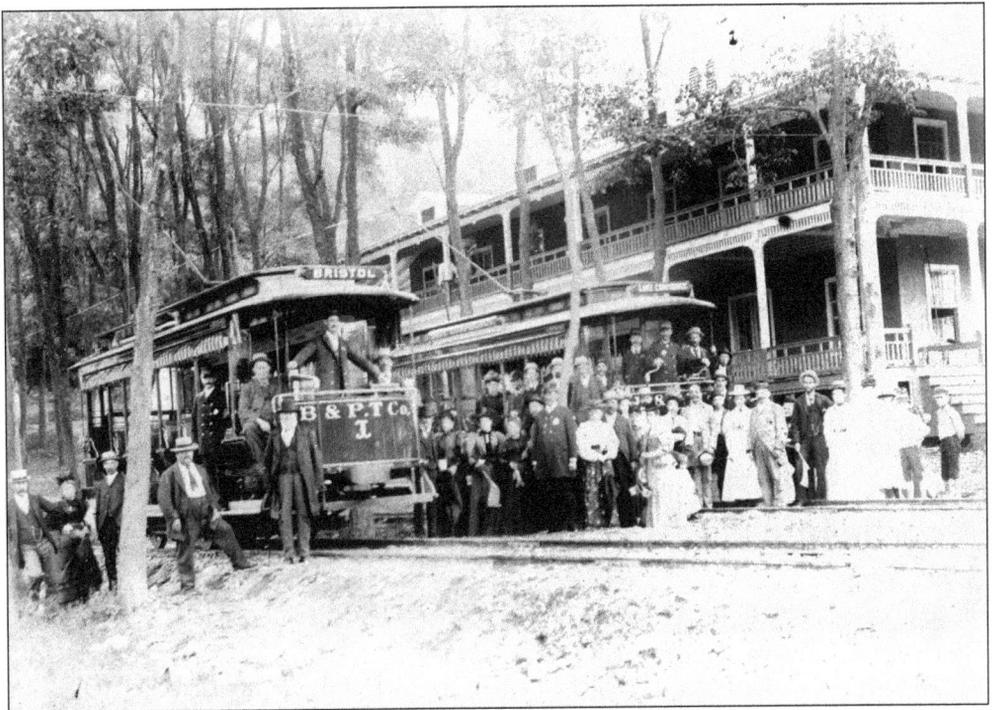

In 1893, the Bristol and Plainville Tramway Company was organized by Charles S. Treadway and John H. Sessions of Bristol, who were the main backers of this business. Taken on August 13, 1895, this picture shows one of the first trolleys at Lake Compounce. In the background is the casino on the right.

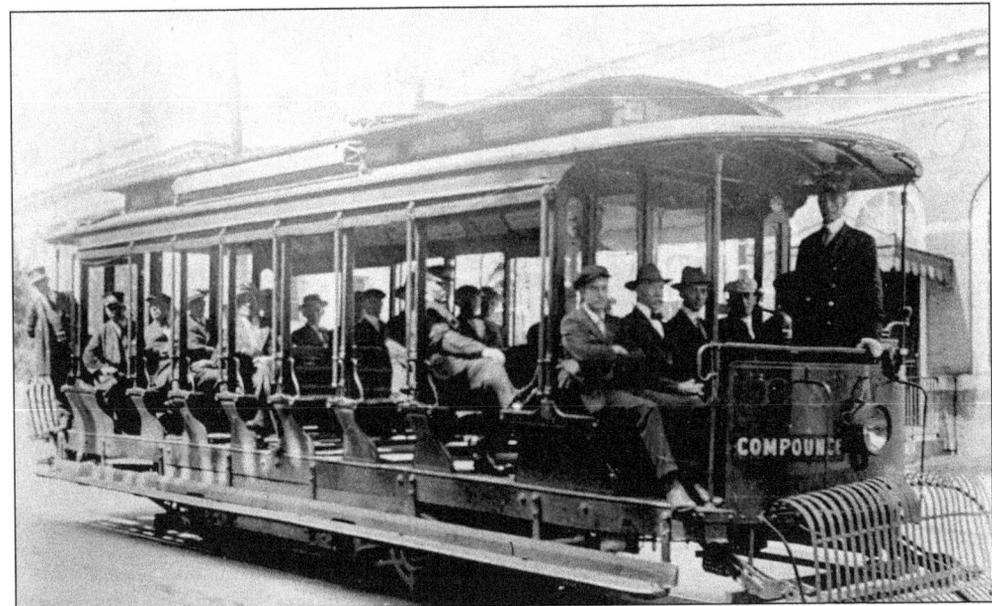

The trolley car in this picture, taken on Riverside Avenue near Main Street in Bristol, took passengers to Lake Compounce on a daily run.

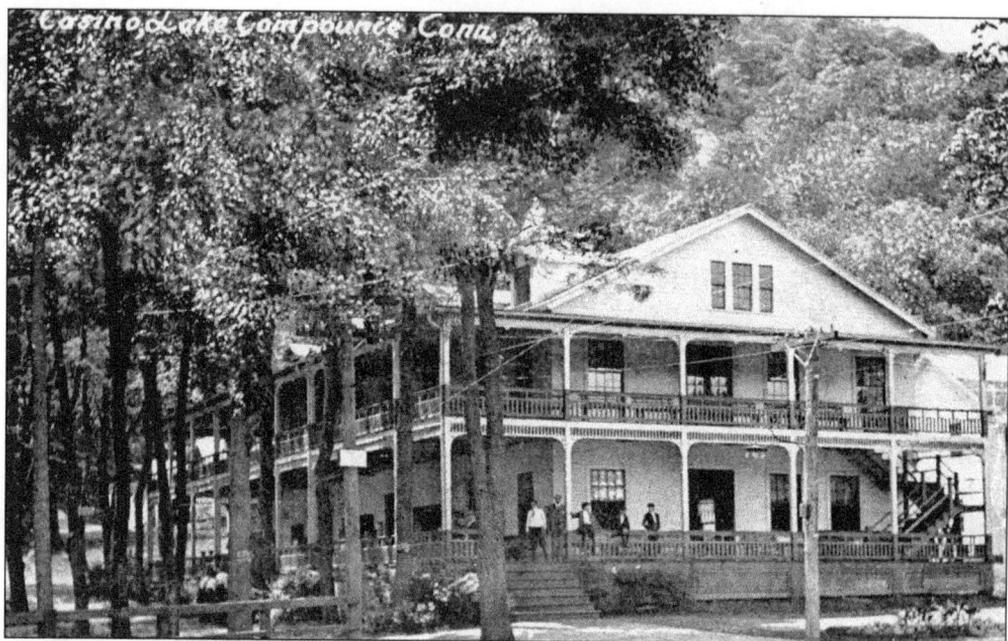

The casino, also known as the pavilion, was built in 1895. The contractor was F. L. Burr. On the first floor was the dining room. The kitchen was in the back of the dining room, and the dance hall and dressing rooms were on the second floor. The veranda went around three sides. In that first year, a served full-course dinner cost 50¢.

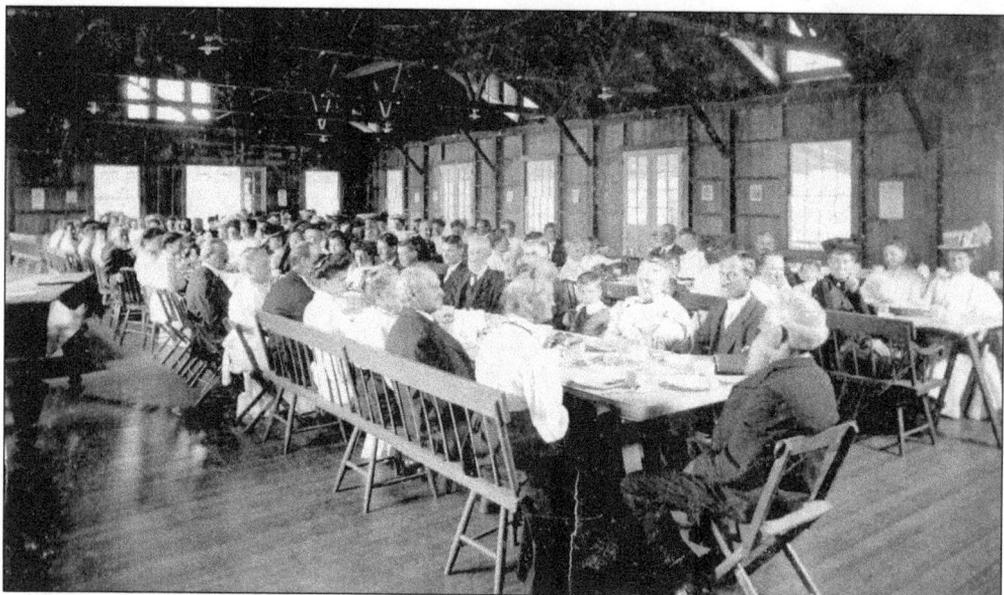

Isaac Pierce and Gad Norton advertised the casino in the *Bristol Press*, promoting it as a place for businesses, families, and clubs to come and have a meal prepared at reasonable prices. This picture of a family gathering was taken inside the dining room of the casino in the early 1900s.

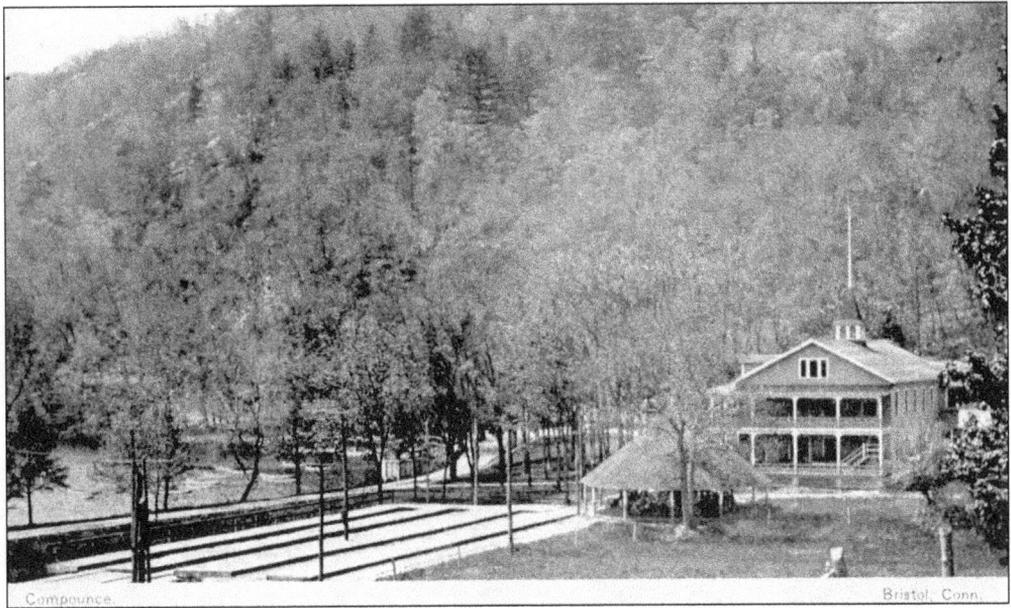

This 1912 picture shows the trolley tracks where people were dropped off and picked up when they left the park. The carousel was purchased in 1911. The casino is behind it. No other amusement rides were here at this time.

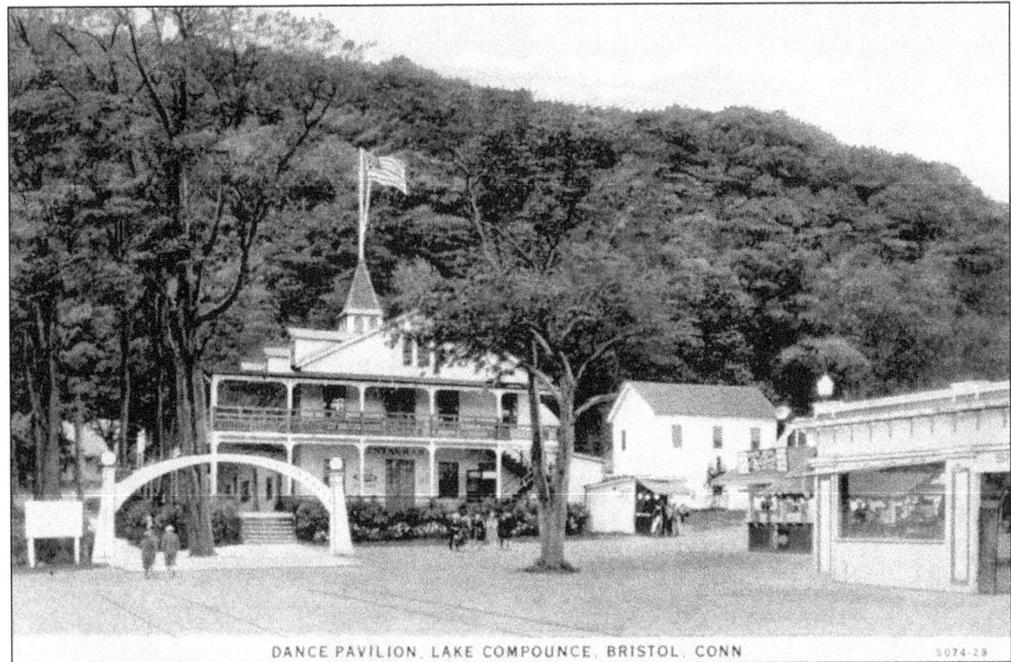

DANCE PAVILION, LAKE COMPOUNCE, BRISTOL, CONN

This later picture shows the arch on the left before the casino. Concession stands have been added, and the laundry building on the right of the casino was moved there from the area near the lake.

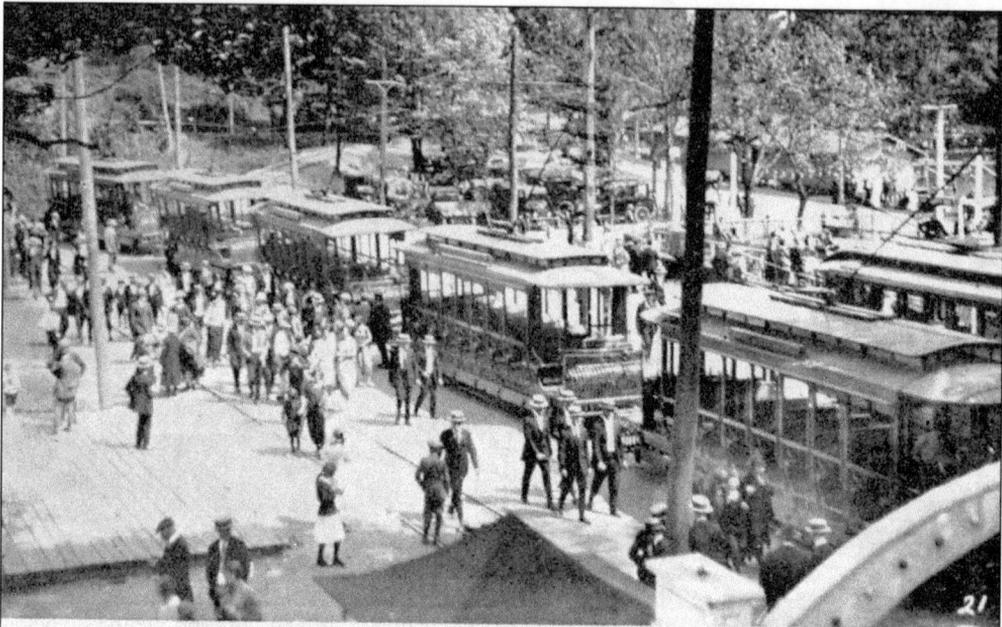

Trolley Terminal at Lake Compounce, Bristol, Conn.

The trolley terminal was photographed in 1920 with all the cars lined up. In the background, automobiles are starting to be used for transportation.

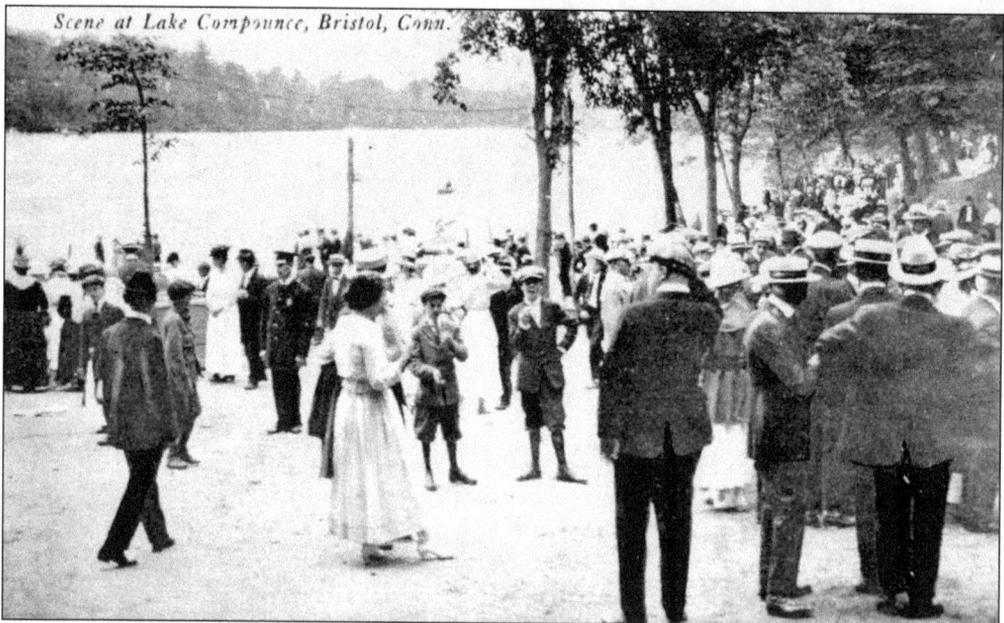

Scene at Lake Compounce, Bristol, Conn.

As better transportation became available, more families came and enjoyed all the park had to offer.

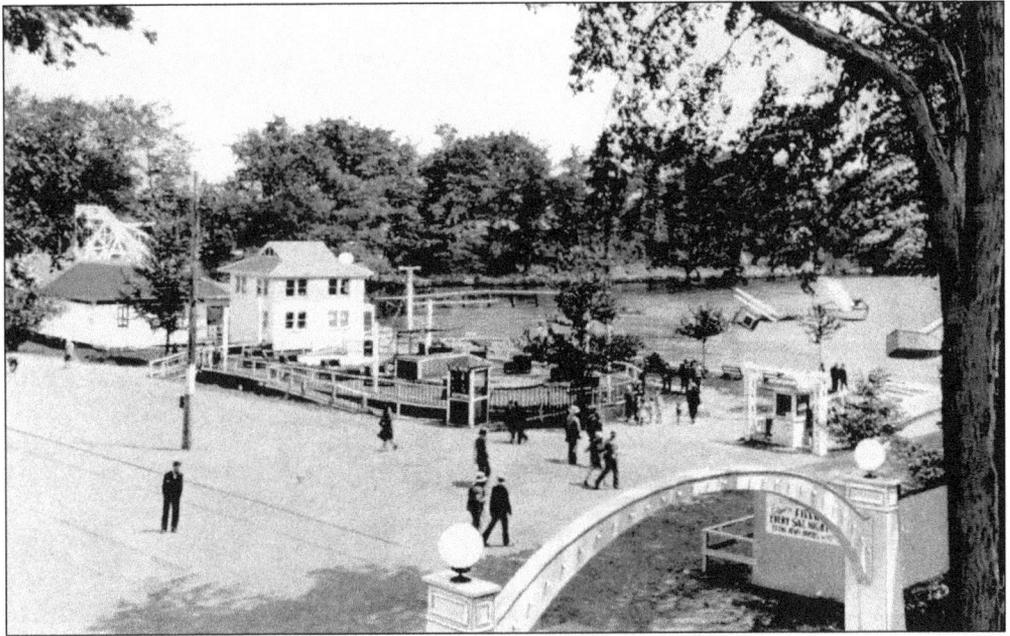

In 1924, the park made changes near the lake. From the right of the bathhouse, a laundry building was added in the middle. A couple of new amusement rides have been added as well.

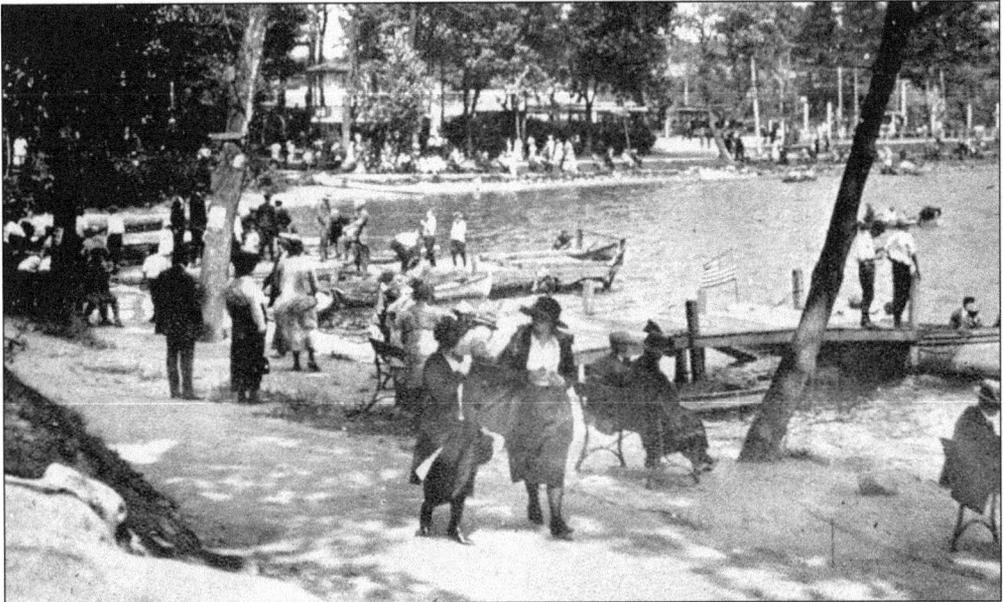

Near the dock area, a couple of women are taking a stroll while others are waiting by the docks for a boat ride.

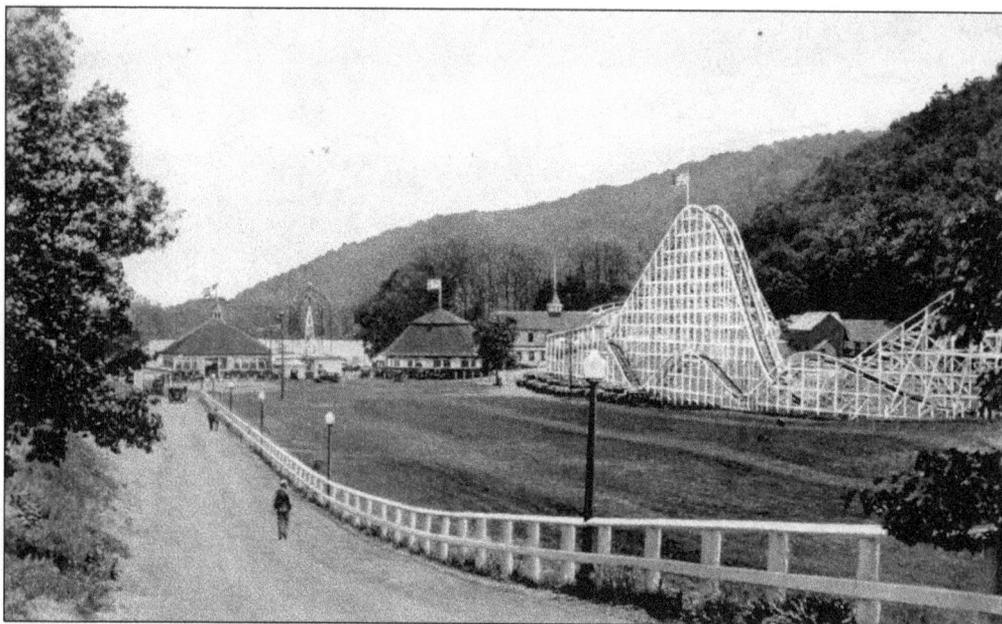

Once the trolley cars stopped coming to the lake, a new entrance was made to accommodate the automobiles. The field next to the Wildcat roller coaster was used for baseball games. At one time, this was the area where the Nortons grew their crops.

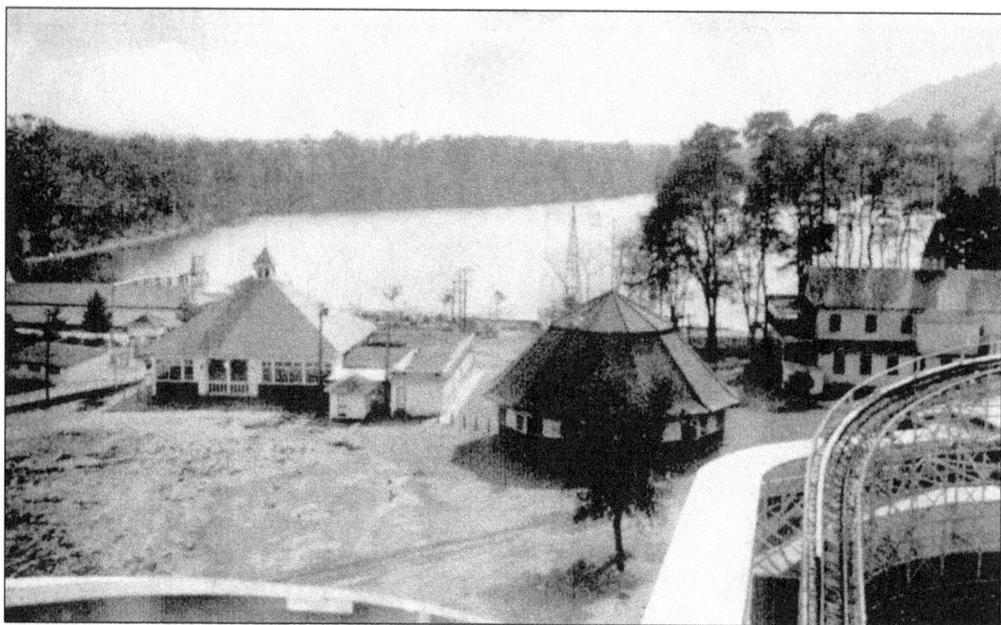

A view of the penny arcade is on the left with the carousel now in its new location. The Wildcat roller coaster is on the right.

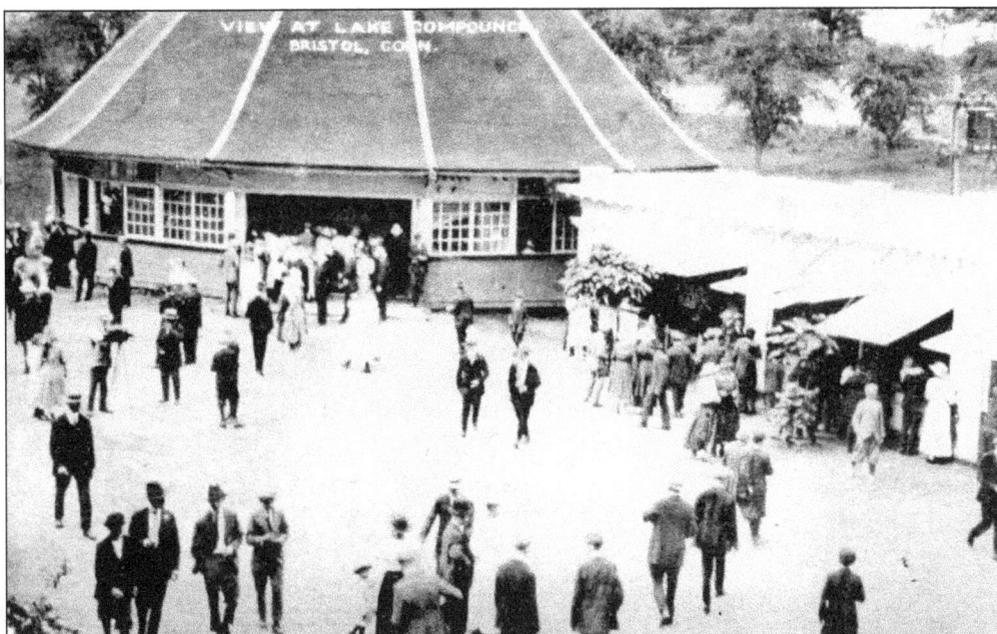

This 1919 view shows the carousel with the start of concessions on the right. There are still trees in the background behind the concessions.

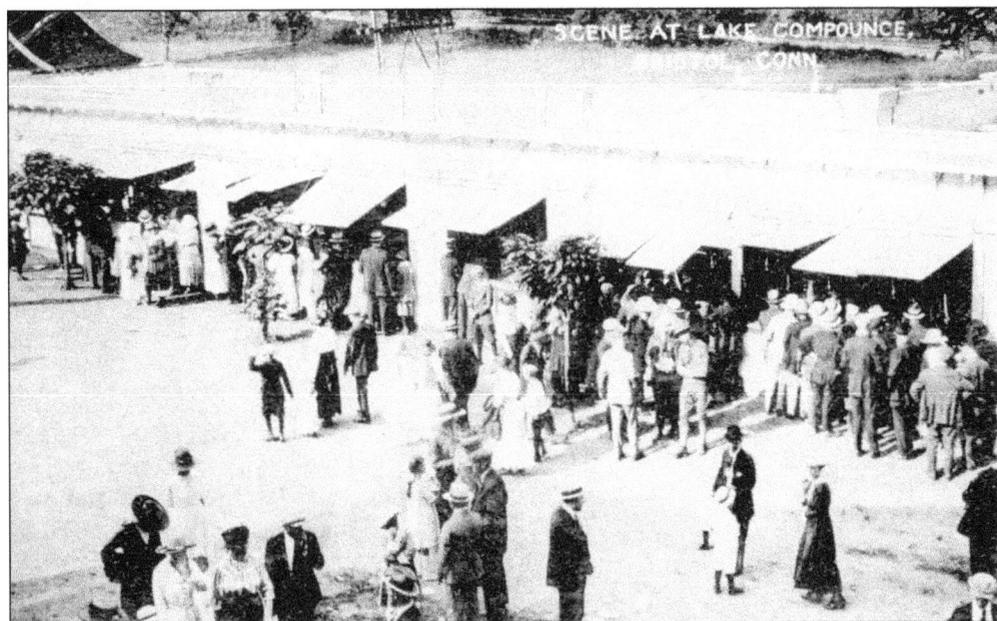

This picture of the food and game concessions area would later become known as the midway.

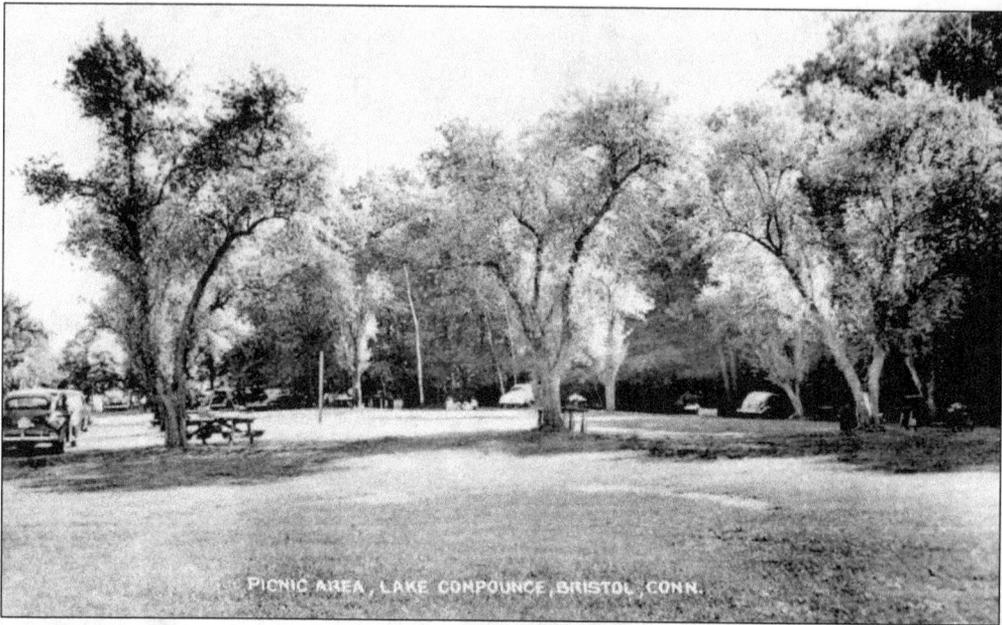

Families now came by car for the day. A picnic area with tables was another added feature to the popular park.

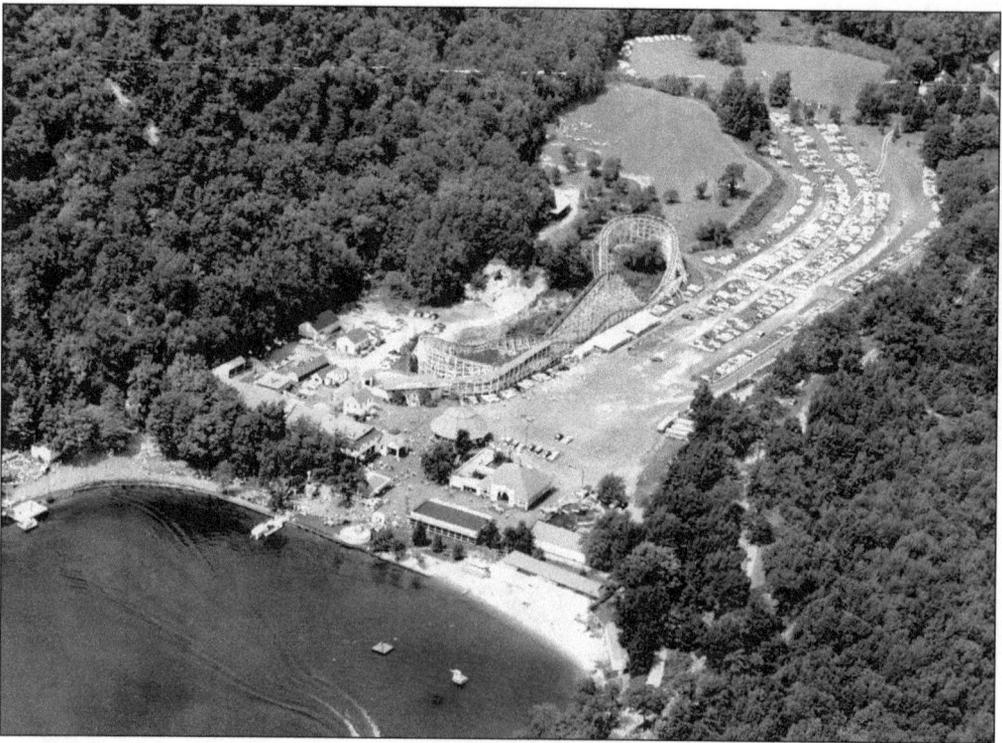

This aerial view of the park was taken in 1947. At the top is the picnic area.

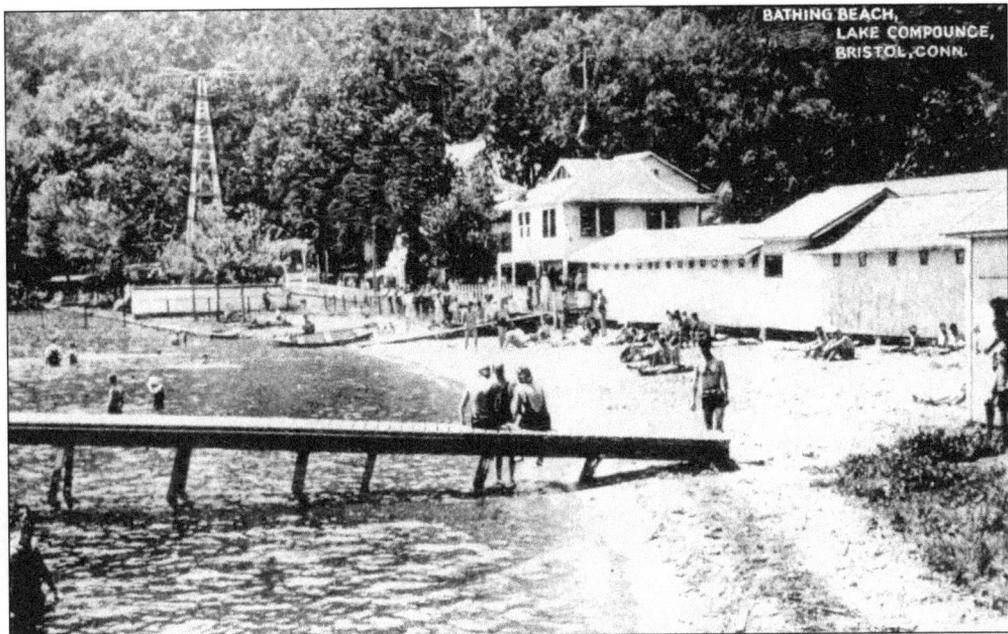

In this 1940s picture, the building on the left was where the laundry was done. Bathing suits and towels were available to rent if patrons did not bring their suits. The bathhouse to change was on the right. J. Harwood "Stretch" Norton started his first job here at nine years old, giving keys out for the locker rooms.

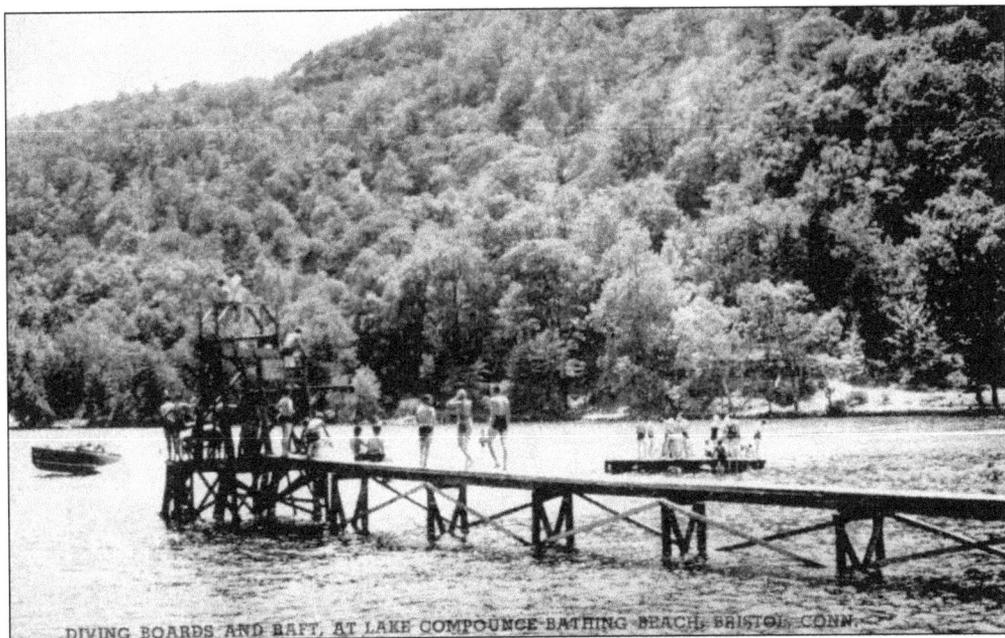

At the end of the dock was the wooden high dive with the raft to swim to. In the background, the mountain area has not yet been developed.

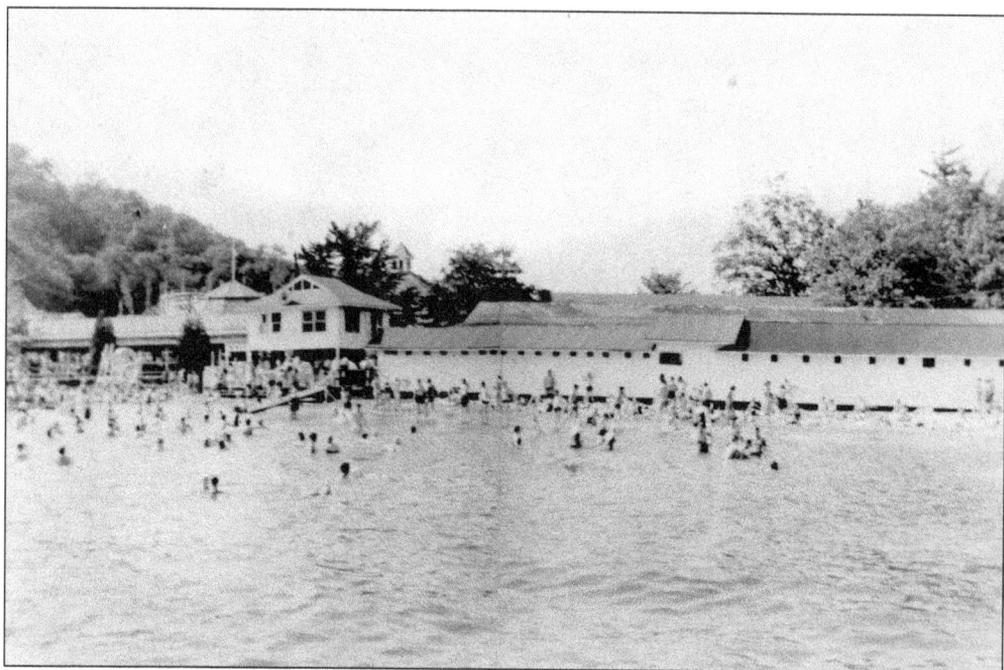

Many came to enjoy swimming in the lake, a popular place to be on a warm day, as seen in this picture.

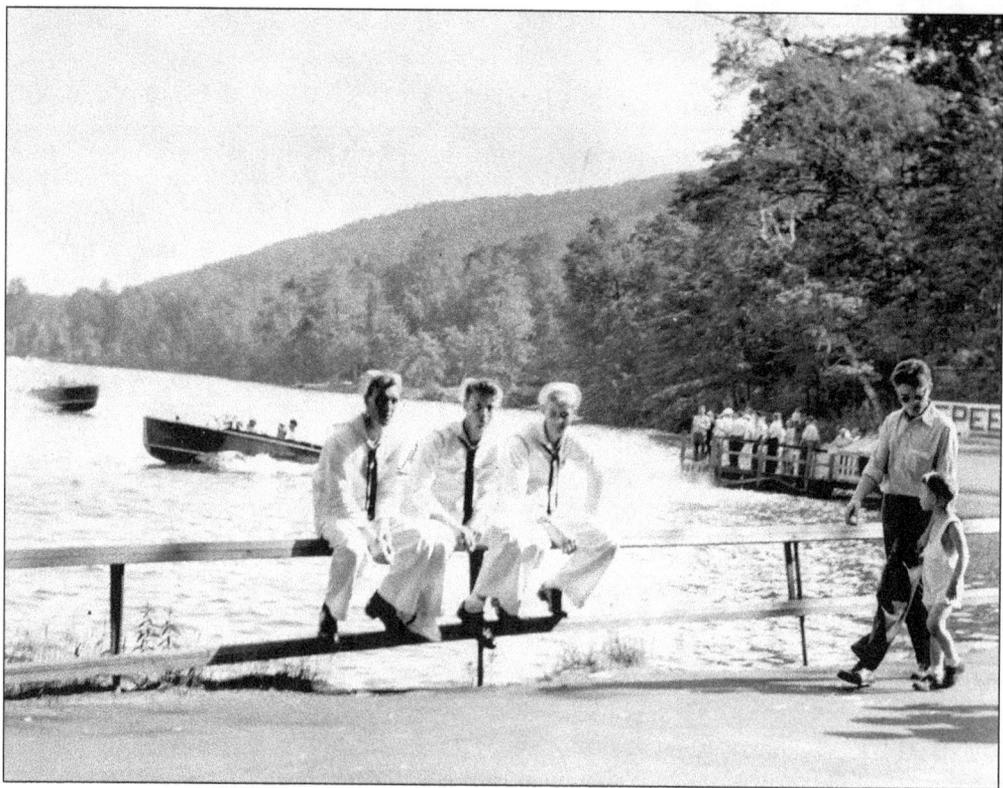

These three navy sailors who came to enjoy the day are resting on the railing near the lake.

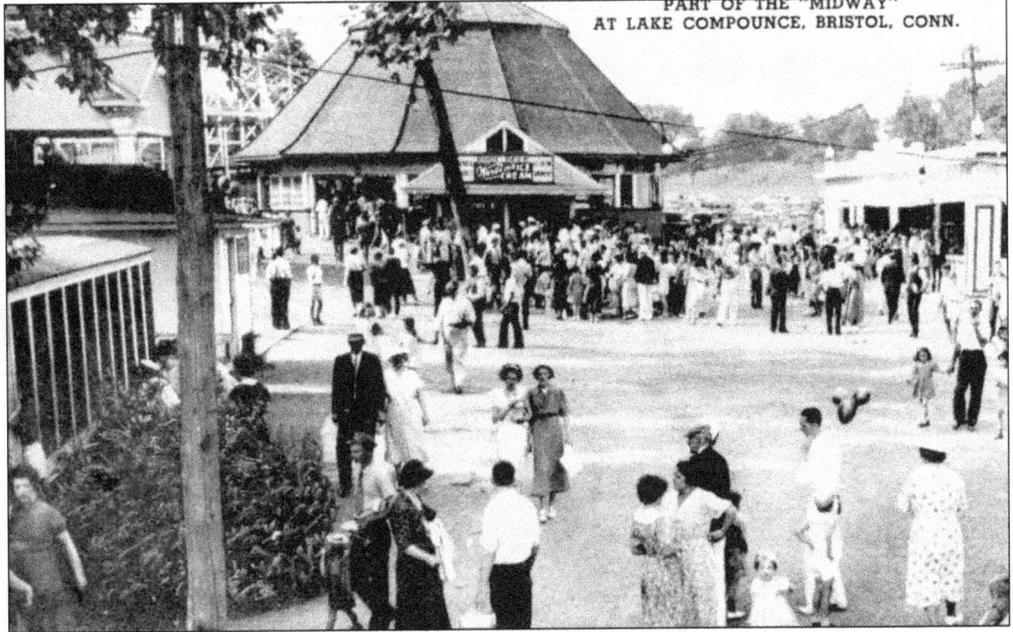

This 1940s picture shows part of the midway. A large crowd in the back is near the carousel that now has a food concession in front of it.

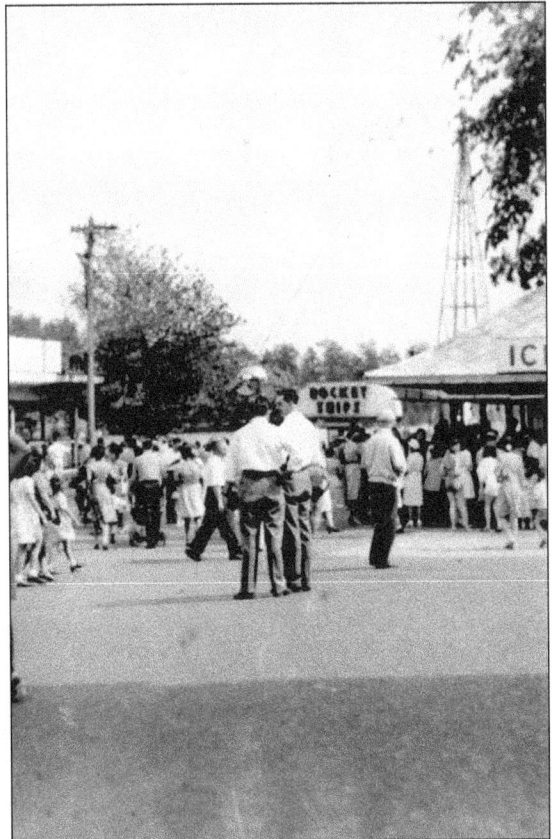

This 1950s picture shows where some of the food concessions were in the midway.

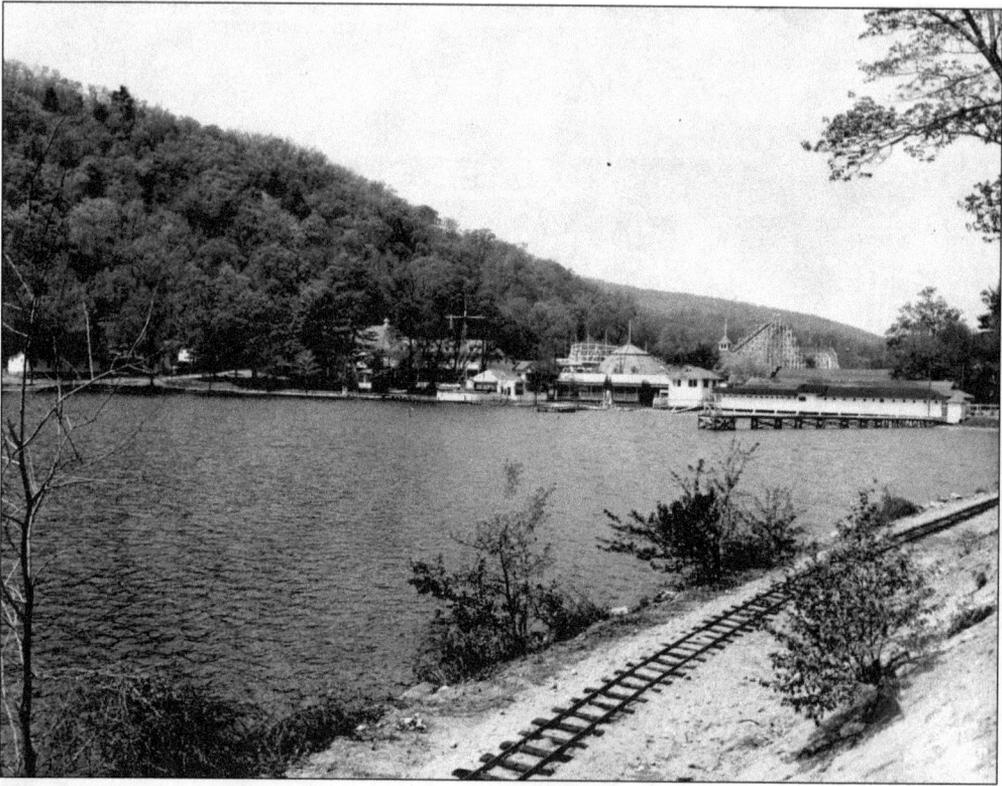

This view taken in 1945 shows the railroad tracks for the famous Gillette train that went around the lake at the shore on the right.

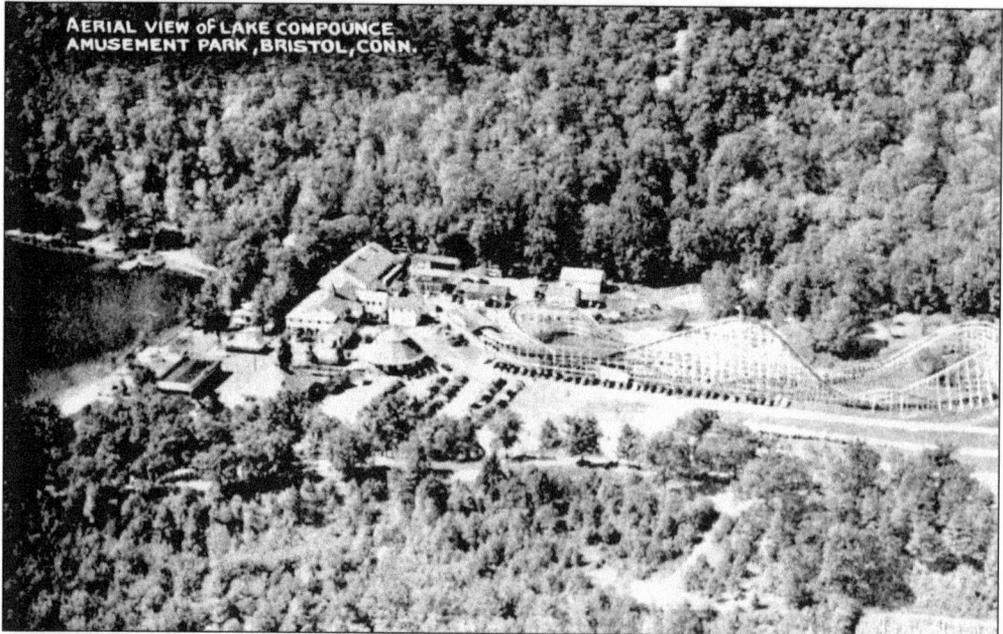

AERIAL VIEW OF LAKE COMPOUNCE
AMUSEMENT PARK, BRISTOL, CONN.

This 1953 aerial view of the park shows that the entrance to the park is still in the same place as it was in the 1920s.

Three

CROCODILE CLUB

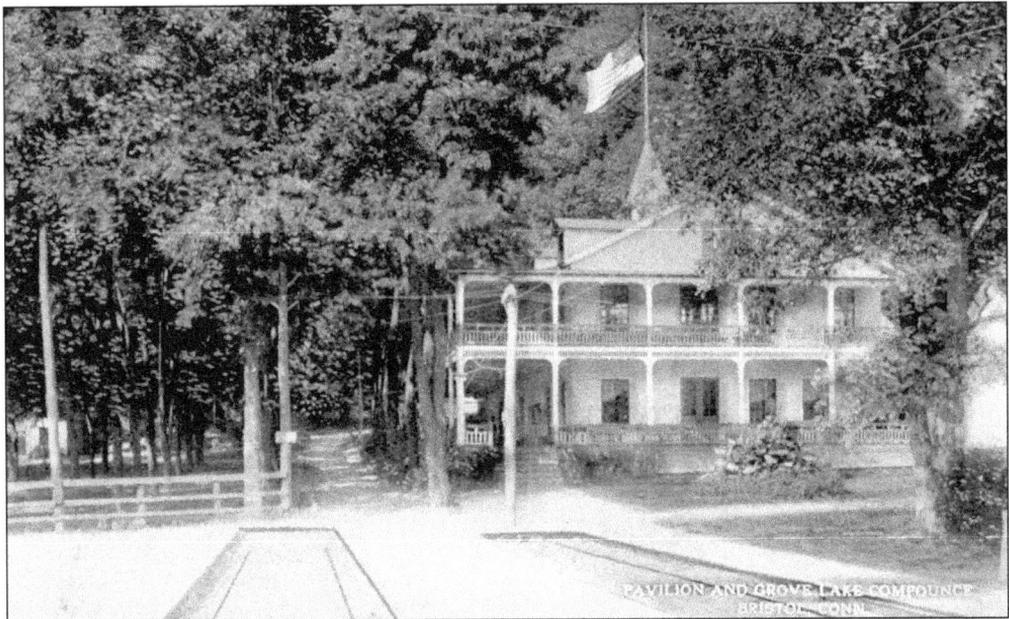

Gad Norton and Isaac Pierce gave a sheep barbecue on September 9, 1875, to 30 invited guests. Two were state senators, along with members of the House of Representatives, and the rest were men from the local area. The dinner was to thank the legislators who granted Norton's and Pierce's requests to change their homes from the town of Southington to Bristol. At the dinner it was decided to make this a permanent club, and the Crocodile Club name was adopted. Starting in 1895, when the pavilion was built, the annual dinners were held here.

This ticket is from the 24th annual reunion of the Crocodile Club that was held on September 6, 1900. The menu remained the same through all the years the event was held. It consisted of roast lamb, fried corn, white and sweet potatoes, sliced tomatoes, rolls and butter, watermelon, beer, and a cigar for after the meal. Each year the members invited new guests, who included local people and politicians.

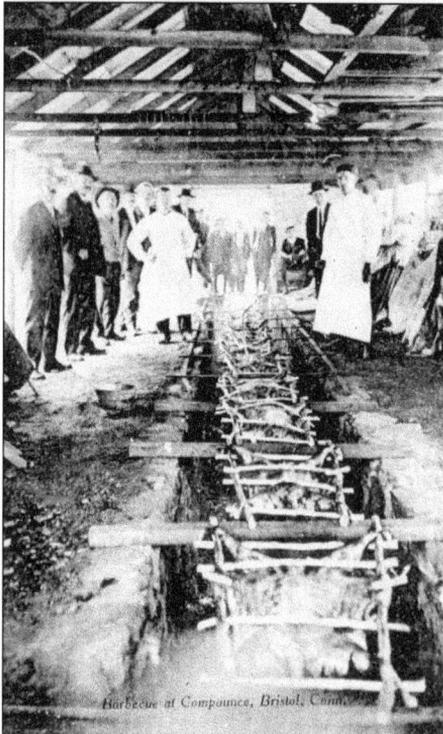

This picture shows an early method of how the sheep were roasted on racks in an open pit with guests watching on either side inside the building.

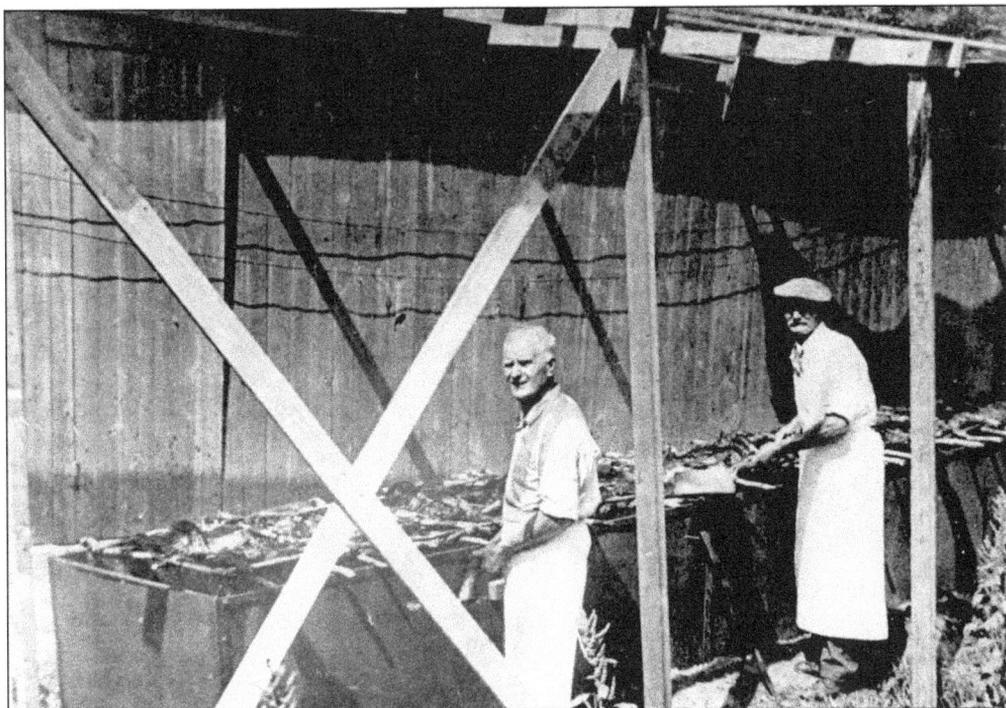

In this 1932 picture are cooks Frank Ritchie (left) and Smitty. They are preparing the lamb in a more modern way for the 57th annual reunion.

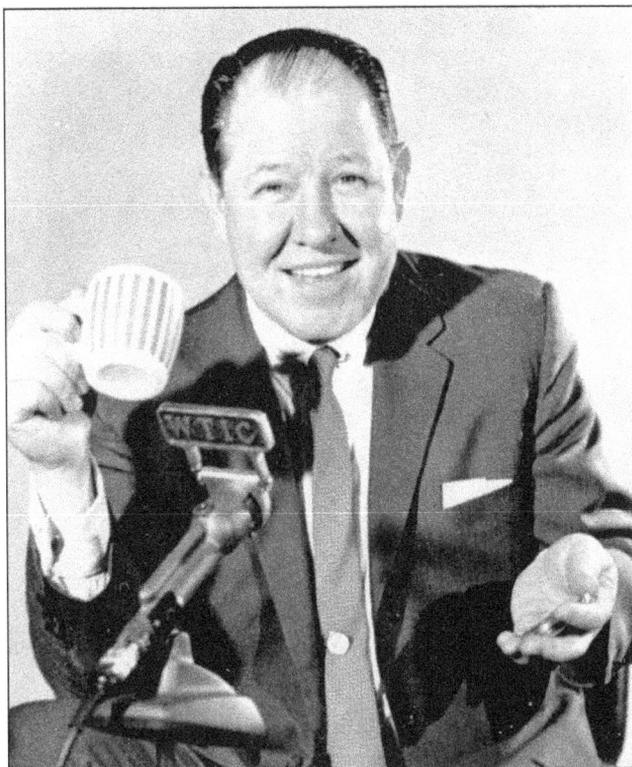

Bob Steele became president of the Crocodile Club starting in 1971 and held the position for 19 years.

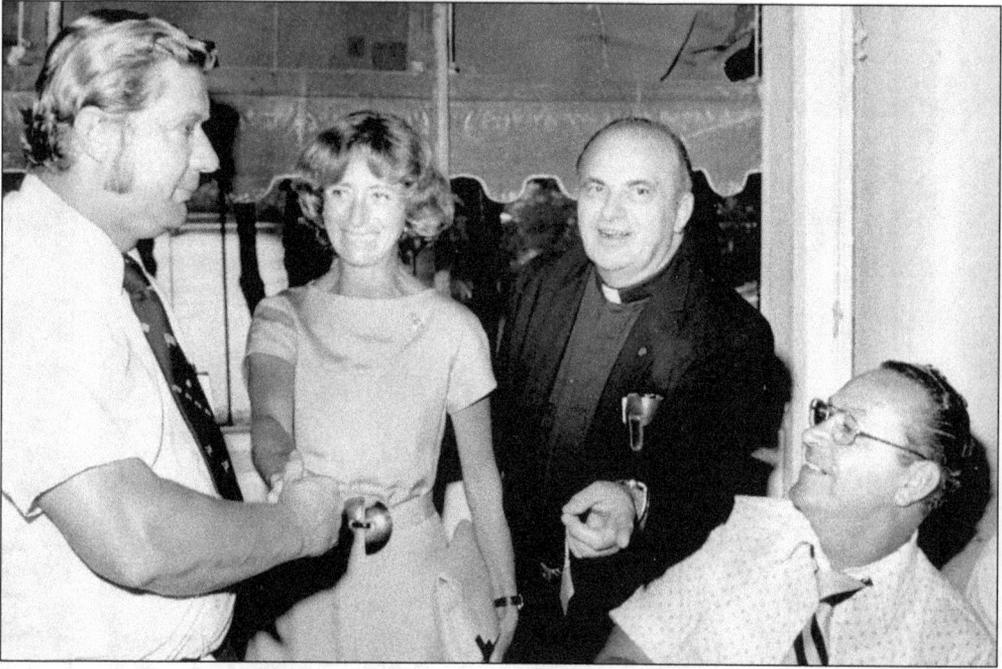

In 1970, women were finally allowed to attend the Crocodile Club annual dinners after 95 years. The first women in 1970 were Mayor Uccello of Hartford, Gloria Schaffer, and Barbara Dunn. In the picture above, taken on September 5, 1975, from left to right are Walter Lassy, mayor of Plymouth, Gloria Schaffer, secretary of state of Connecticut, Fr. Joseph Shaloka, and John Krinitsky, police chief of Plymouth.

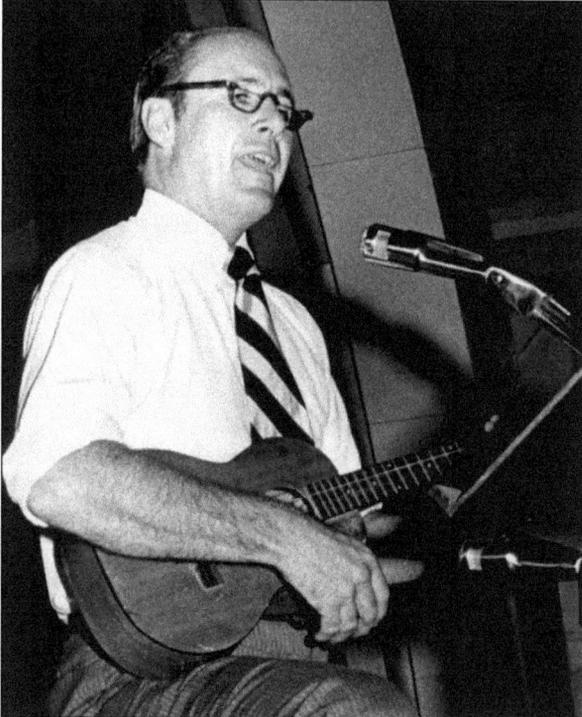

Wally Barnes from Bristol is singing as he plays his guitar at the 100th annual Crocodile Club dinner that was held on September 5, 1975.

Attending the 100th annual Crocodile Club dinner that was held on September 5, 1975, are Brett Quinion and his 88-year-old grandfather George Quinion.

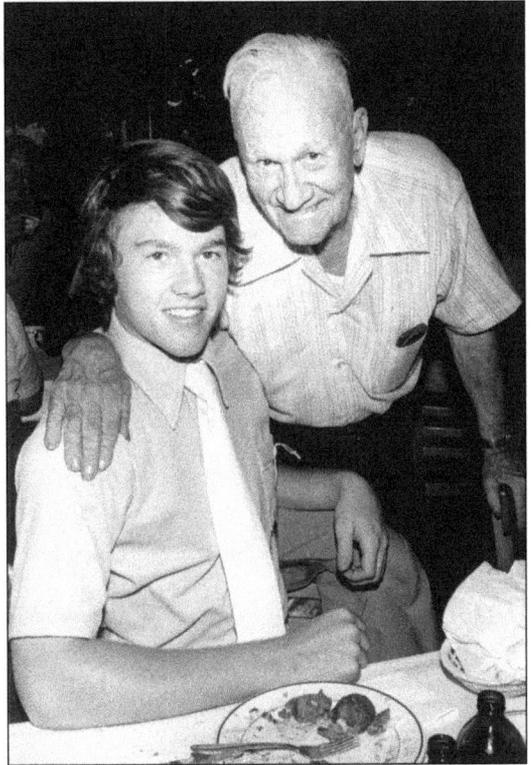

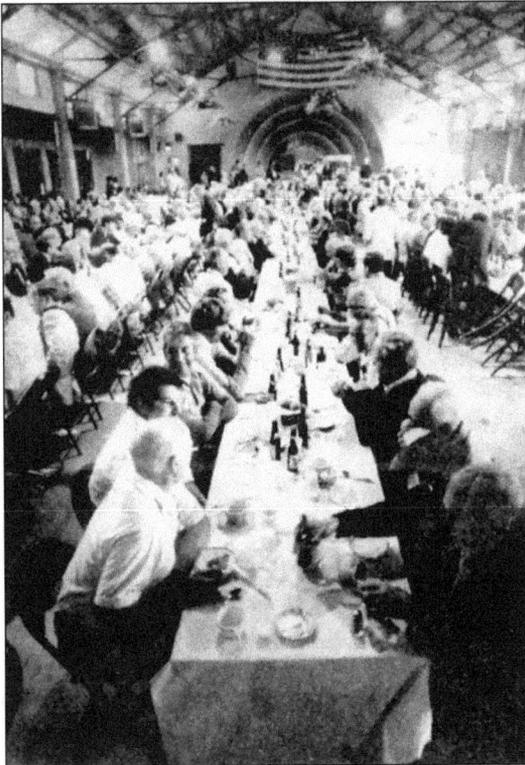

Inside the Starlite Ballroom in the casino was where the annual dinners were held. In this 1977 picture is the 102nd dinner with members and guests enjoying their meals.

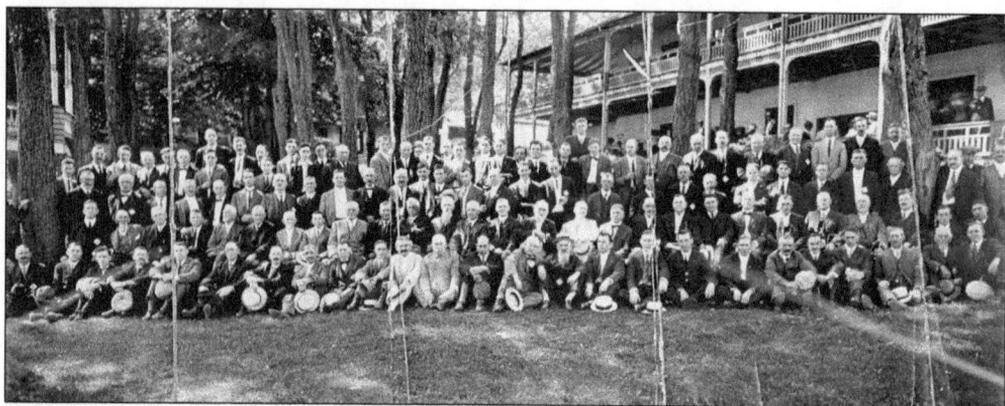

In this picture, taken outdoors in front of the casino, are the members and guests at an annual Crocodile Club meeting.

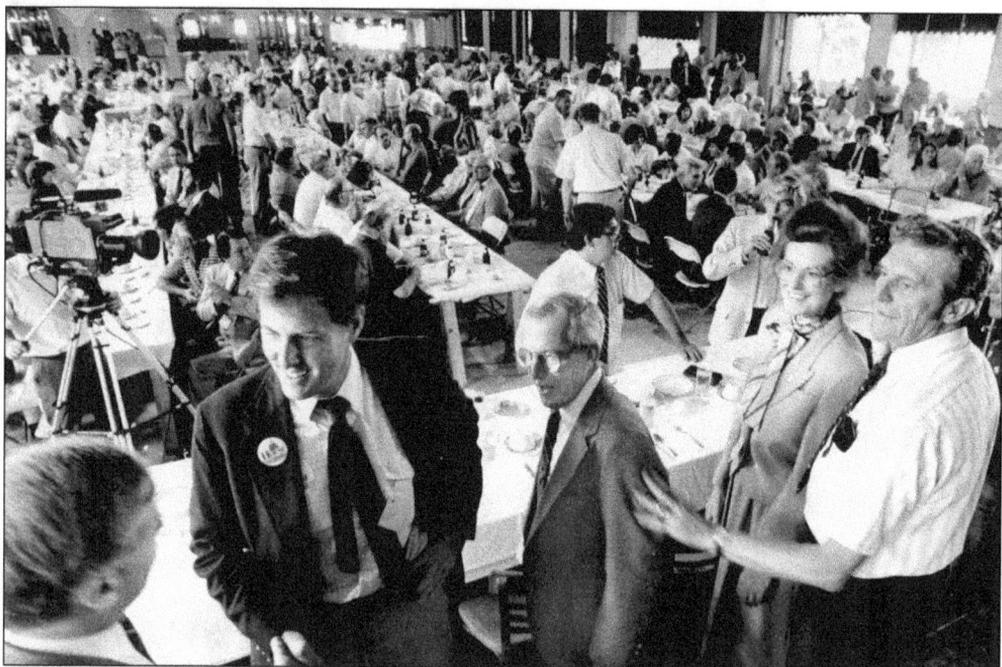

Arthur House (second from the left), a candidate running for the Democratic Sixth Congressional District, is talking to other guests. On the far right is J. Harwood "Stretch" Norton, whose family owned the park and planned the annual Crocodile Club dinners each year. This picture was taken at the 109th annual dinner on August 24, 1984.

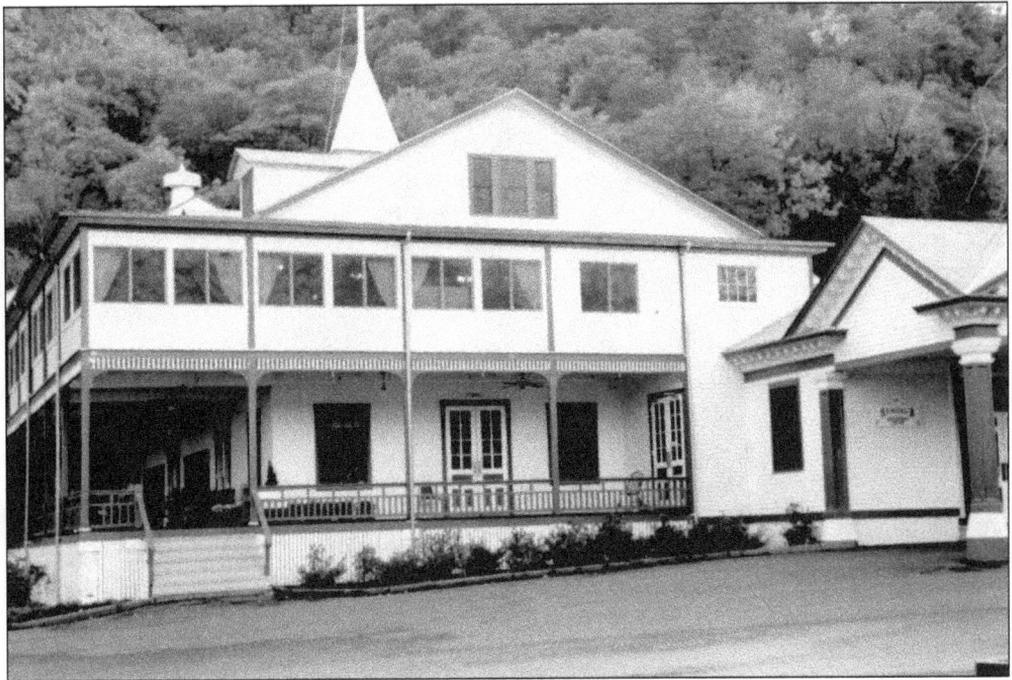

This 1987 picture of the newly renovated casino shows many changes made to the building since it was built in 1895. This is where the annual dinners were held for the Crocodile Club.

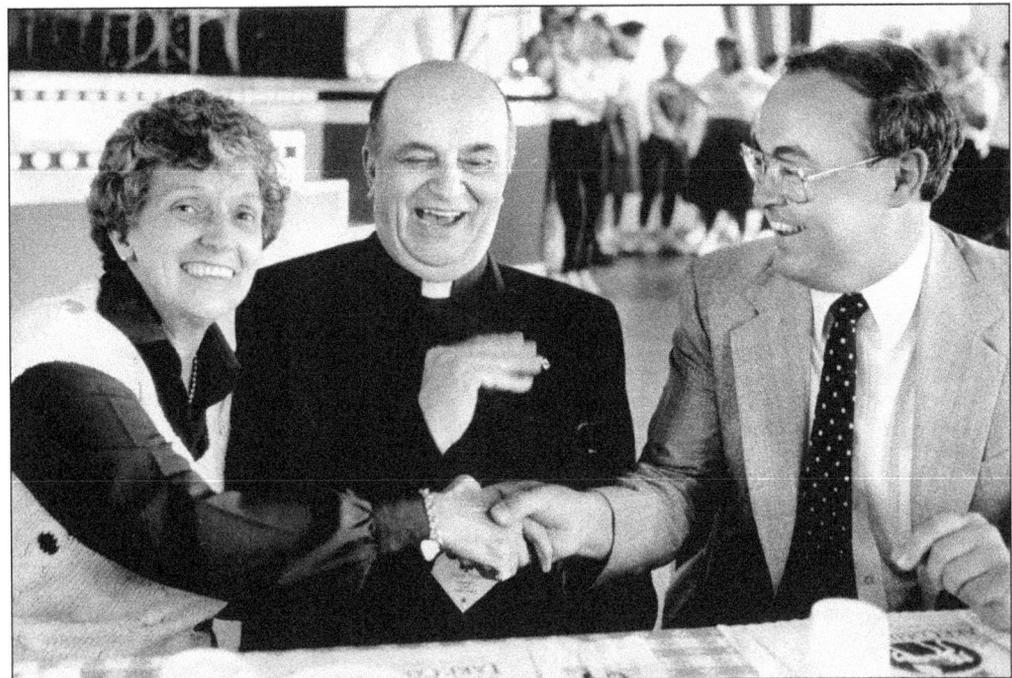

Enjoying their dinners are, from left to right, Eleanor Klapath, Rev. Msgr. Joseph Shaloka, and Mayor John J. Leone Jr. at the 112th annual dinner of the Crocodile Club on August 21, 1987.

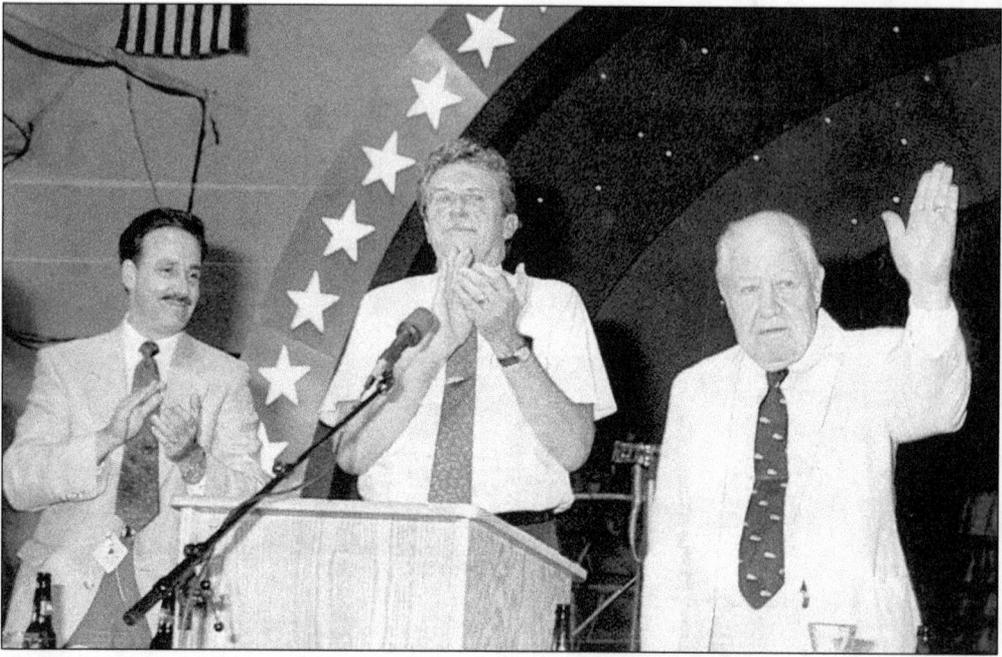

At the 115th annual Crocodile Club dinner held on August 24, 1990, standing on the left is news reporter Gerry Brooks from the local NBC television station. Brooks became the new president of the club. In the center is J. Harwood "Stretch" Norton, and WTIC radio station's Bob Steele, the outgoing president of the Crocodile Club, is on the right.

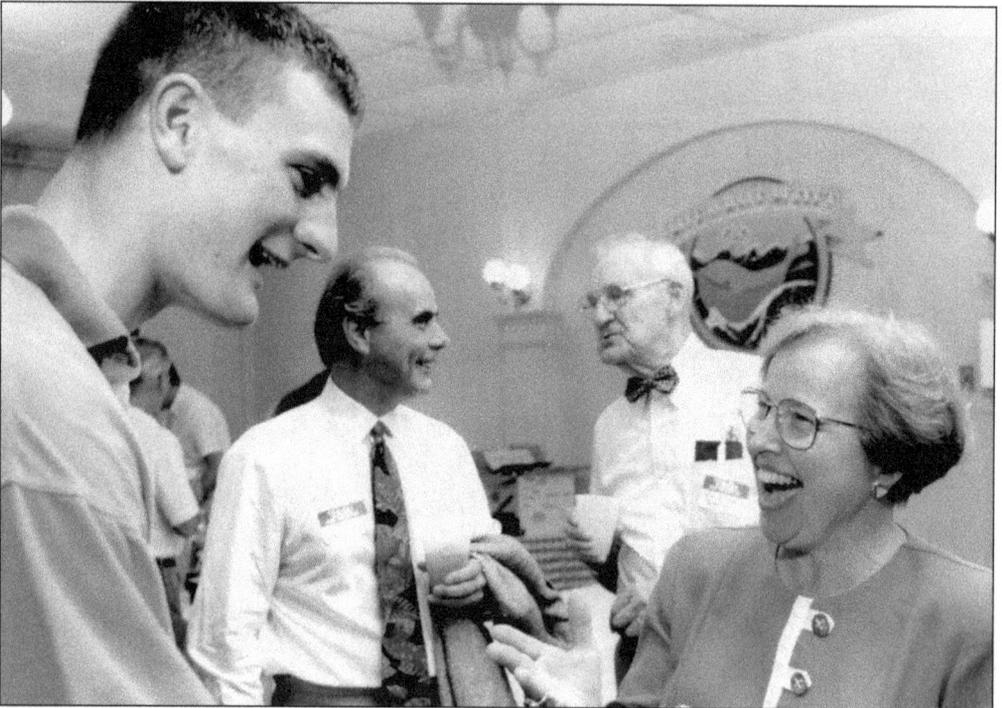

On the left is Peter Nye of Bristol speaking to Nancy Johnson, congresswoman from Connecticut, at the 118th annual Crocodile Club dinner held on August 27, 1993.

Four

AMUSEMENTS

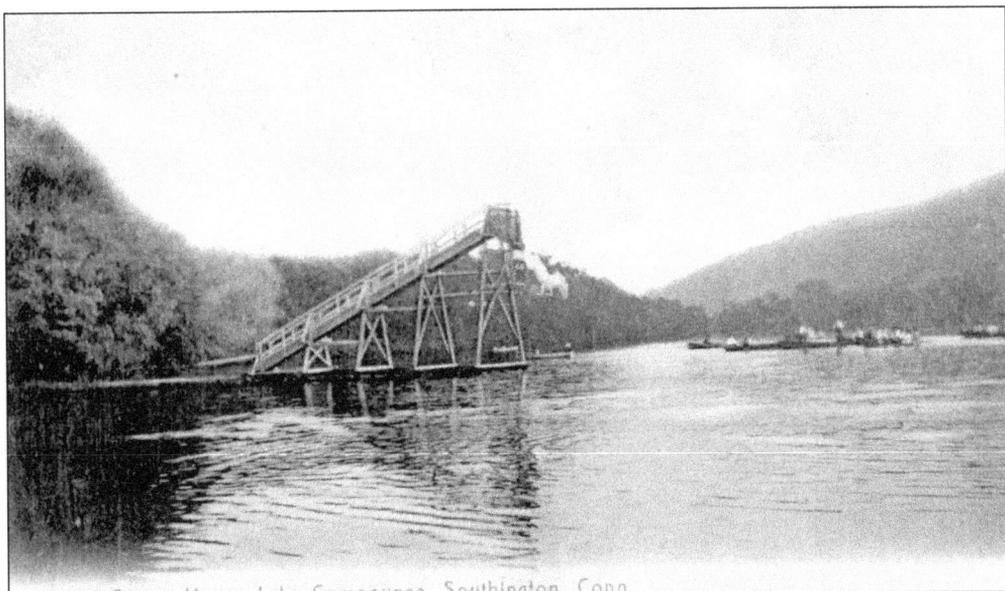

From New York, J. W. Gorman's famous high-diving horses called King and Queen performed at Lake Compounce in 1904. At this time, it was the biggest attraction in the history of the park. The horses trained to dive from a 50-foot platform into the lake. They performed twice a day, first at 5:45 p.m. and then again with special lighting at 9:00 p.m.

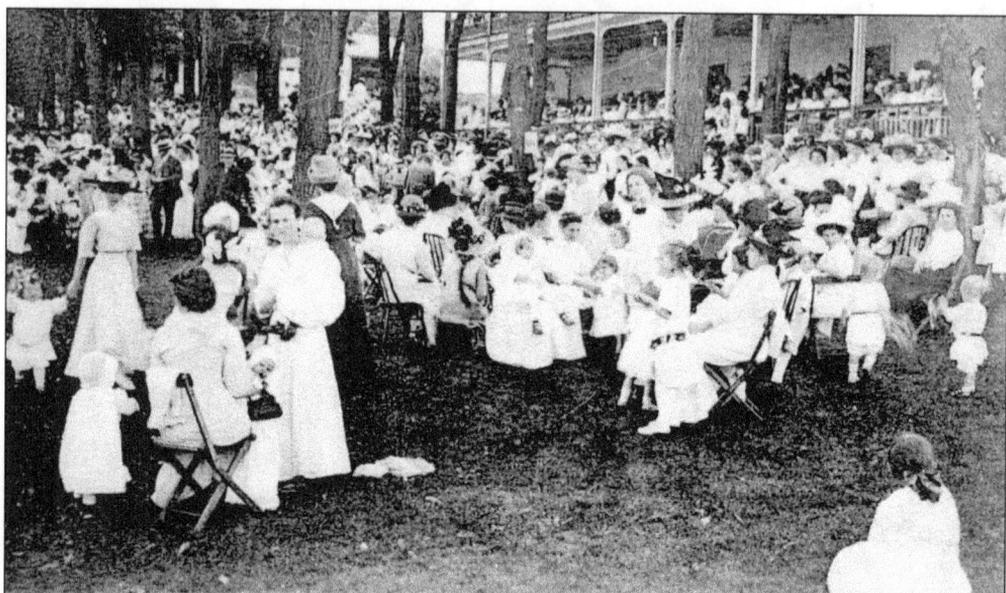

BABY SHOW. LAKE COMPOUNCE, CT.

In 1899, the first "baby show" event was held at Lake Compounce. The babies were judged in various categories, such as the handsomest boy, handsomest girl, handsomest twins, best natured, noisiest, and weight. Bristol, Southington, Terryville, Plainville, Meriden, New Britain, Hartford, and Waterbury participated. Every baby that entered the show was given a doll. Older children were also given presents.

Martin Andrew Stephenson of Plainville was born on July 12, 1900. In the second annual baby show held on August 28, 1900, he won the Most Beautiful Baby award and received as his prize a silver cup.

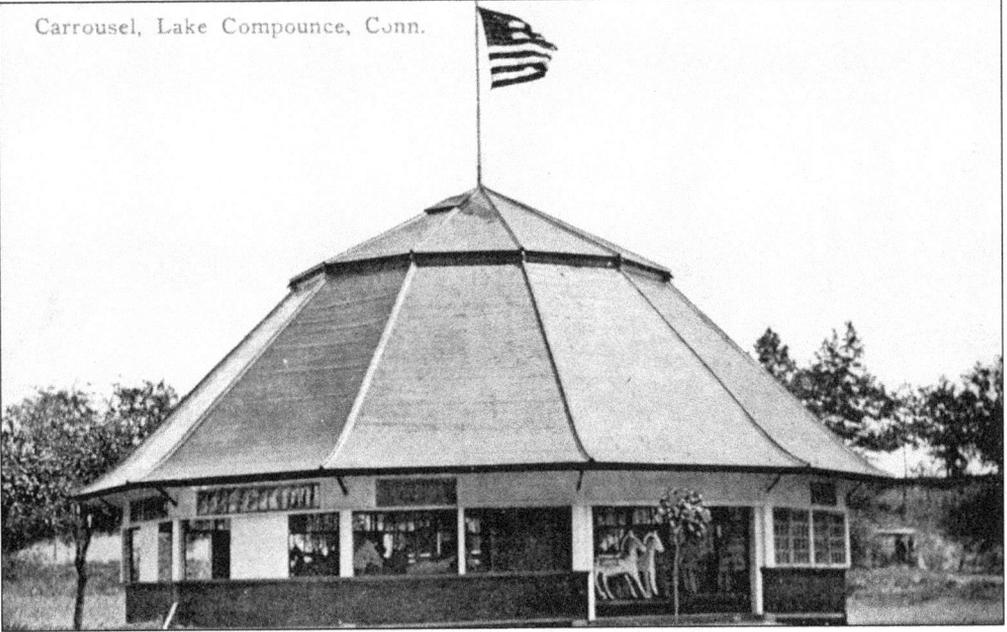

Carrousel, Lake Compounce, Conn.

The carousel was built around 1890 and was purchased for $10,000 by Lake Compounce in 1911. It was advertised as part of one of the new features on Memorial Day 1911. When it first arrived, it was placed next to the casino. Later as new rides were purchased, the carousel was moved to another location.

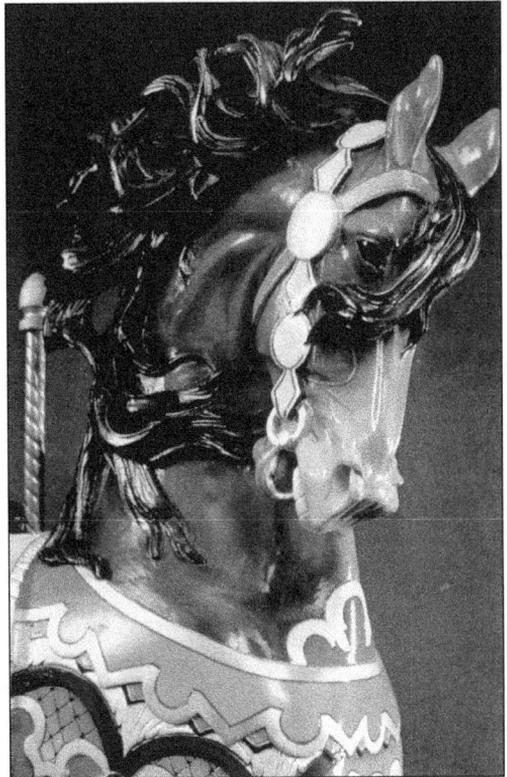

The carousel came with 49 horses, one goat, and two chariots that were all hand carved. In 1979, the carousel was listed on the National Register of Historic Places.

Scene at Lake Compounce, Bristol, Conn.

This early-1900 view along the lake features the outdoor bandstand on the left. Located on the far right is the bathhouse.

The dock area has most of the boats out on the lake in this picture. Across the lake are a few amusement rides near the shore area.

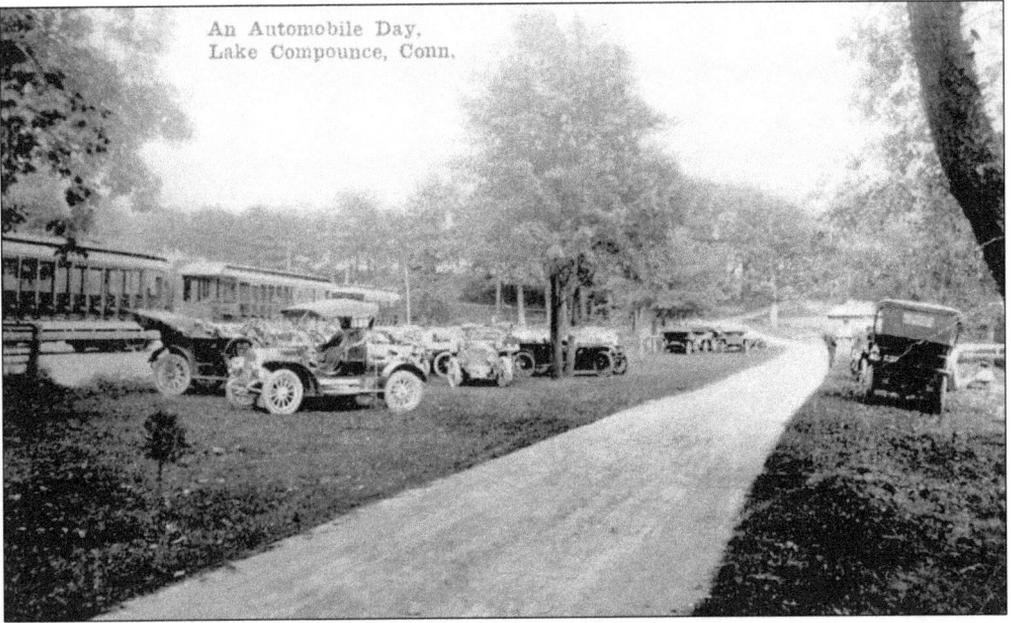

An Automobile Day,
Lake Compounce, Conn.

Pierce and Norton Company Inc. offered many ways to have events at the park. As the automobile became more available for people to own, an event called Automobile Day took place. On the left behind the cars are the trolley cars. The dirt road is the main entrance into the park.

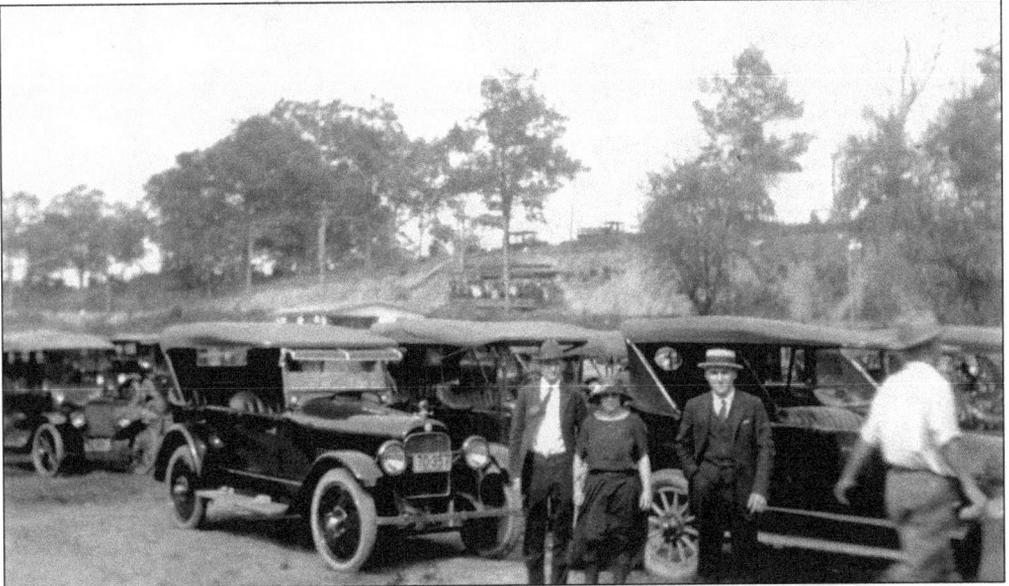

In this 1914 picture, on the left are the grandparents of Bill Plaweski of Bristol. The trolley car is in the back behind the cars.

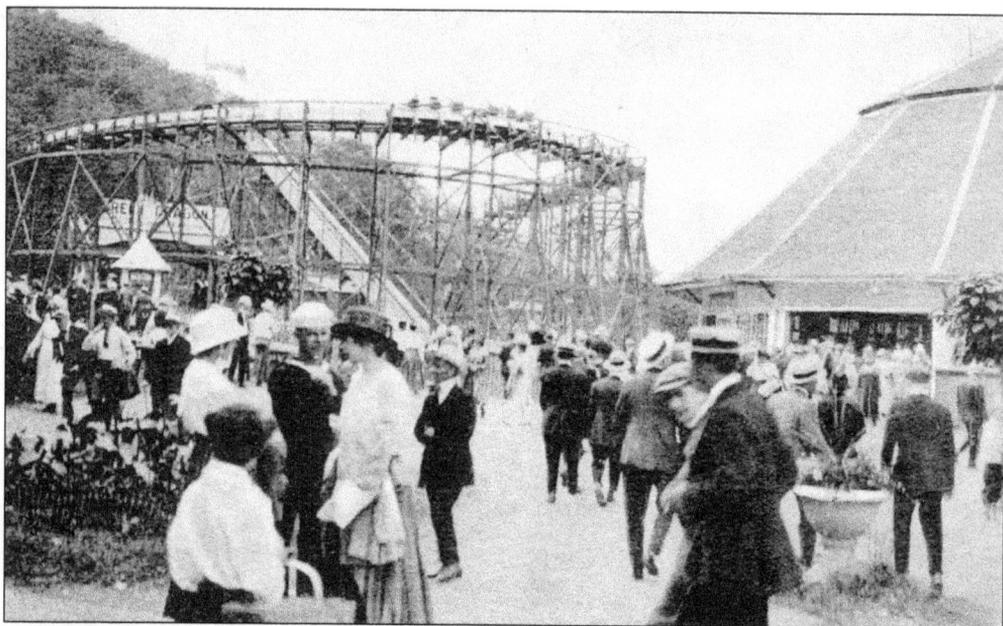

The first roller coaster came to Lake Compounce in 1916 and was called the Green Dragon. It was built by Edward Bowan. It was located near the carousel and was torn down in 1927 and replaced by the Wildcat roller coaster.

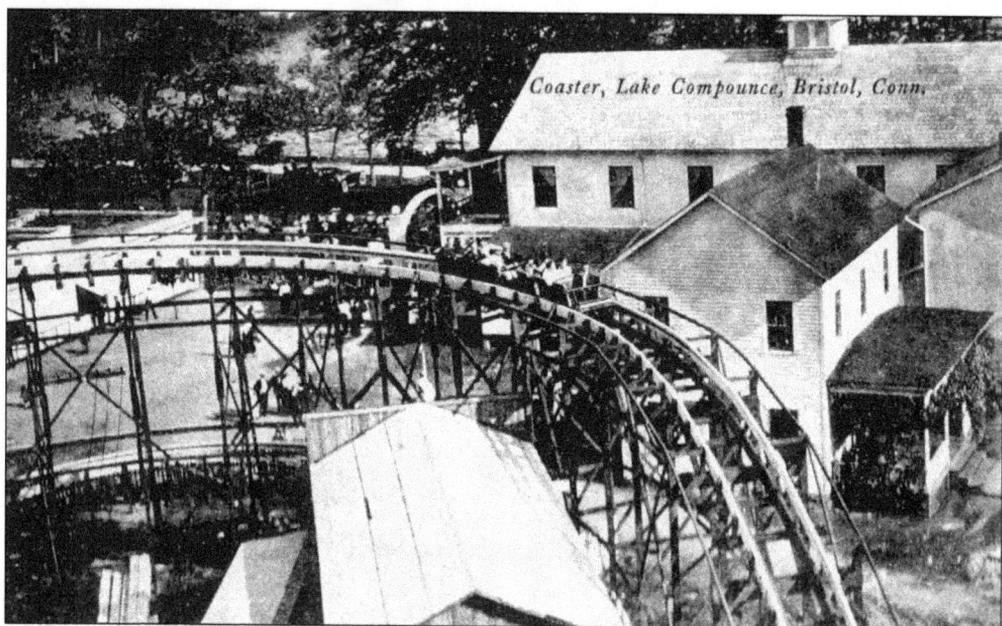

This view of the track of the Green Dragon roller coaster shows the casino in the back. The laundry building is next to the track on the right.

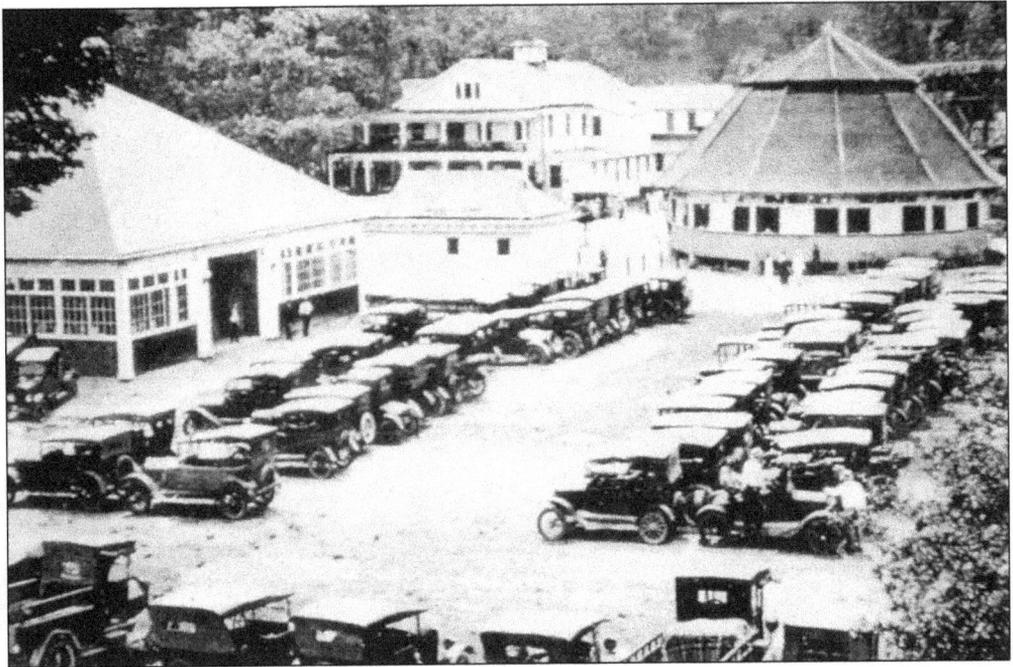

Traveling by automobile brought more people from other towns to the park. On the left in this picture is the arcade. In the back is the casino and on the right the carousel.

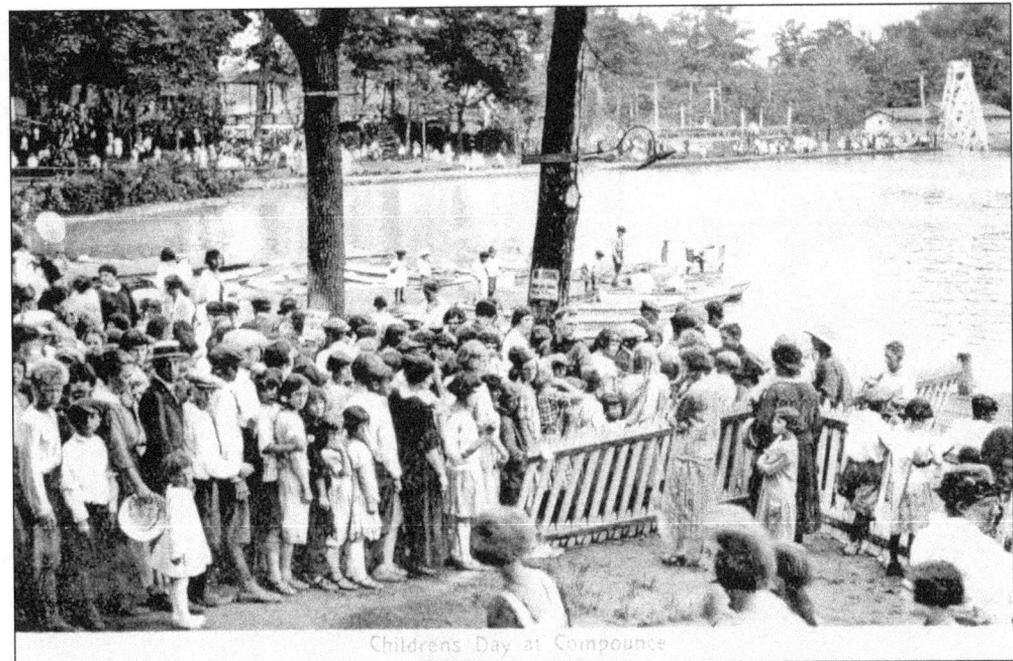

Lake Compounce advertised in the *Bristol Press* on Friday August 31, 1906, a boys' and girls' carnival with band concerts, fireworks, sports, and contests. Every child that attended received a present. In the picture above, a later Children's Day event takes place. As part of their day, these children are waiting for a boat ride.

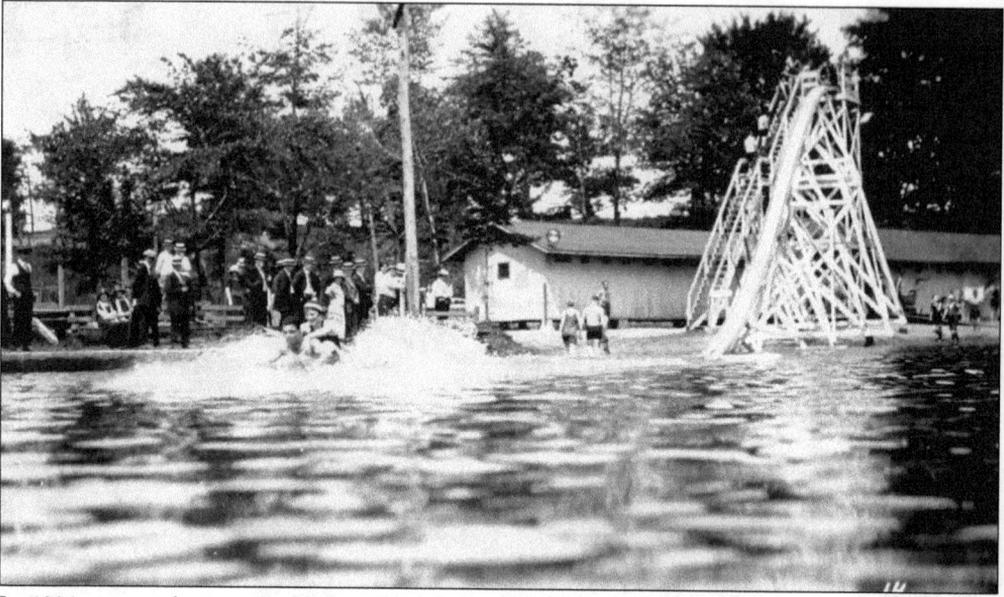

In 1924, a new chute was added to the lake area. The bather would ride down the chute on a toboggan, and when the toboggan struck the water, it would skim across.

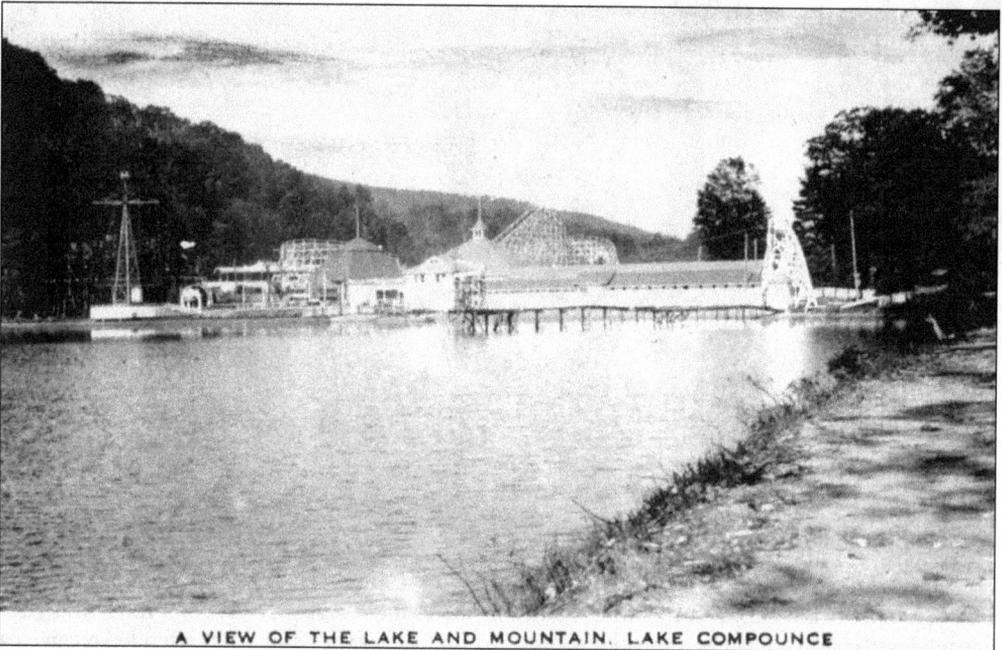

A VIEW OF THE LAKE AND MOUNTAIN. LAKE COMPOUNCE

This view of the shore shows the bathhouse on the right and the casino on the far left in back. The dry dock is in front of the bathhouse.

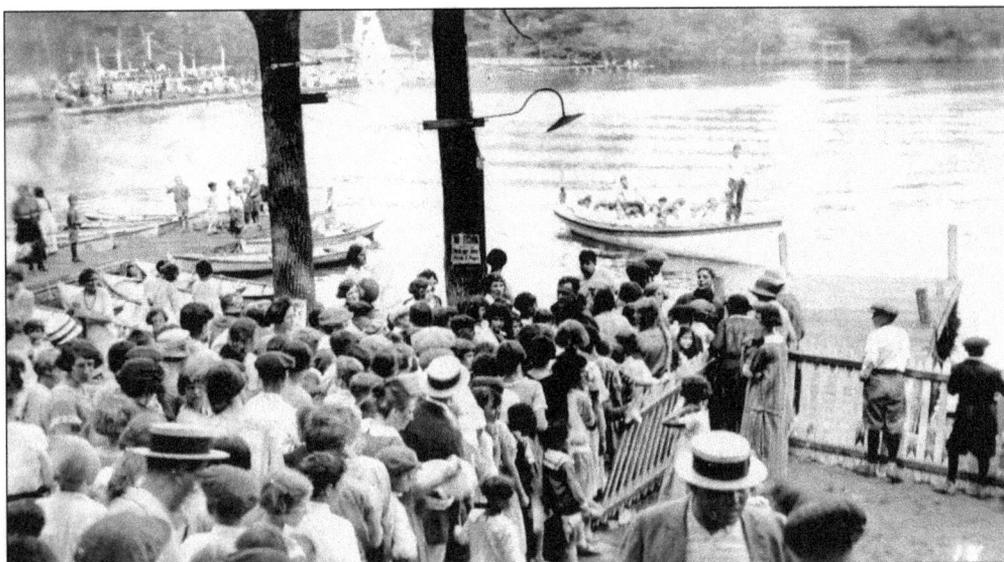

For the visitors who came to the park, boating was very popular. Rowboats were still available on the left. The motorboats on the right were the replacements for the rowboats.

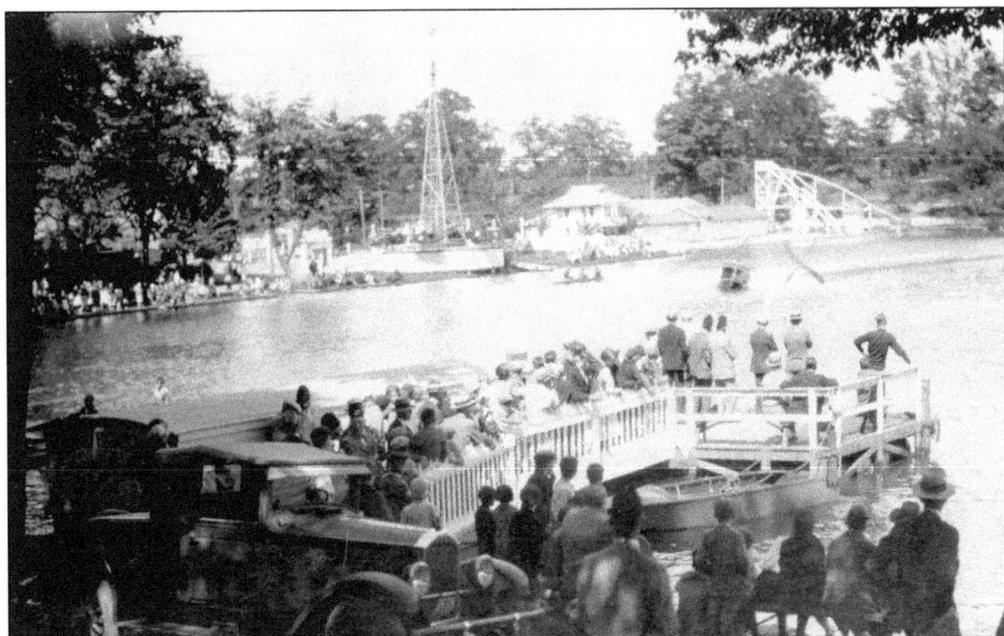

At the season opening in May 1929, the first of the three Chris Craft speedboats was added to the park. Each boat cost $2,800. The price of the ticket to ride was 15¢. By July of that year, the first boat was paid for.

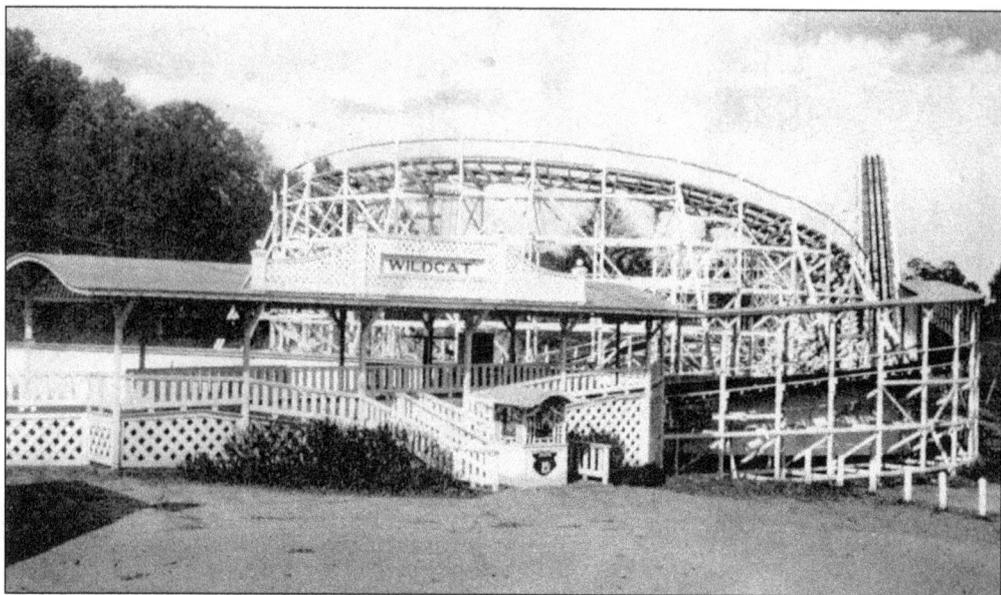

In 1927, the Wildcat roller coaster replaced the Green Dragon. It was built by the Philadelphia Toboggan Company. This wooden roller coaster still stands today at the park.

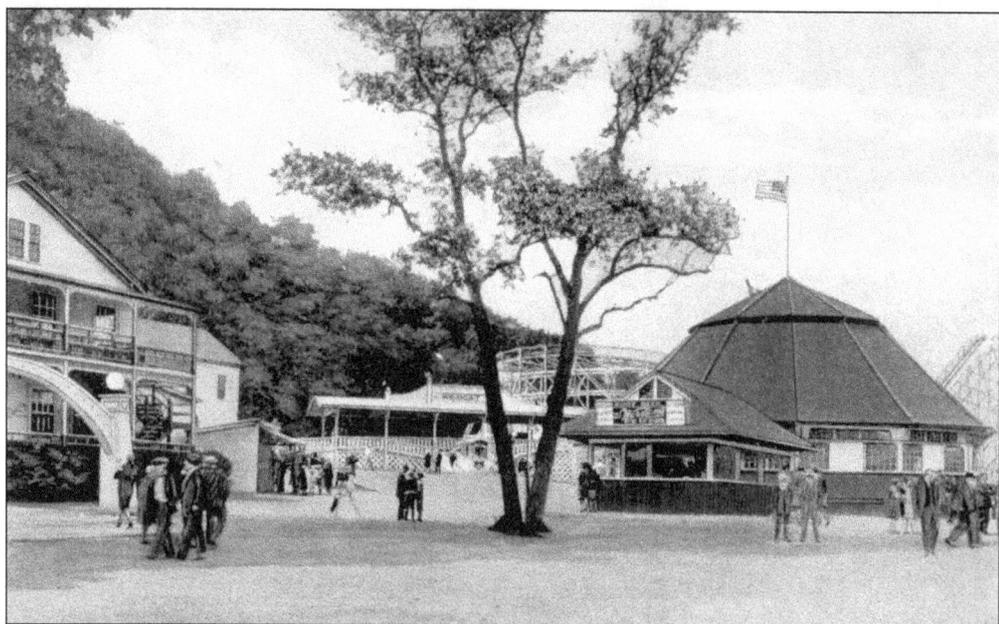

On the left is the visitor entrance to the casino. The Wildcat is in the background. An ice-cream stand has been built in front of the carousel.

Starting in 1936, roller-skating became popular, using the ballroom floor in the casino. As the big bands started playing, the skaters had to share the place with bands and dancing. The skating continued through the 1950s, using the ballroom on the weekend afternoons.

COOL

LAKE COMPOUNCE

BRISTOL, CONNECTICUT.

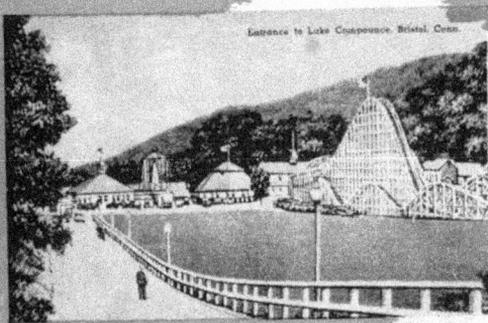

Entrance to Lake Compounce, Bristol, Conn.

COME
BE OUR
GUESTS!

The management will be pleased to assist in your plans for a picnic, outing or dinner party. Communications addressed to:

PIERCE & NORTON CO., INC.
LAKE COMPOUNCE
BRISTOL, CONN.

are given prompt, courteous attention . . . arrangements made to meet your particular requirements. Special rates on all rides except on Sundays and Holidays.

This advertising booklet promoting the park shows the entrance to the park from the 1920s in the upper left side.

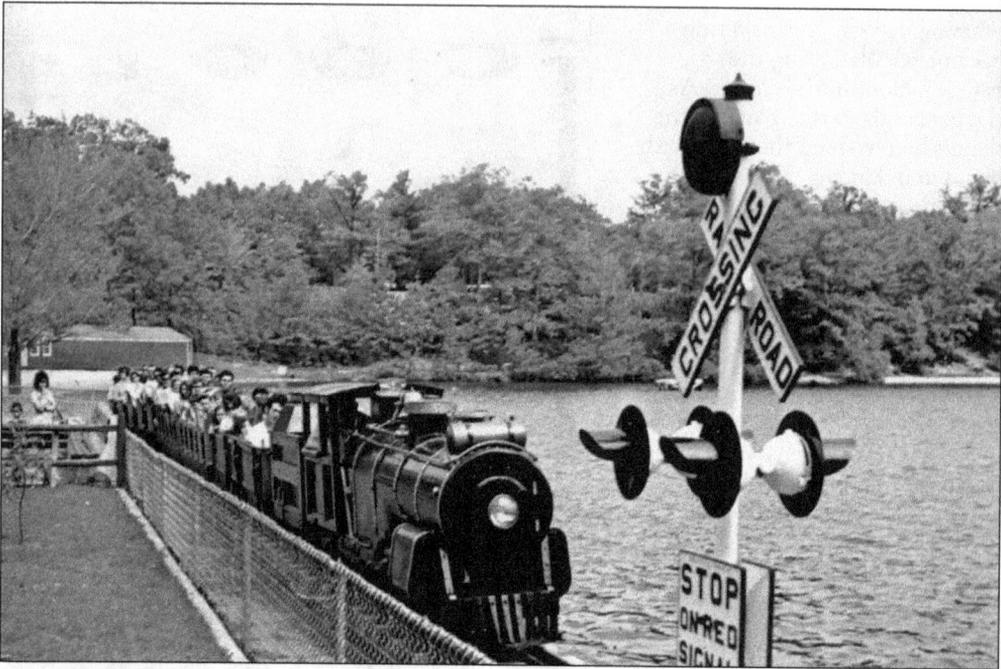

The famous Gillette train was one of the trains built for William Gillette, an actor who built Gillette Castle in East Haddam. When Gillette died in 1937, his estate became the property of the State of Connecticut Department of Environmental Protection. Lake Compounce bought both trains in 1943 for $3,000. The trains were refurbished, and the track was laid down to go around the lake. The Gillette train remained at Lake Compounce for 54 years. In 1997, the train went back to Gillette Castle State Park where it remains today.

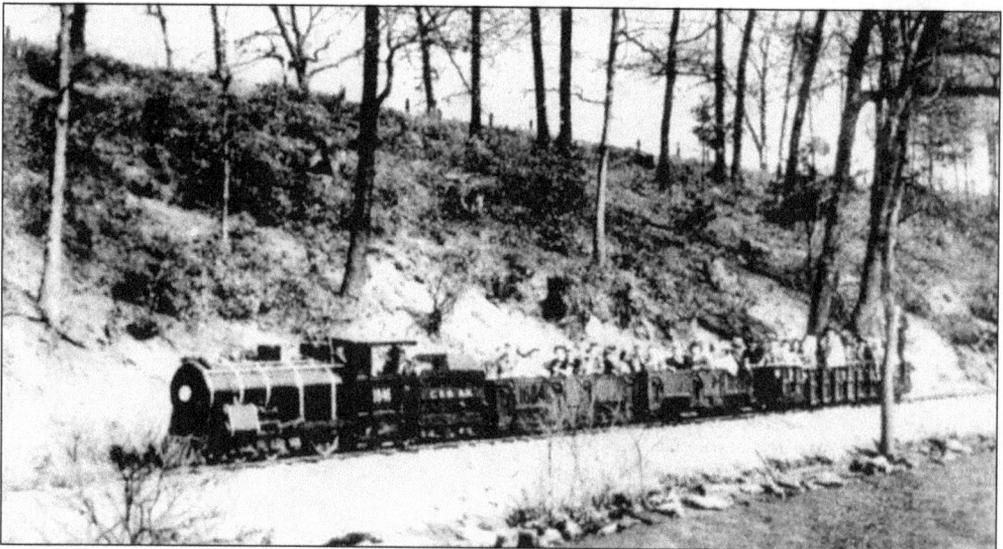

When the season opened in 1944, the Gillette train went around the lake near the shore. It became a popular ride among the visitors.

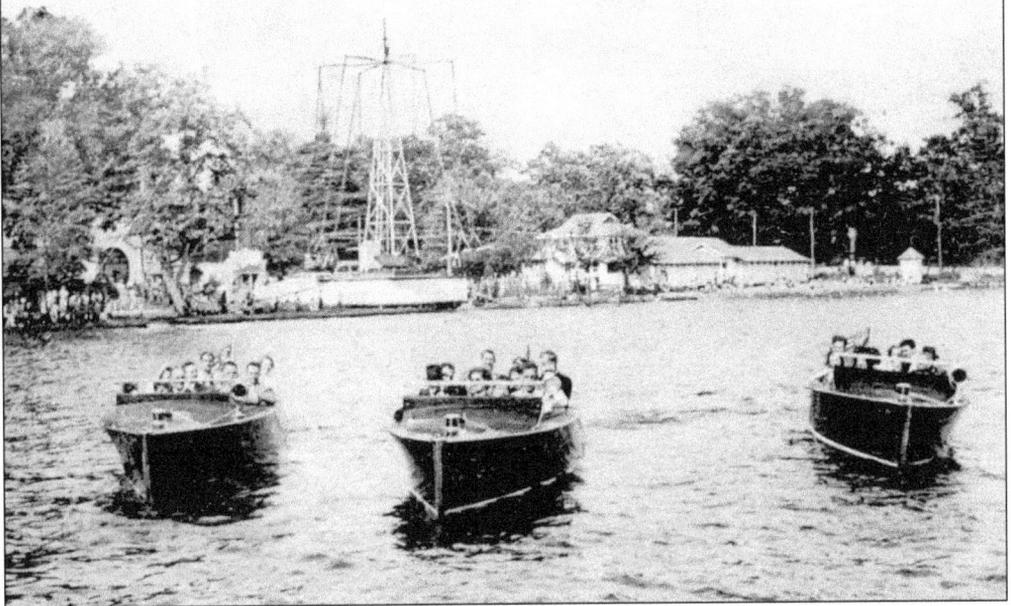

This picture shows the three Chris Craft boats that became so popular that each year a motor would have to be replaced. These boats remained from 1929 to 1962 when they were replaced by a newer, faster speedboat called the Jet 35 that carried 8 to 10 passengers and could cruise at 45 miles per hour.

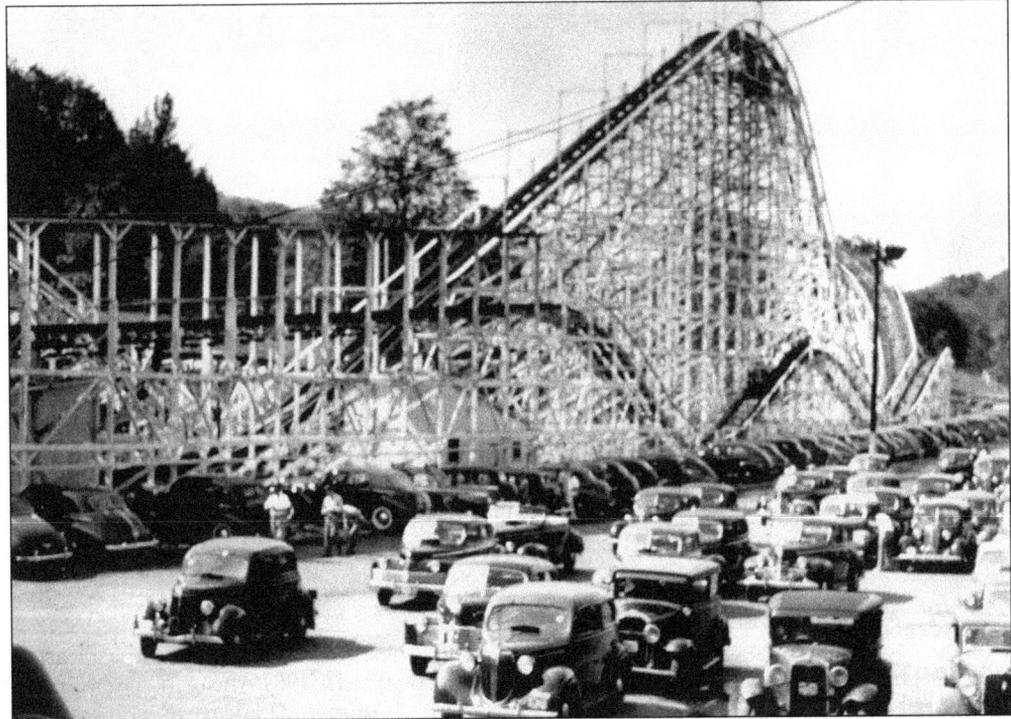

When the trolley service to the park ended in 1933, the park had to make more room for parking. This 1944 picture shows the Wildcat roller coaster in the background.

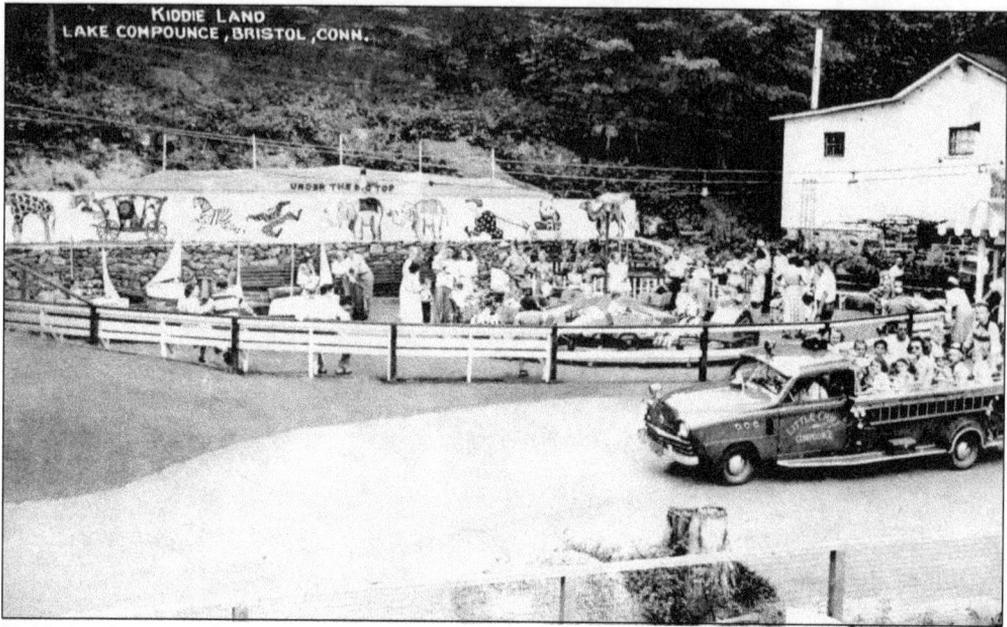

Kiddieland was a place where younger children could enjoy miniature rides similar to the grown-up rides. On the right is the fire engine that came in 1950 for children to ride on.

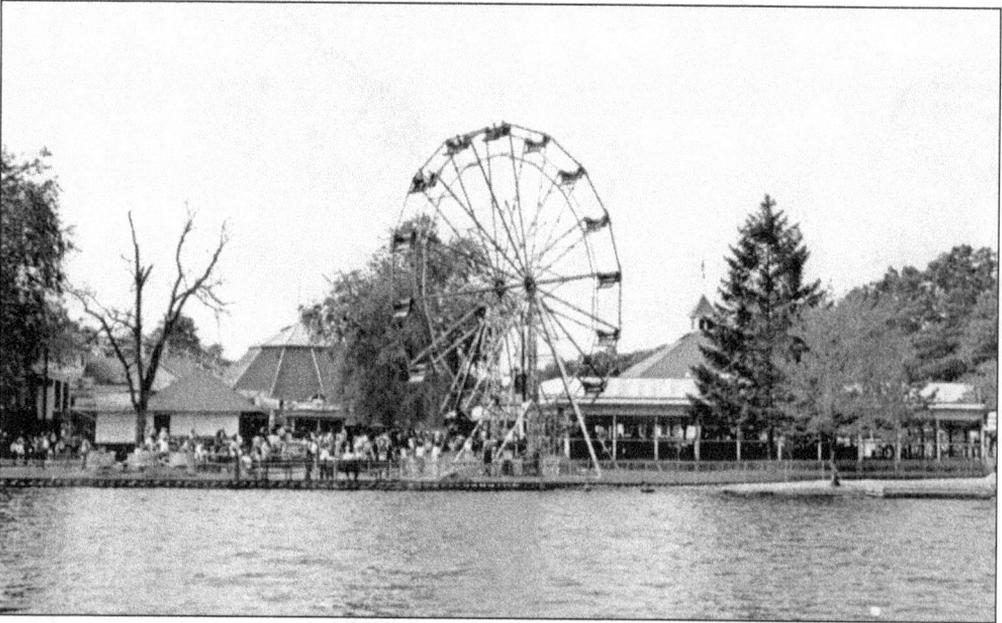

In 1850, the first amusement ride was a hand-cranked 20-foot-high device called the Pleasure Wheel. The ride had eight seats and was rotated vertically. In 1967, the park purchased a 55-foot-tall Ferris wheel, named after the inventor George Washington Gale Ferris who designed the first wheel for the 1893 world's fair held in Chicago. The Ferris wheel in the picture was located by the shore area.

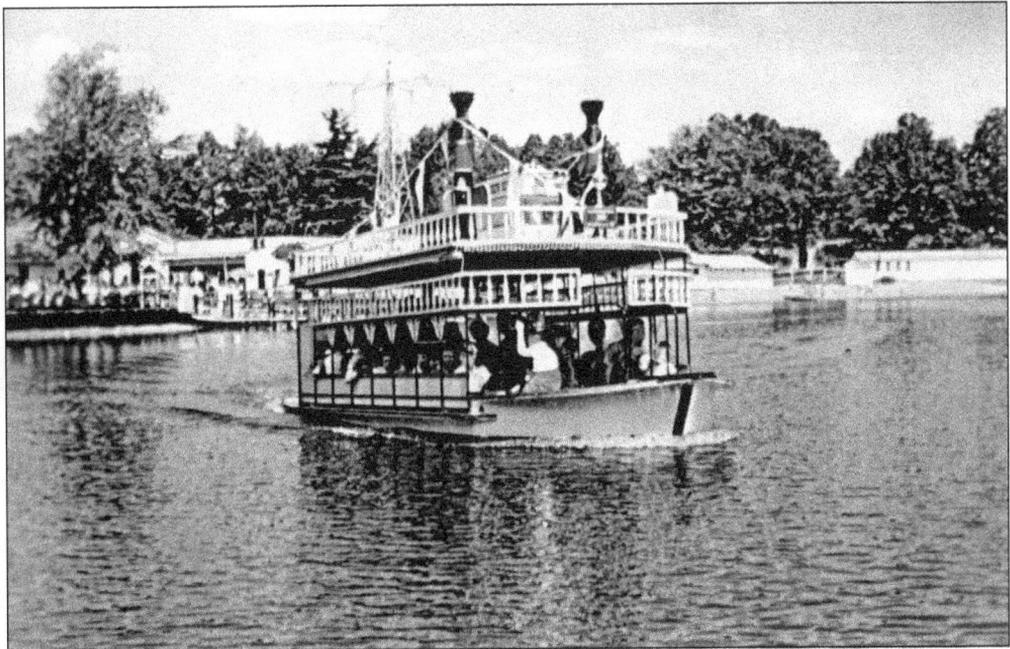

In 1957, the showboat was added, taking passengers on a leisurely ride around the lake.

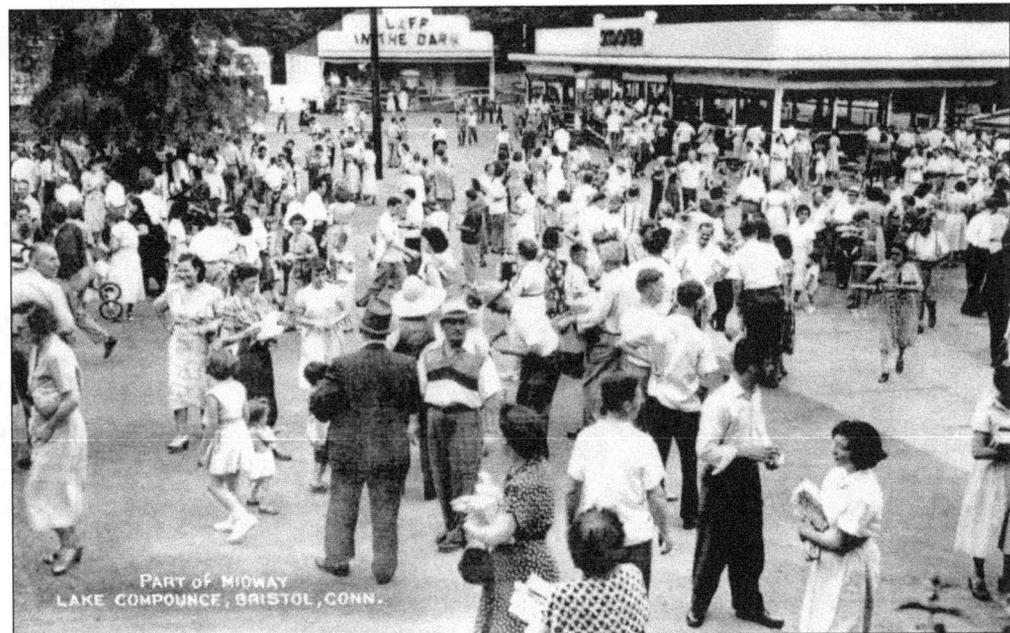

Amusements such as the bumper cars and Laugh in the Dark became part of the midway. *Midway* is the name given to the area in amusement parks where the games and concessions are.

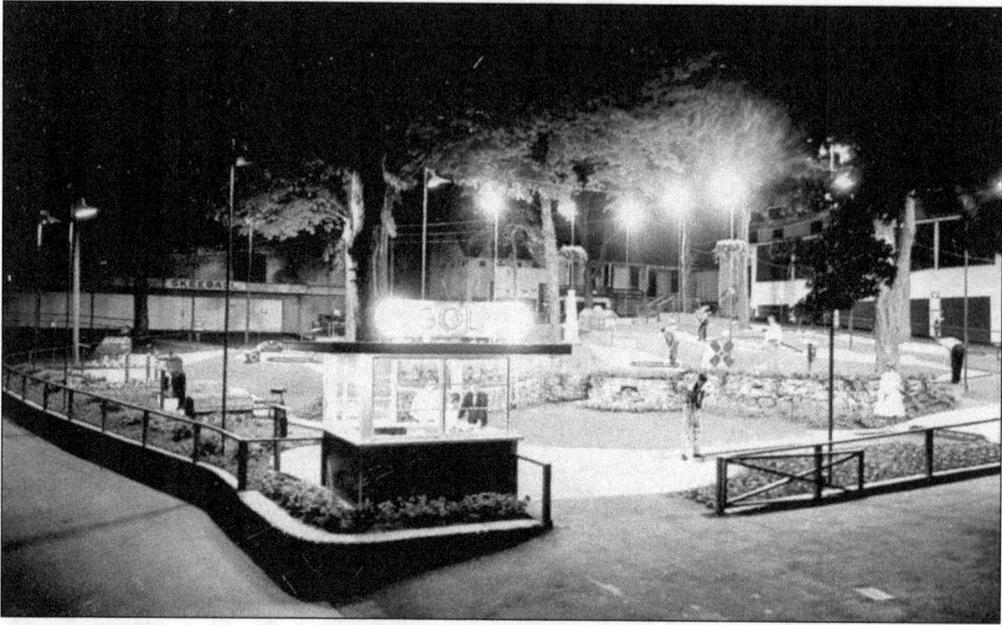

In 1959, an 18-hole miniature golf course was added next to the casino. The golf course replaced Kiddieland, which was moved to another area of the park.

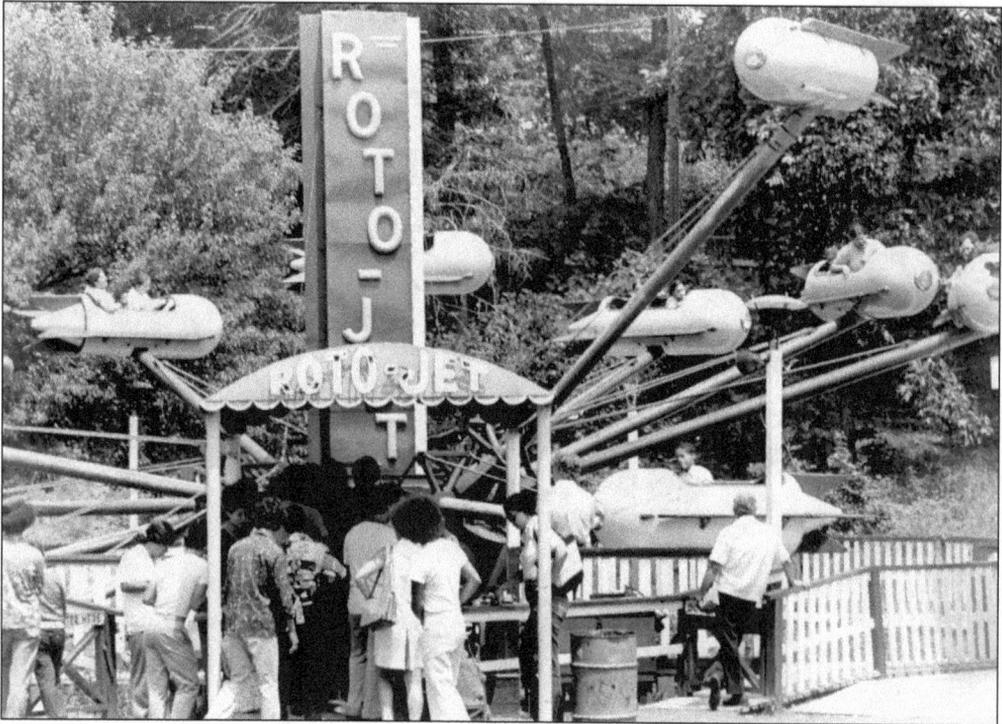

In this picture taken on August 1, 1975, is a popular ride called the Roto-Jet. It was located next to the penny arcade.

Five

BIG BANDS
AND CONCERTS

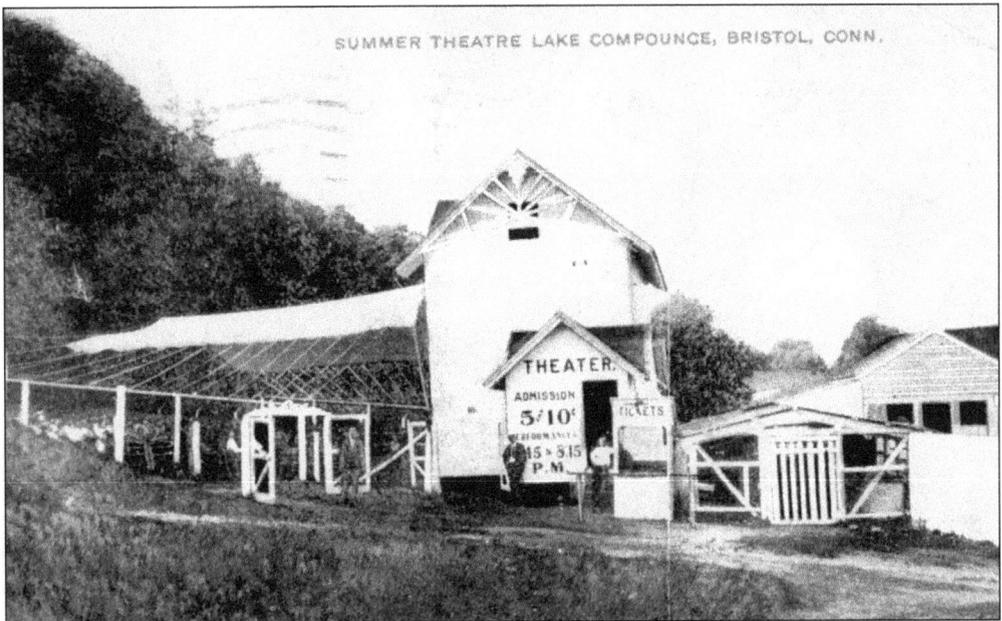

The summer vaudeville theater had a small stage with scenery in the background. It was built into the early 1900s. There were five acts of vaudeville performed daily in the afternoon and evening. Admission to the theater was 5¢ and 10¢, with the seats in front costing 10¢ and the rest costing 5¢.

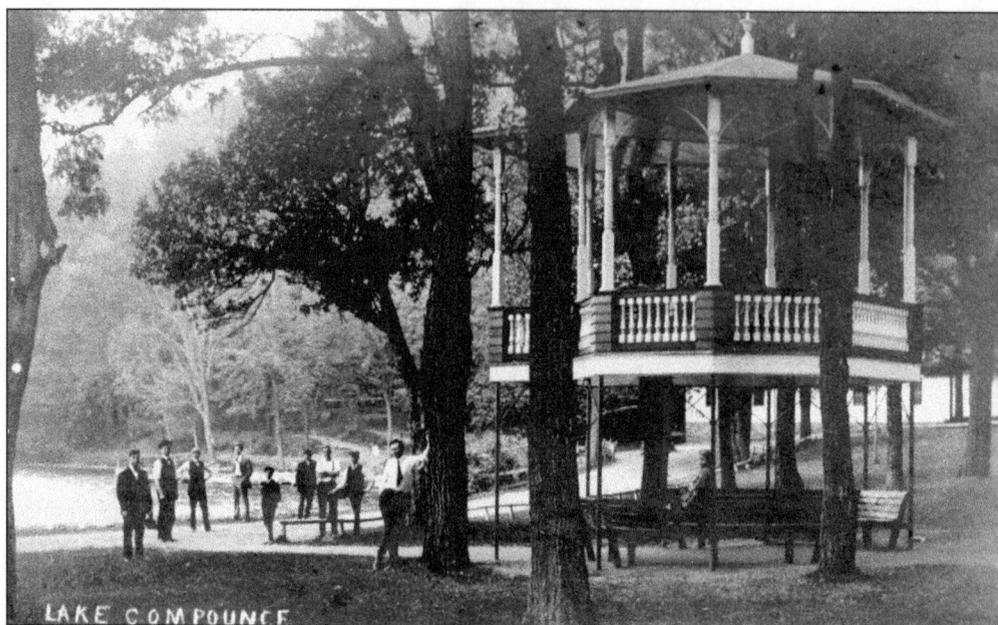

This 1917 picture of the outdoor bandstand shows where the bands played their concerts. There were benches on the bottom to sit, and the rest of the listeners would sit on the lawn or near the casino.

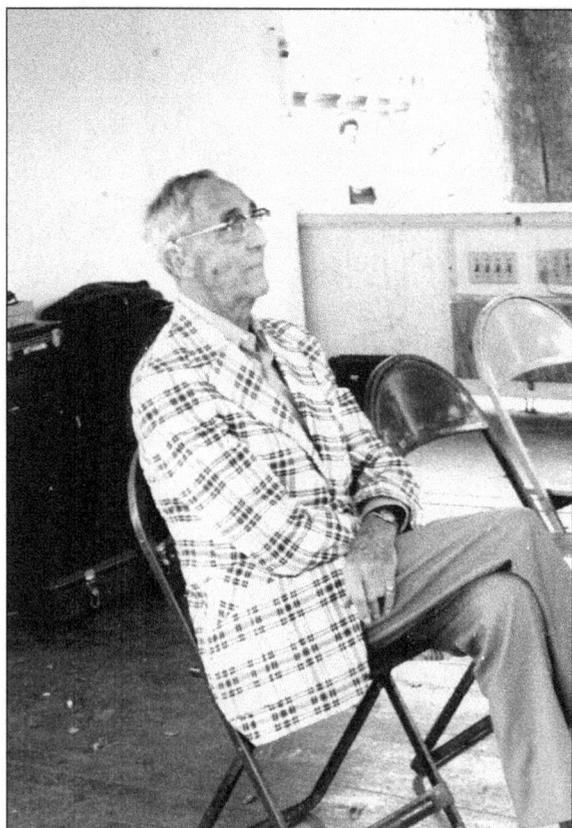

Julian Harwood Norton enjoyed listening to bands give a demonstration of their music before he would hire them to perform. Many big bands got their start at Lake Compounce.

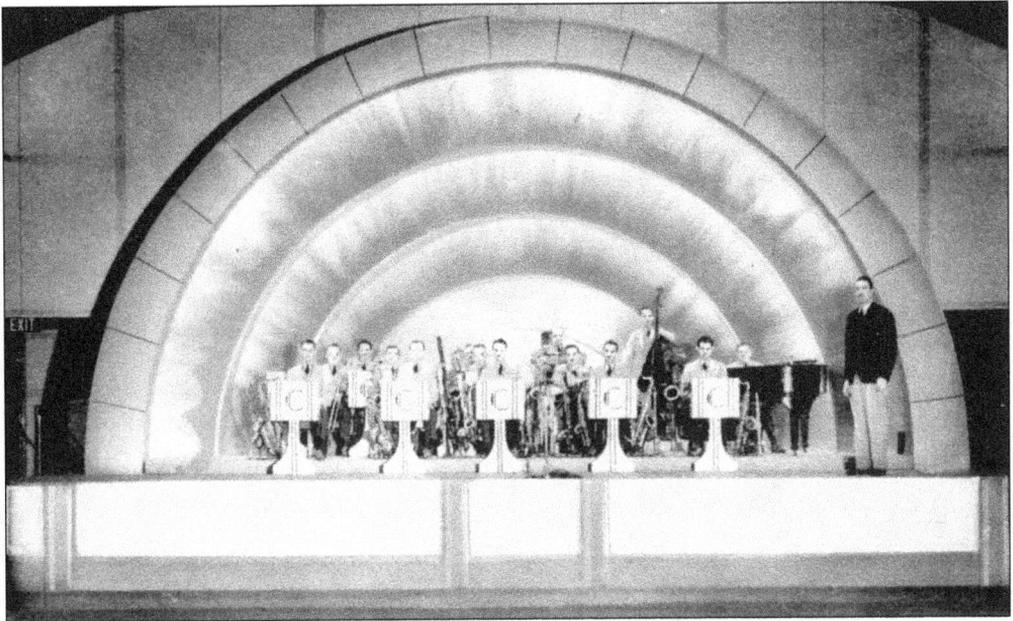

During the 1930s, the casino ballroom was renovated to include a larger dance floor without walls. In 1937, large windows were put up on the sides, and a high arched ceiling was added. On Easter Sunday that year, Glen Gray and the Casa Loma Orchestra opened the Starlite Ballroom.

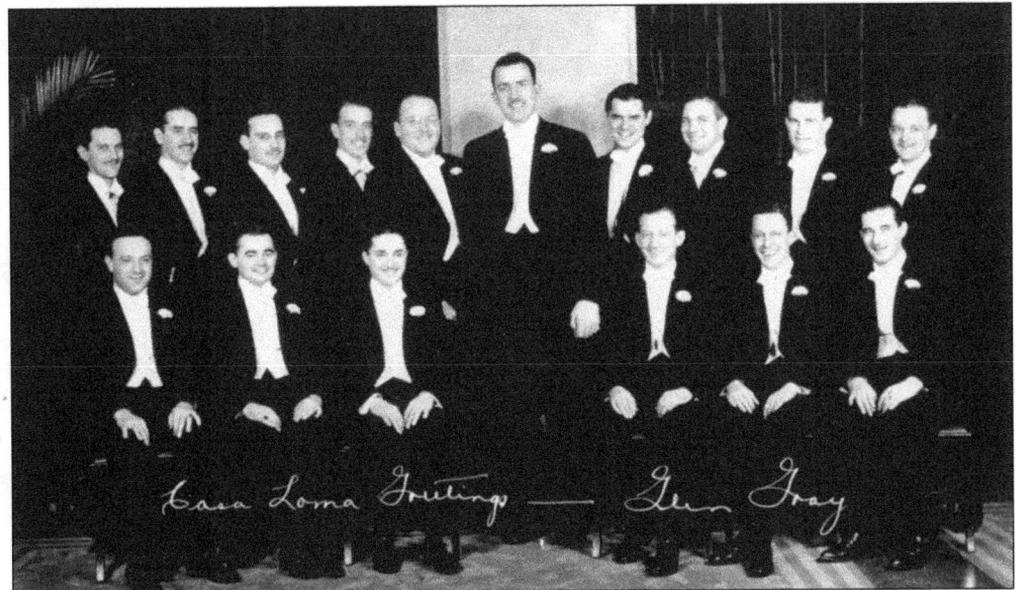

The Casa Loma Orchestra appears here in 1937 with Glen Gray standing in the center.

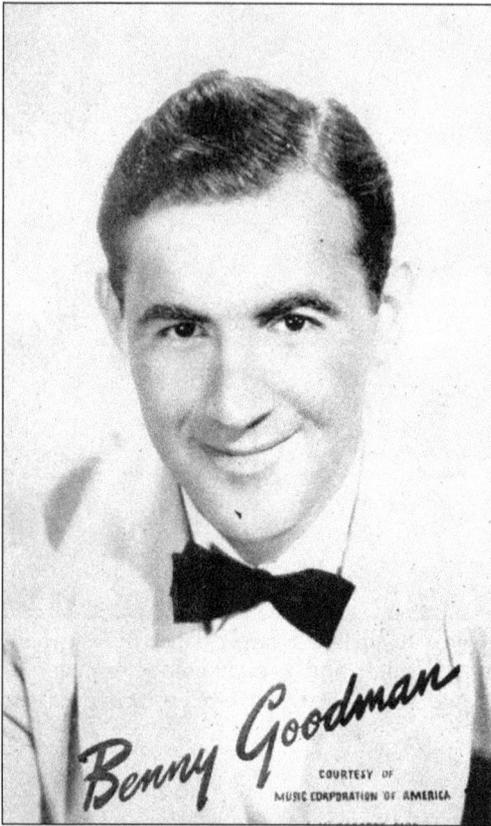

Benny Goodman played in the late 1920s, offering his band for an evening at the park. His concerts became a trend for the start of many big bands to come and play.

COURTESY OF
MUSIC CORPORATION OF AMERICA

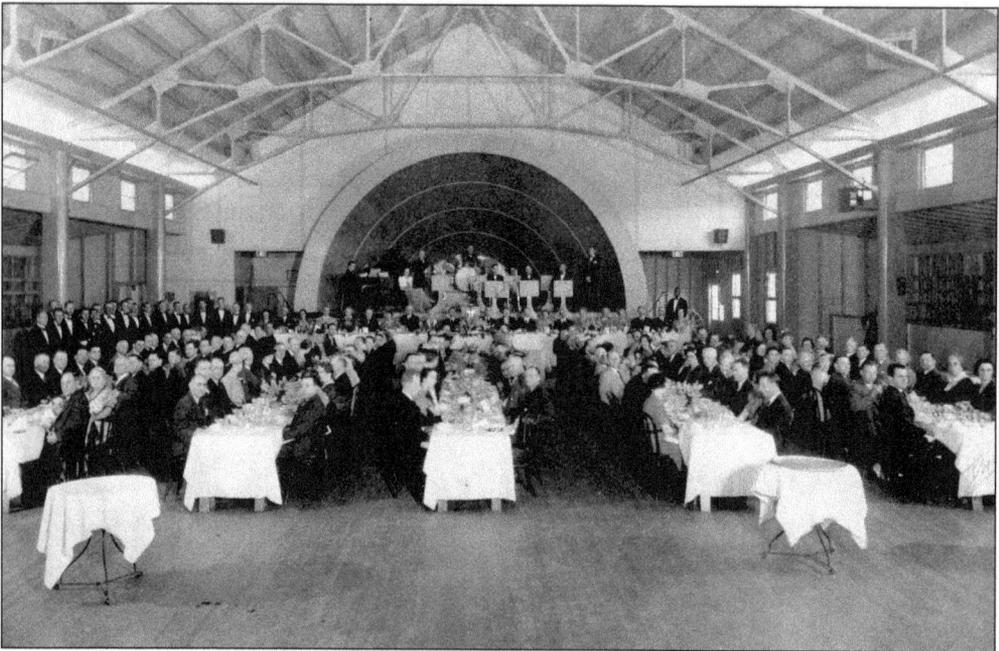

This is the ballroom where other bands and singing performers played, such as Harry James, the Ames Brothers, Guy Lombardo, and the McGuire Sisters.

In 1937, Sammy Kaye and his orchestra played swing-type music. "Swing and Sway with Sammy Kaye" was how they were advertised. Duke Ellington and Cab Calloway also performed this type of music at the park.

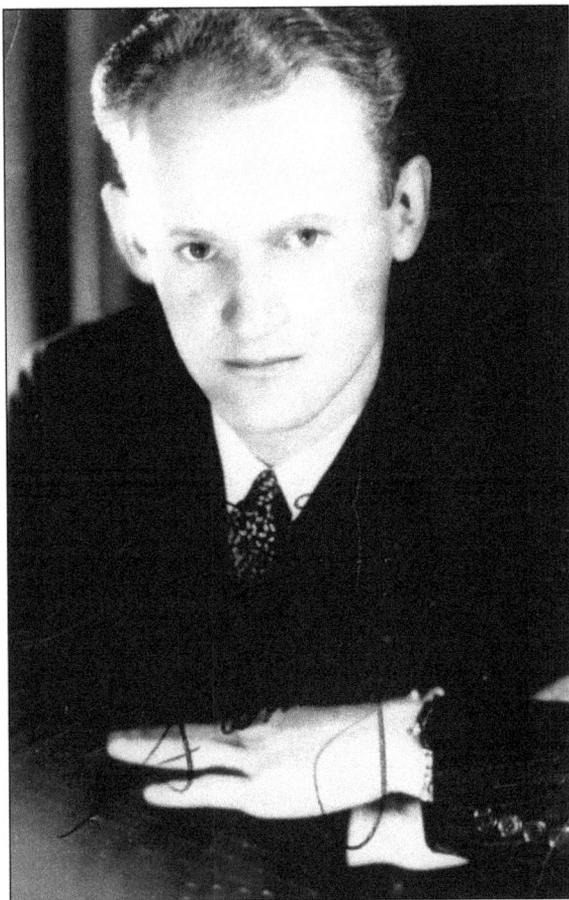

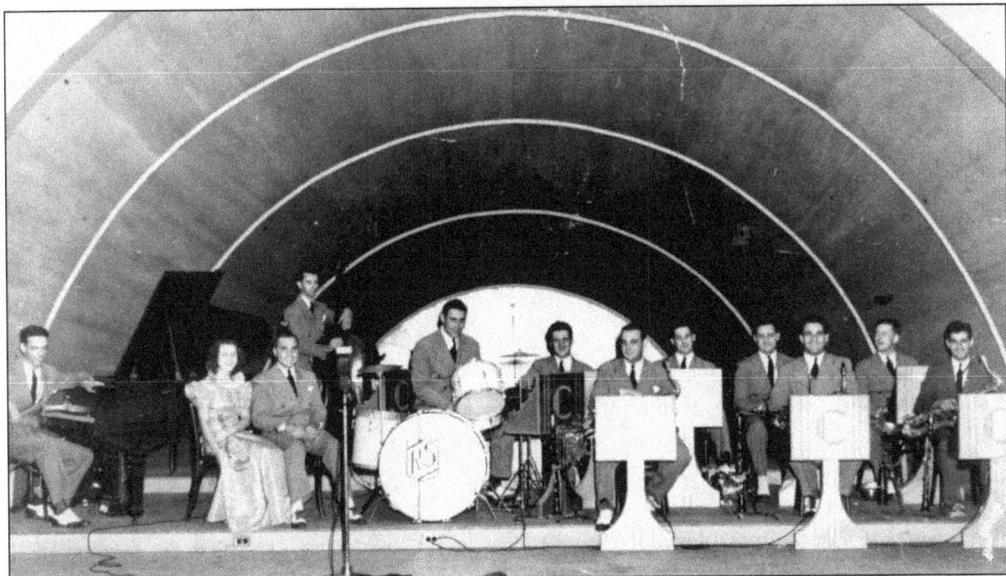

In 1941, the Hal McIntyre Orchestra played under the direction of Russ Schurer in the Starlite Ballroom.

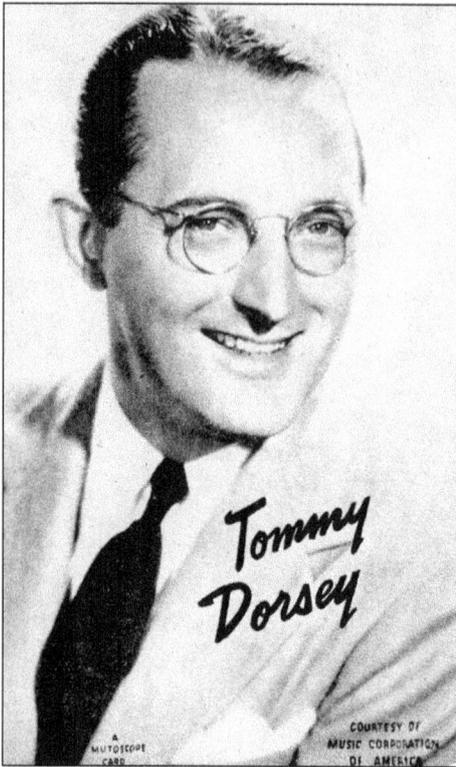

Tommy Dorsey and his band played on August 21, 1941, to a record crowd of 5,000 people, which turned out to be Lake Compounce's largest crowd to date. Lake Compounce advertised door prizes of Tommy Dorsey's record featuring his classic "Yours Forever."

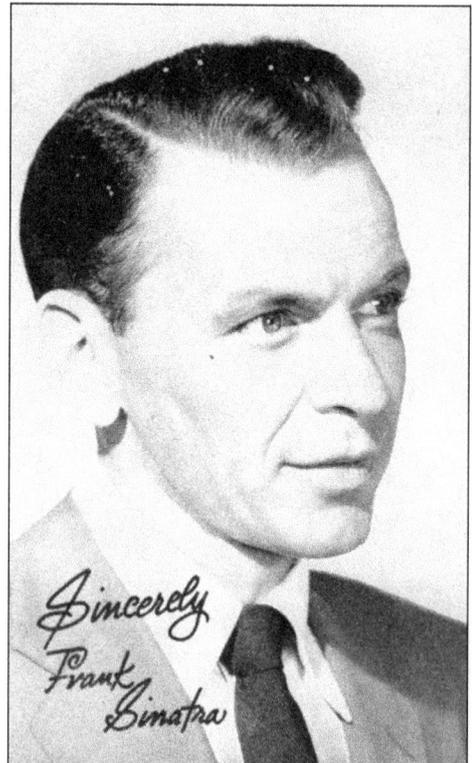

Frank Sinatra, a newcomer, played with Tommy Dorsey's band on August 21, 1941. Many singers got their start in their careers by playing with the big bands.

Glenn Miller and his orchestra performed at the lake on May 7, 1939, September 10, 1939, and May 5, 1940. At his performance on June 14, 1942, there were 4,500 people in attendance.

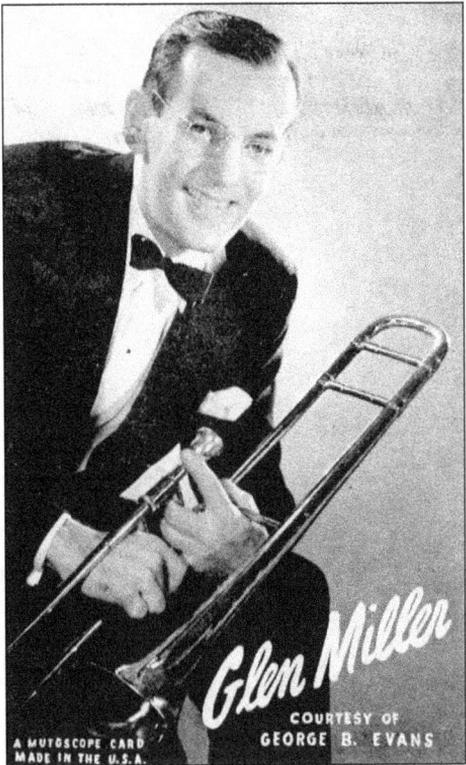

Glen Miller

COURTESY OF
GEORGE B. EVANS

A MUTOSCOPE CARD
MADE IN THE U.S.A.

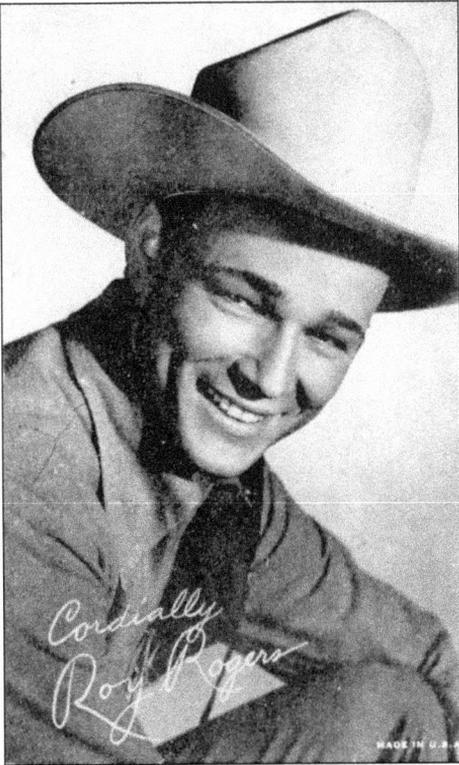

Cordially
Roy Rogers

MADE IN U.S.A

In the 1940s, the music styles started changing from the big bands to country music. Roy Rogers performed at the park. Tim McCoy, another country western singer, also performed there.

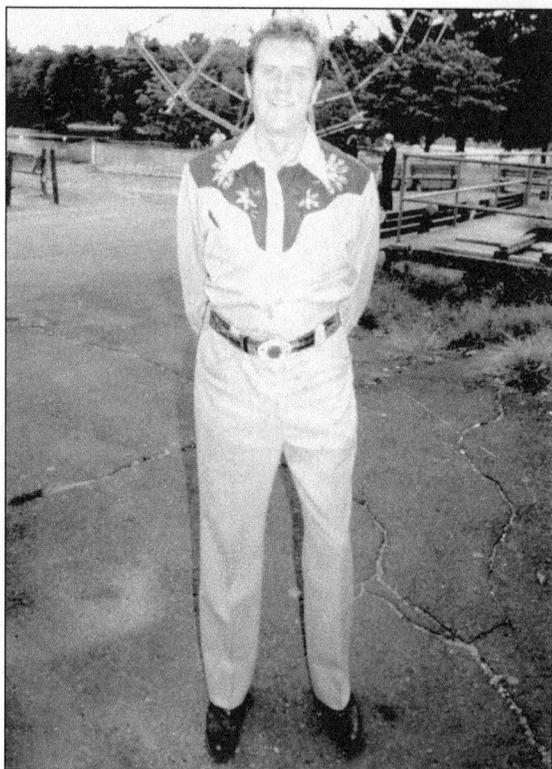

Greeting guests at the lake, J. Harwood "Stretch" Norton, son of Julian Harwood Norton and Norberta Smith Norton, would dress up in western-style clothing on Sundays when the various western bands played.

A group of people sitting on the grass are enjoying the music from the outdoor stage that was next to the casino.

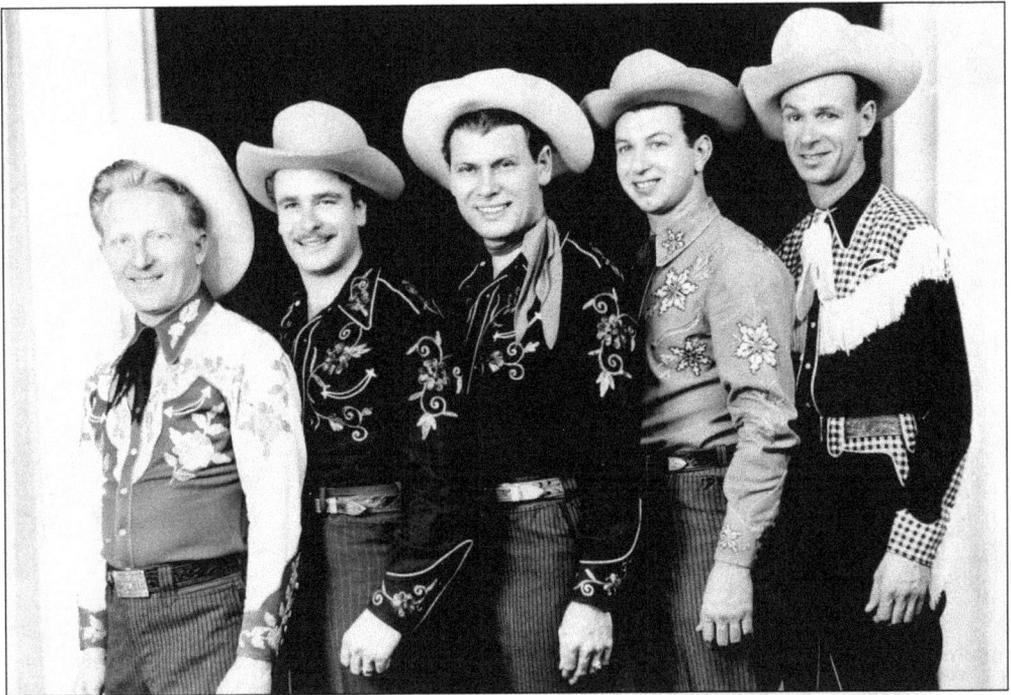

The most popular western group, called the Down Homers, started performing in 1948. Hired by Julian Harwood Norton, this group was enjoyed by many fans under the leadership of Guy Campbell. From left to right are Shorty Cook, Rusty Rogers, Guy Campbell, Rocky Coxx, and Slim Coxx.

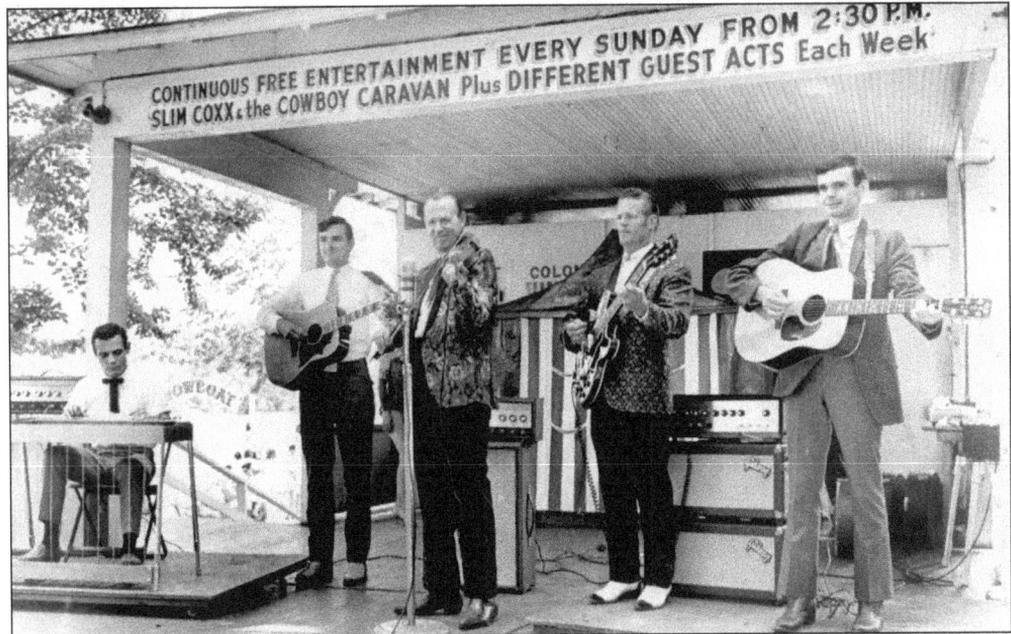

When the Down Homers decided to leave for Chicago in 1950, Slim Coxx and his brother Rocky stayed behind. Slim started a new music group called the Cowboy Caravan, and it performed for 26 years on the outdoor stage.

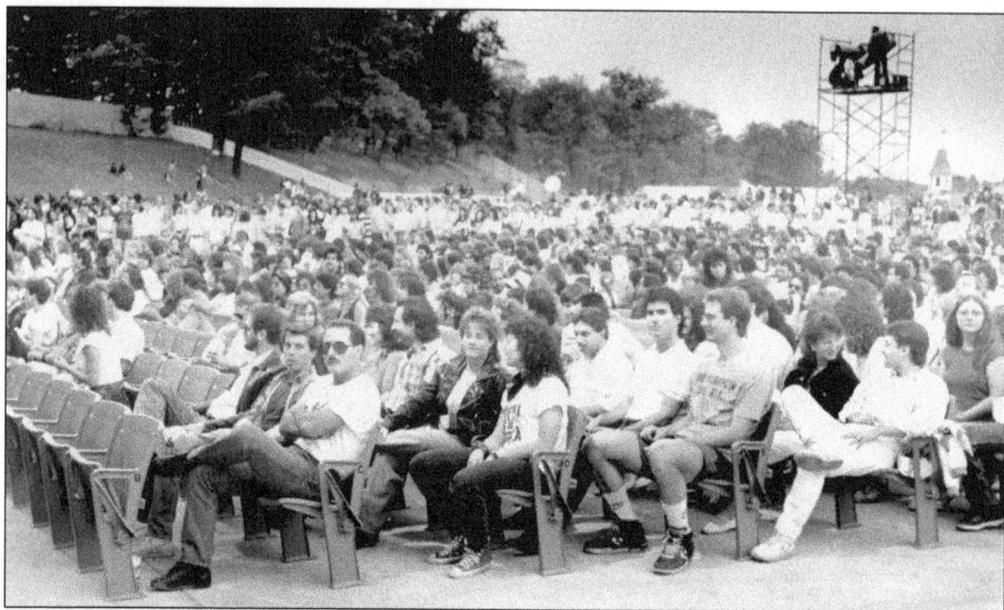

In 1987, Joseph Entertainment Group bought the park and constructed a 20,000-seat outdoor amphitheater. This picture illustrates the large crowds that attended various performances.

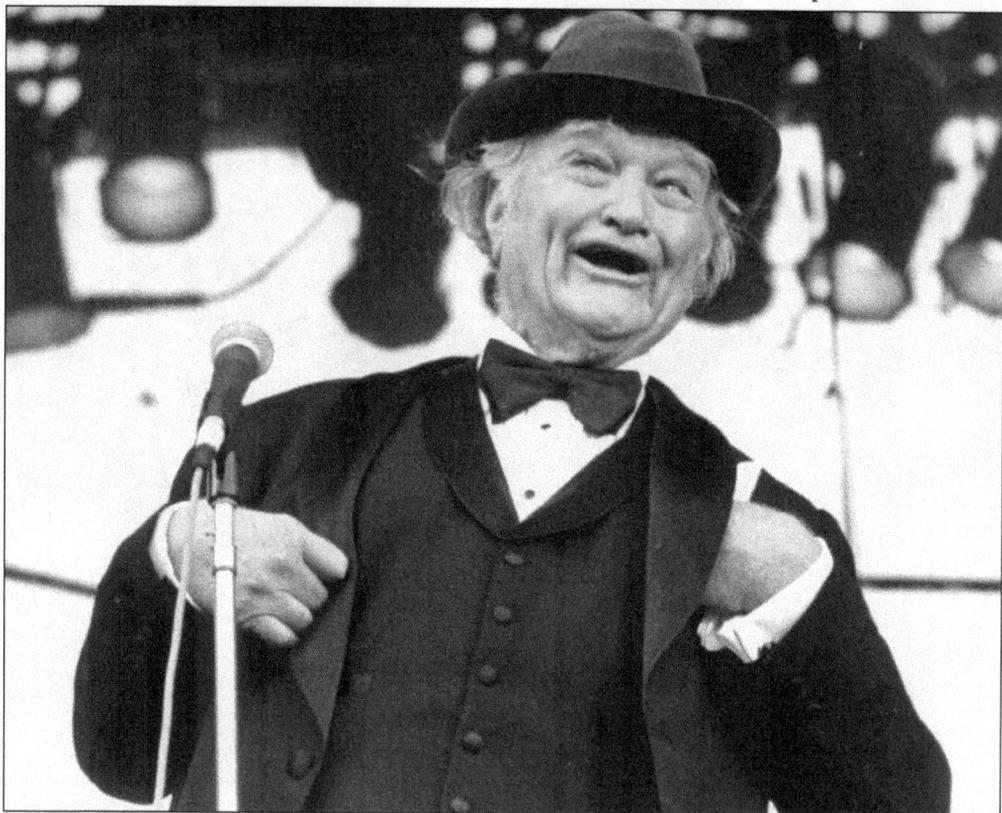

On July 3, 1988, comedian Red Skelton performed at the park, doing all his famous television routines that he was known for.

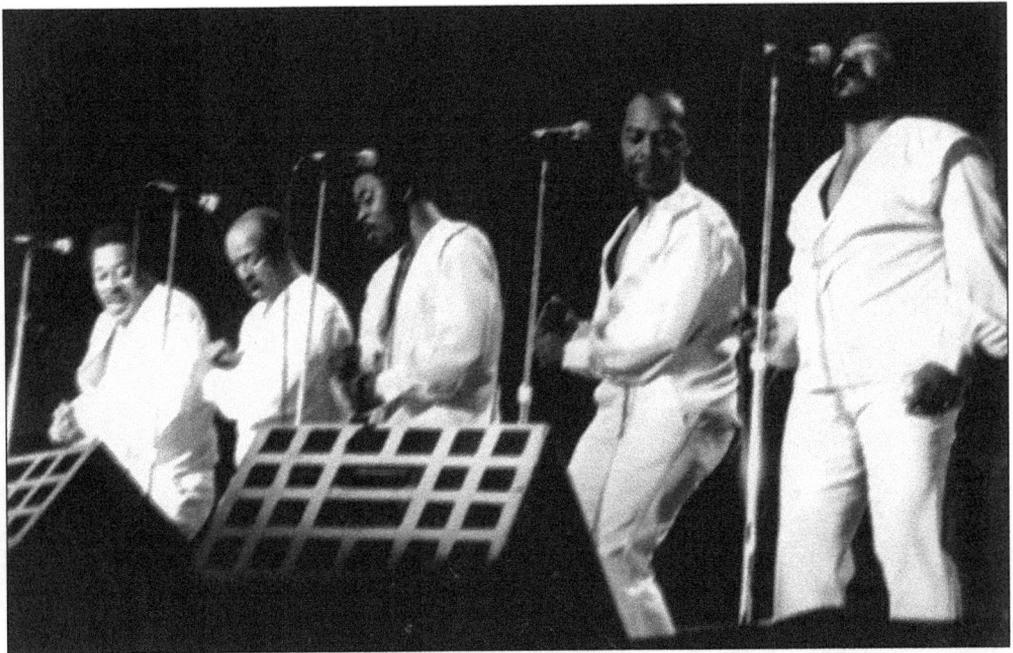

In this picture is the music group the Contours performing on the stage on August 6, 1988.

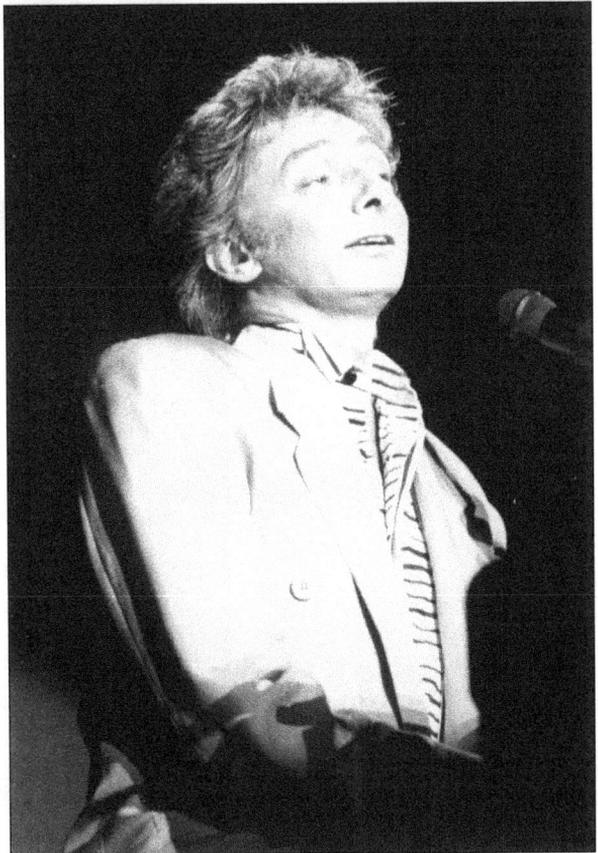

A popular singer, Barry Manilow performed onstage at the lake on August 28, 1988.

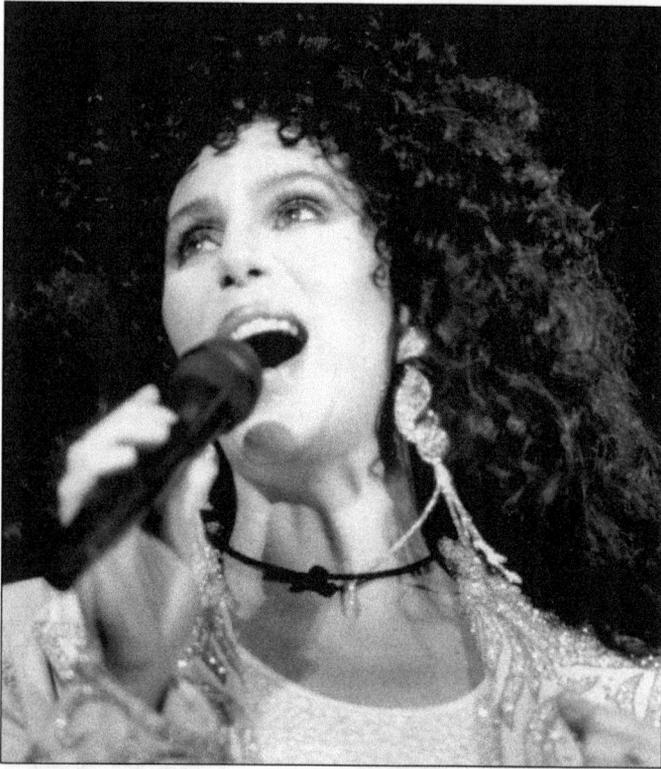

The summer of 1989 brought many singers and groups to perform at Lake Compounce. Cher sang to a record crowd of nearly 20,000 fans.

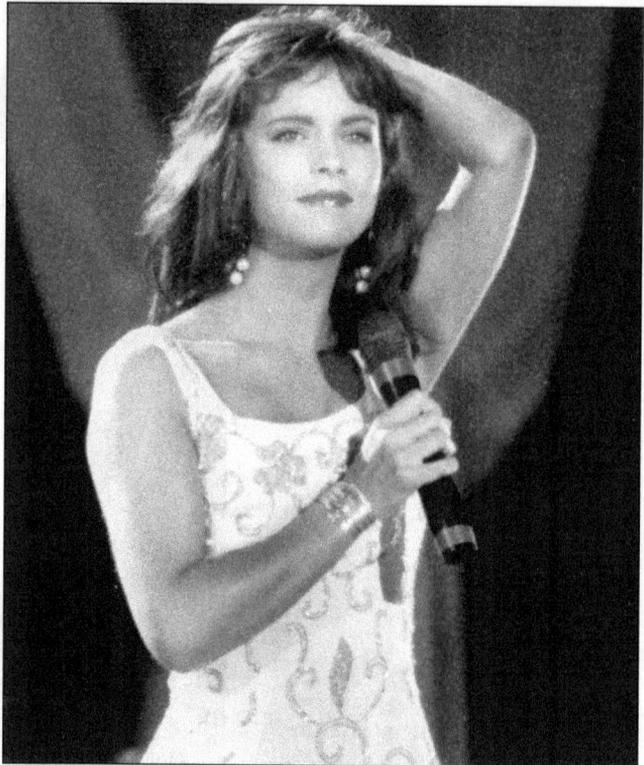

Sheena Easton, a two-time Grammy Award–winning singer, performed songs from her latest album on July 25, 1989. Her music included pop, rhythm and blues, dance, country, and adult contemporary.

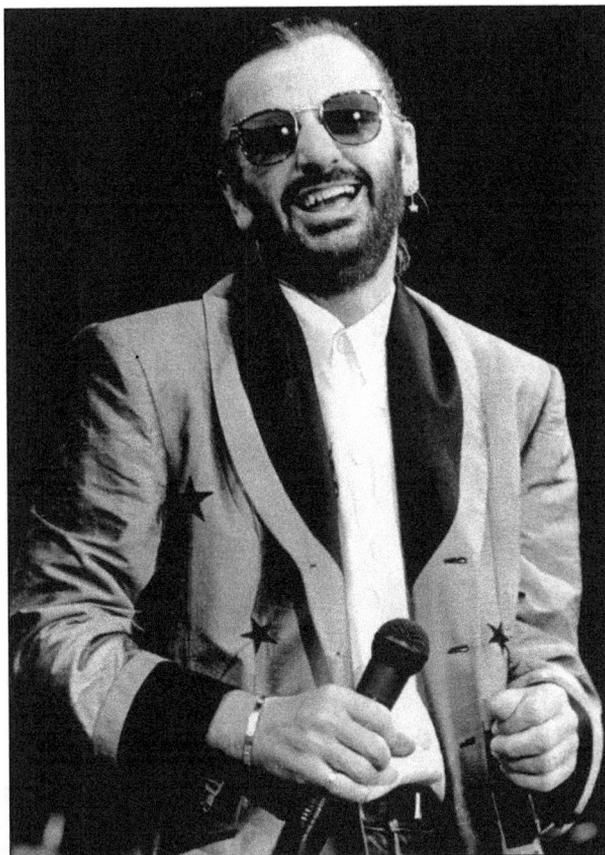

Former Beatle Ringo Starr performed with his All-Starr Band that consisted of a nine-piece band of talented musicians on August 2, 1989.

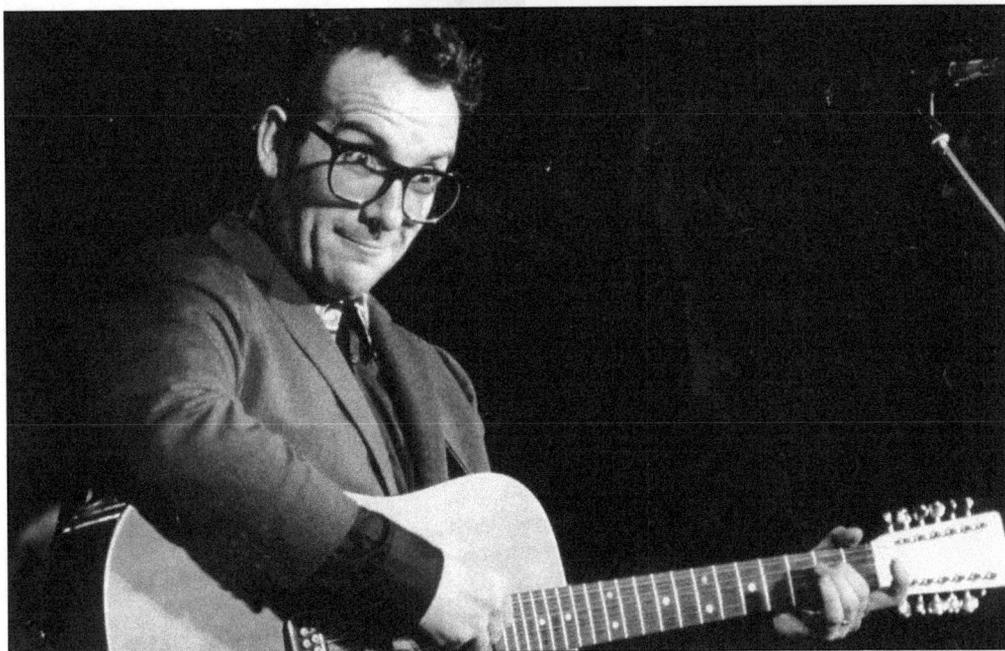

Elvis Costello performs first by himself, then with his band the Rude 5 on August 15, 1989.

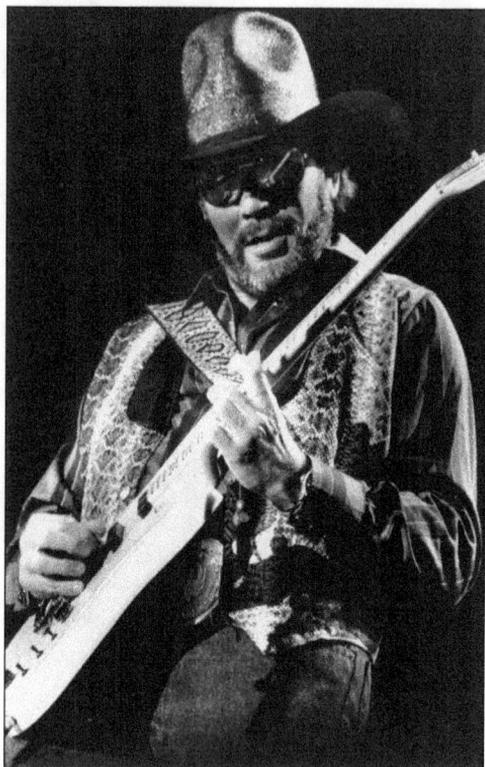

Hank Williams Jr., son of famous country music superstar Hank Williams, performed on July 27, 1989. Hank Jr., a four-time winner of country music's Entertainer of the Year award, is playing his steel guitar for his fans.

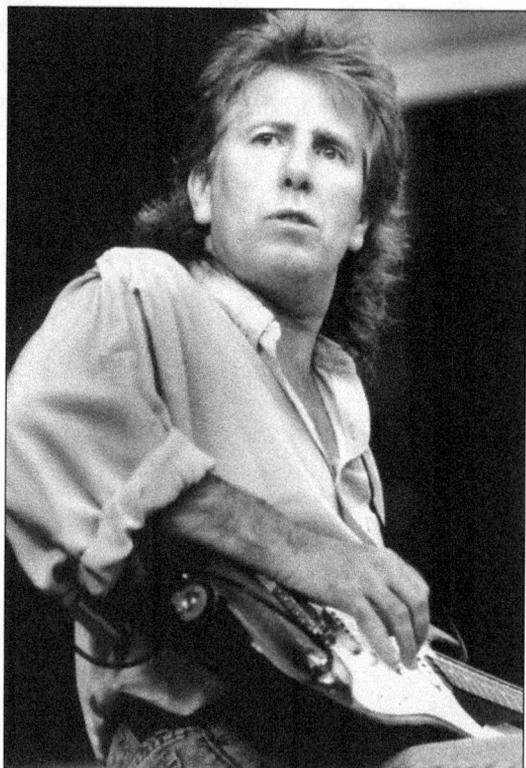

From the original band Crosby, Stills and Nash, Graham Nash performs on July 12, 1990.

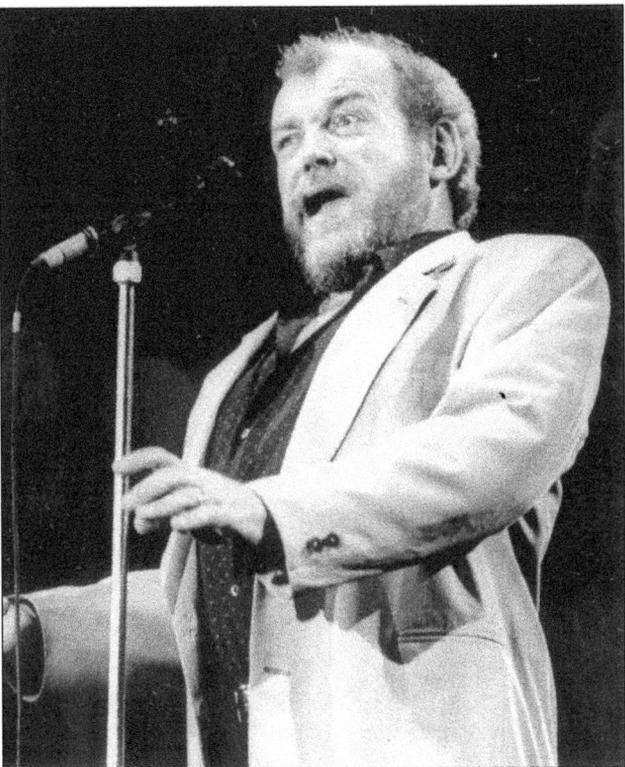

In this picture is singer Joe Cocker performing on July 14, 1990.

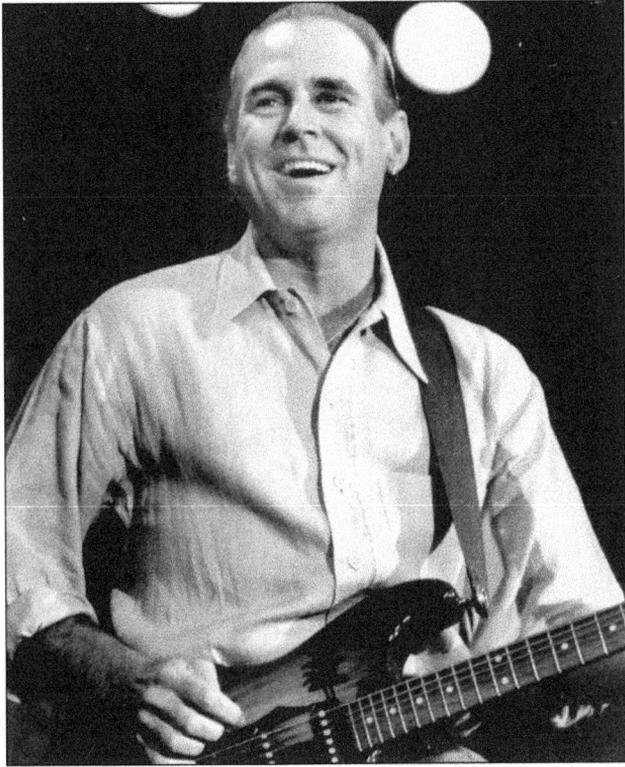

Singer Jimmy Buffet plays his guitar onstage during his performance on July 9, 1990.

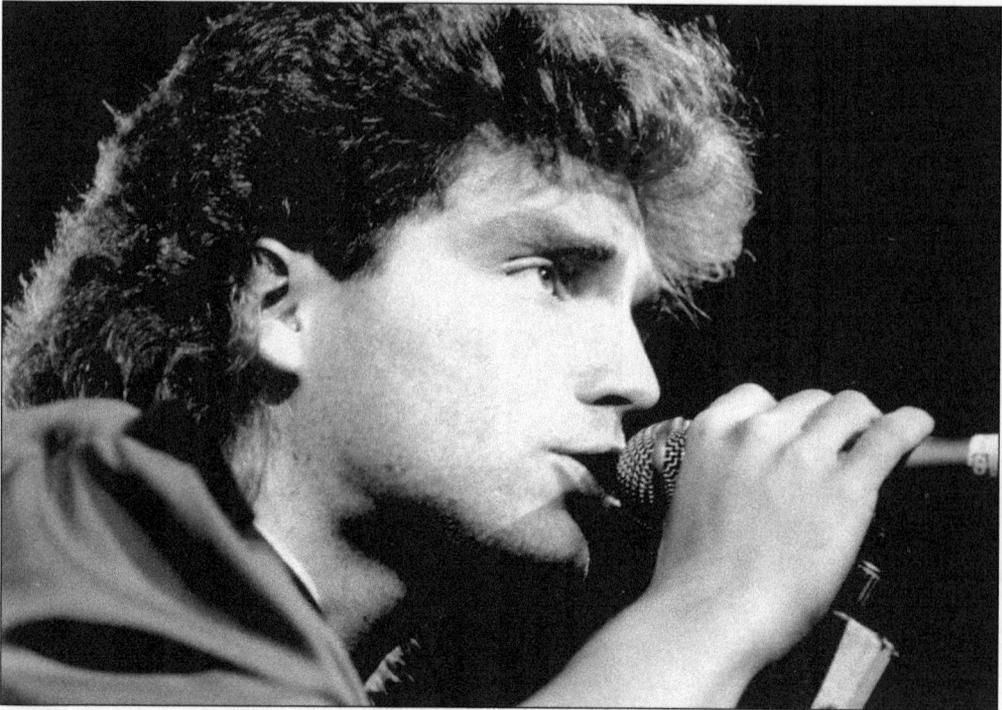

After a 15-month world tour, singer Richard Marx came to Lake Compounce and performed his music on August 16, 1990.

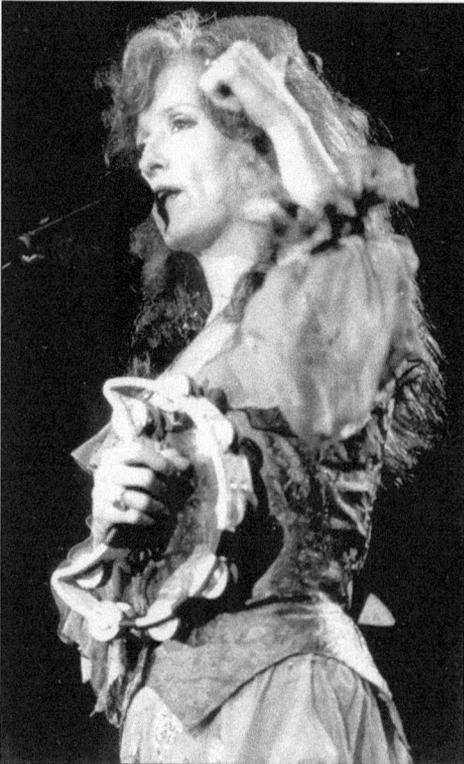

In this picture is singer Bonnie Raitt, a nine-time Grammy Award winner, performing music from her albums on August 8, 1990.

Slim Coxx came back to the park and performed some of his songs on the opening day of Labor Day weekend, September 8, 1992.

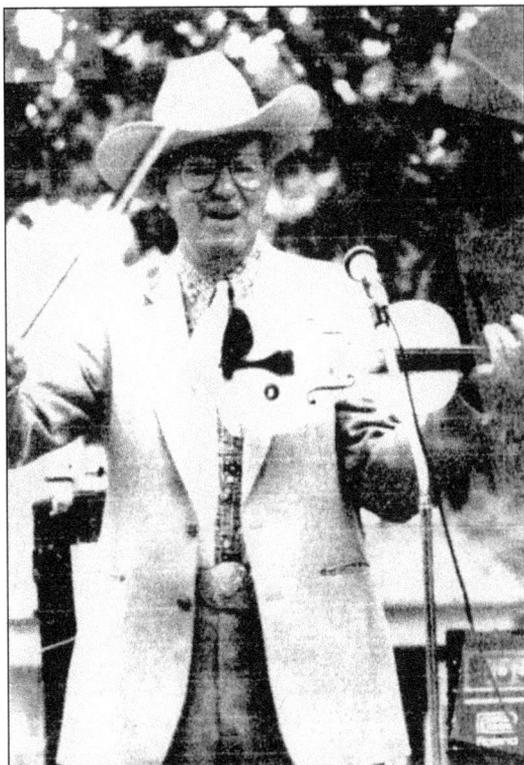

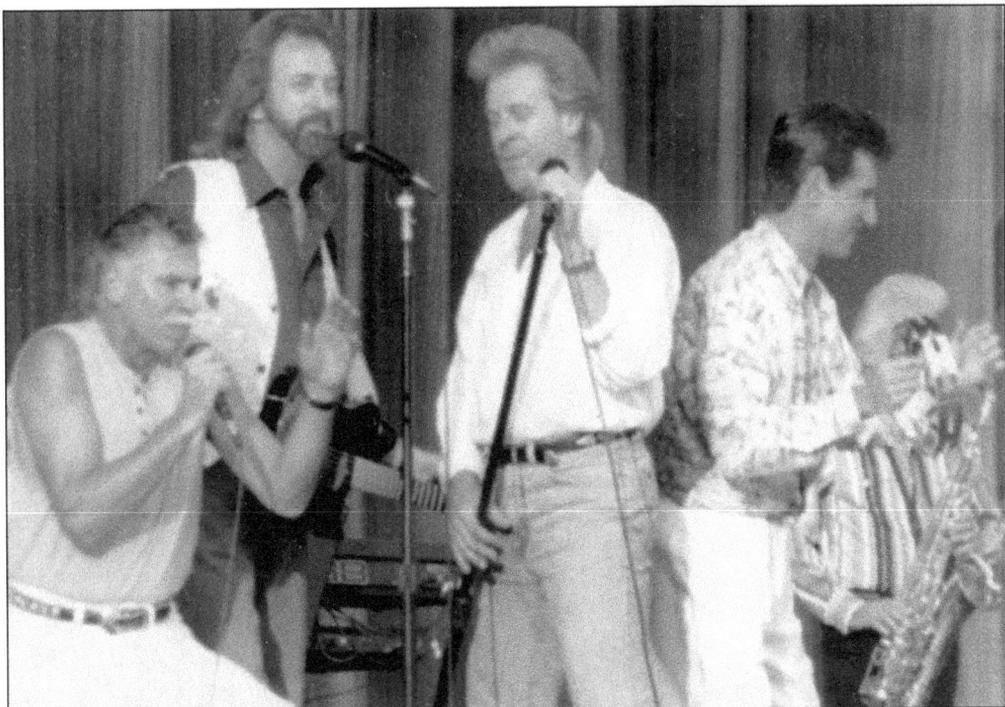

In this picture, singing group Oak Ridge Boys is performing in the Starlite Ballroom on September 5, 1995.

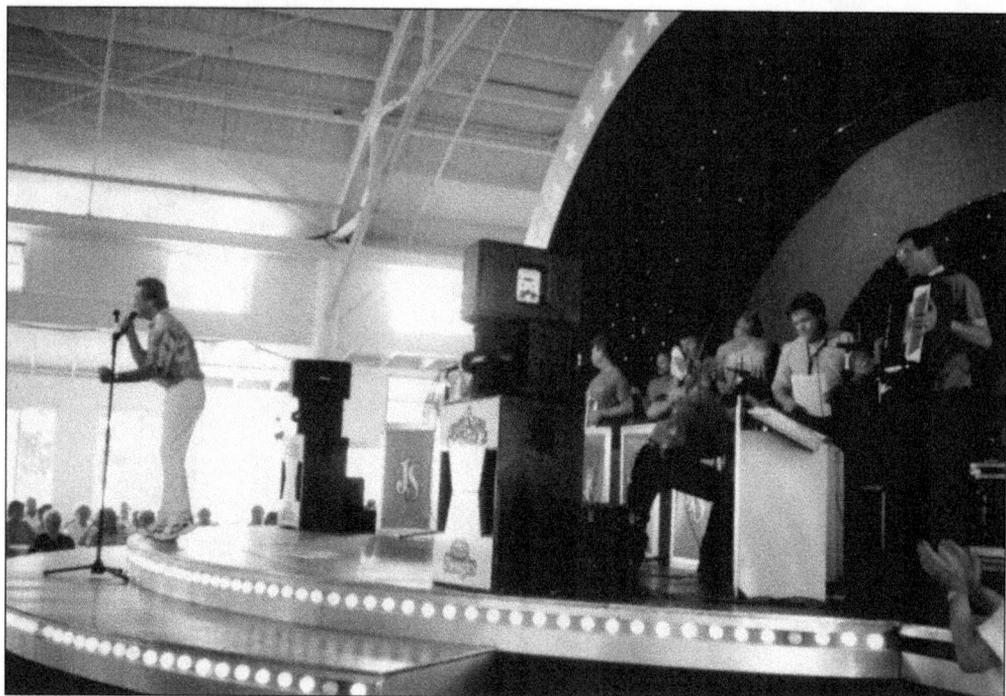

Jimmy Starr and his polka band perform a concert on the stage of the Starlite Ballroom on July 16, 1997.

Enjoying the music of Jimmy Starr's polka band is Sandy Leone of Bristol, dancing with bandleader Jimmy Starr on July 16, 1997.

Six

MEMORIES

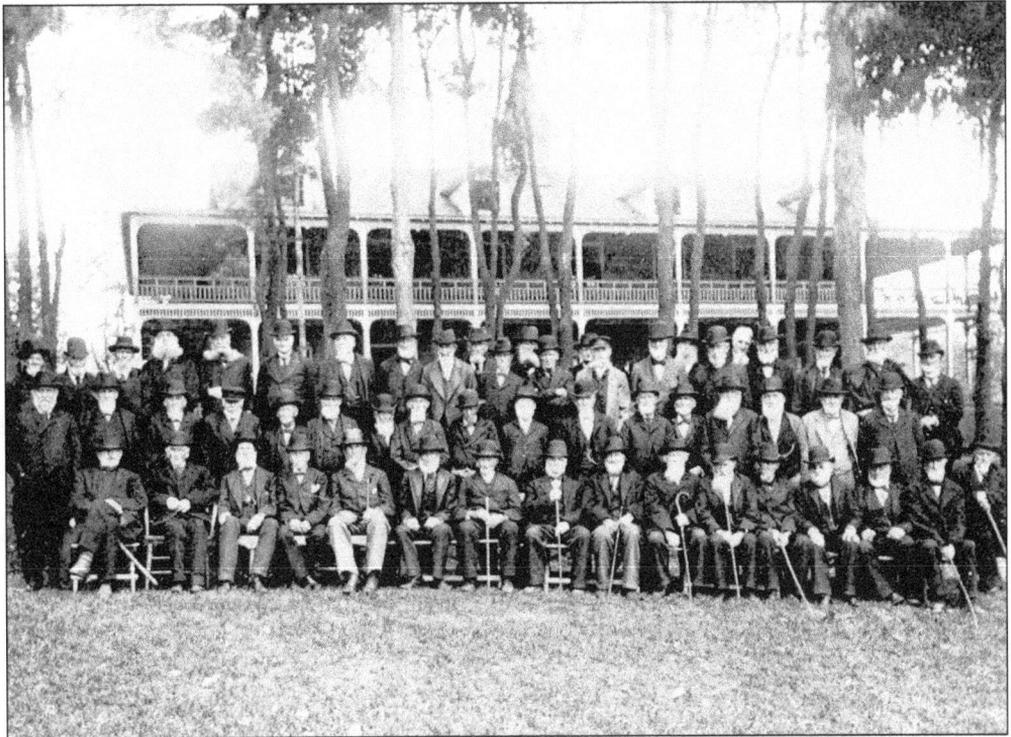

The first meeting of the Old Men's Club at Lake Compounce took place on September 17, 1896. There were 54 men present. The average age of the men was 81 years old. This group picture was taken in front of the casino.

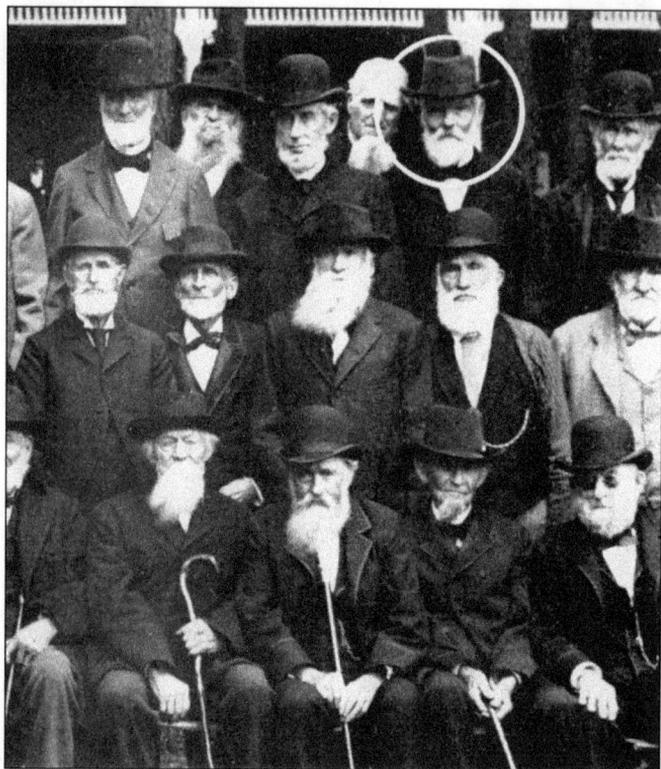

On the right in back is Gad Norton in the circle posing with the members of the Old Men's Club who were gathered for their annual meeting.

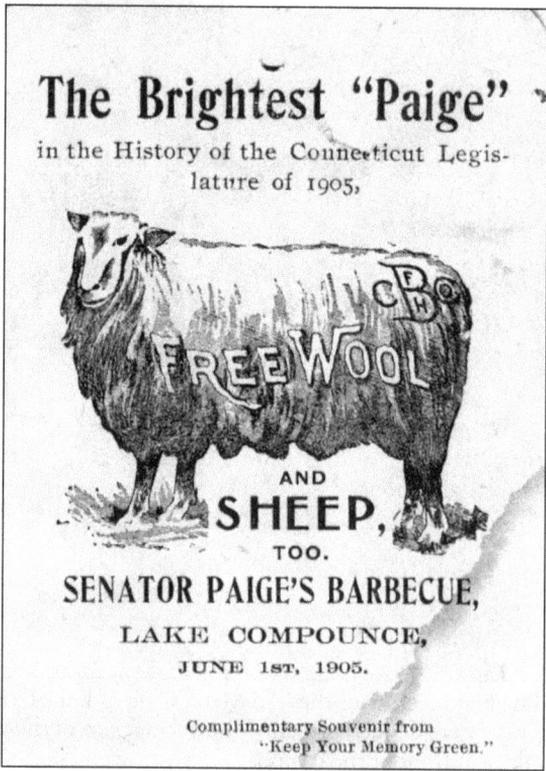

The Brightest "Paige"

in the History of the Connecticut Legislature of 1905,

FREE WOOL

AND

SHEEP,
TOO.

SENATOR PAIGE'S BARBECUE,

LAKE COMPOUNCE,

JUNE 1st, 1905.

Complimentary Souvenir from
"Keep Your Memory Green."

This souvenir was given out by Senator Paige to guests who attended his barbecue held on June 1, 1905.

Annual Reunion of the Hotchkiss Association

The Thirty-second Annual Reunion of the Hotchkiss Association will be held at Lake Compounce, in the Town of Southington, Conn., on Thursday, August 22, 1912.

All direct Hotchkiss descendants and their families are cordially invited to be present.

Trolley connections from all directions.

Table picnic dinner at 12:30.

MABEL F. GRISWOLD, Secretary,

R. F. D. No. 2, Waterbury.

Lake Compounce advertised for special events to come to the park. The casino could provide the food, and sports could be played on the grounds, along with riding on the amusements. The trolley also provided the transportation to come as is noted on this Hotchkiss family reunion announcement.

This group picture was taken at the annual clambake of the Bristol lodge of the Elks Club that was held on September 12, 1912.

The National Spring Bed Club event was held on September 13, 1913. This picture of the club members was taken in front of the casino.

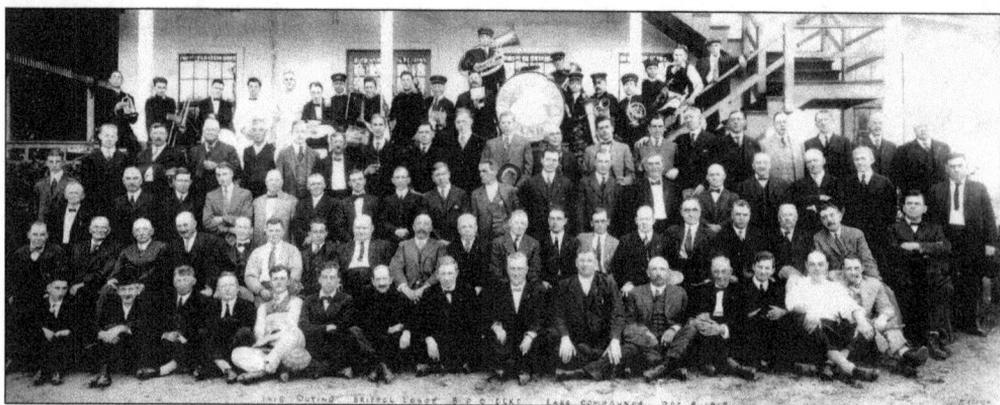

On October 8, 1913, with the musicians in the background, members of the Bristol lodge of the Elks Club are posing in front of the casino.

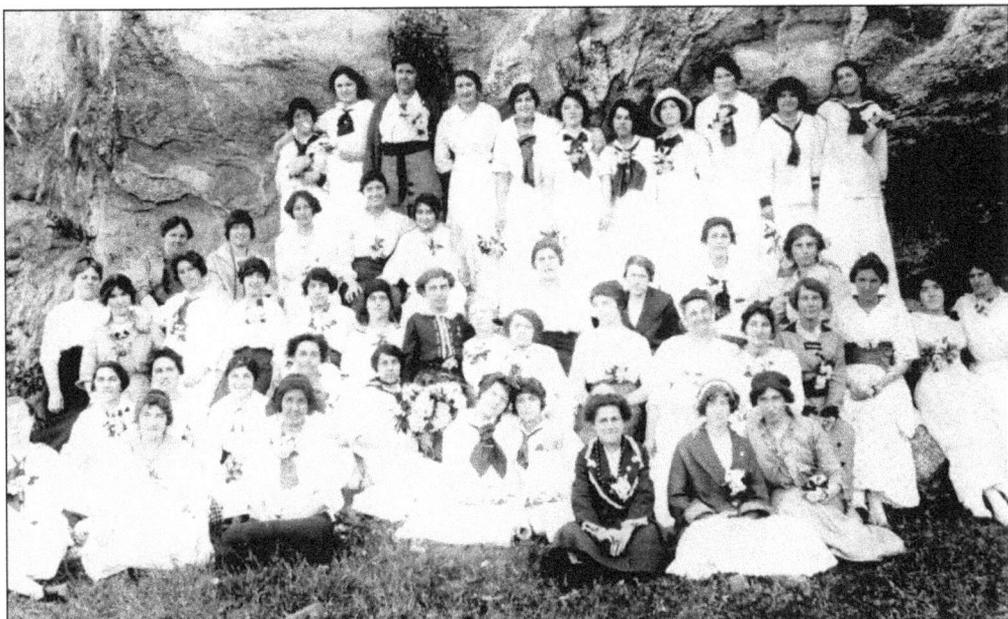

Posing in this July 1914 picture is a group of women who belong to the Laurel Club, which was having a picnic at the park.

The Wallace Barnes factory employees had their annual picnics at the lake starting in 1919. That year, more than 600 attended, enjoying the famous Compounce sheep bake. Games were played, including baseball, swimming, races, and footraces. In this 1920 picture, the Barnes employees play games against the E. Ingraham clockmakers of Bristol, winning eight first places to Ingraham's four, including the tug-of-war.

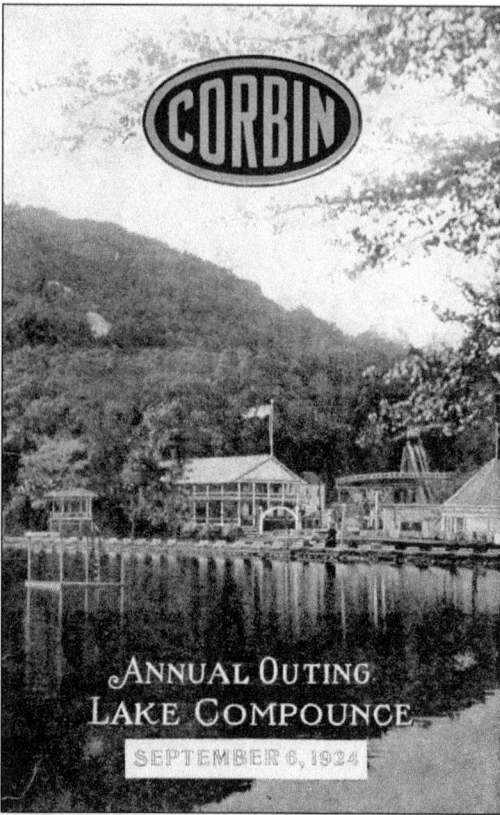

As the park became more popular, many factories from other towns came to Lake Compounce. This is the cover of the program from September 6, 1924, for the Corbin Company from New Britain.

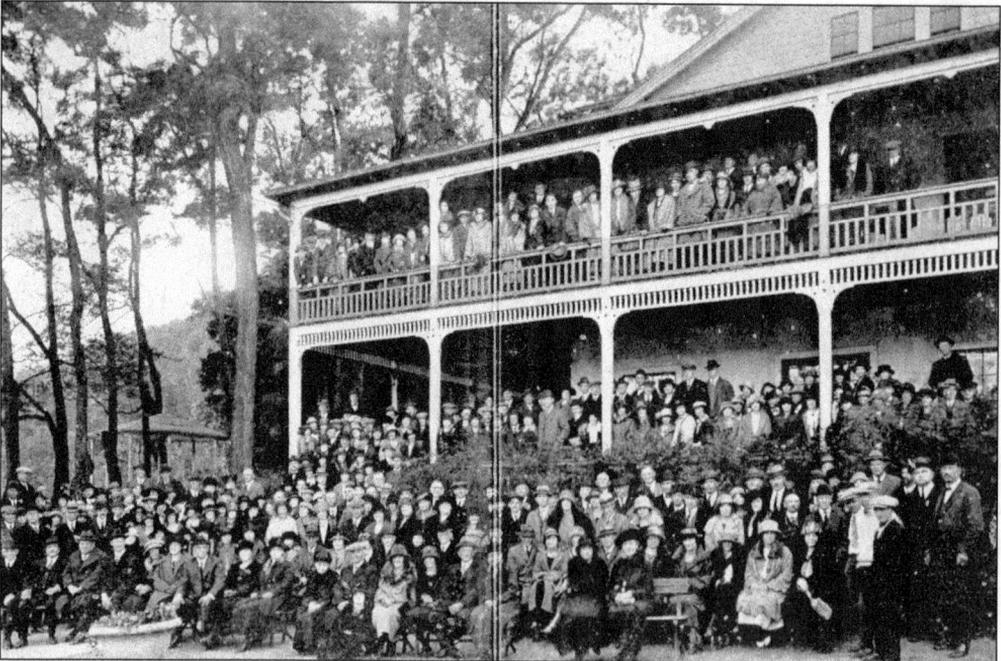

Inside the cover of the 1924 program was this group employee picture that was taken in 1923 of the Corbin Company.

This is the program of Trumbull
Electric from Plainville, from the
Ten Year Club event that was
held on Monday, May 8, 1944.

Annual Banquet

TEN YEAR CLUB

MONDAY MAY 8, 1944
LAKE COMPOUNCE

262

*Gratefully and humbly we salute the
Trumbull employees now serving our
Country. . . Long may our land
be bright with freedom's holy light.*

In this picture taken in the Starlite Ballroom are the New Departure employees from Bristol.
They are enjoying their meals while listening to music on the stage.

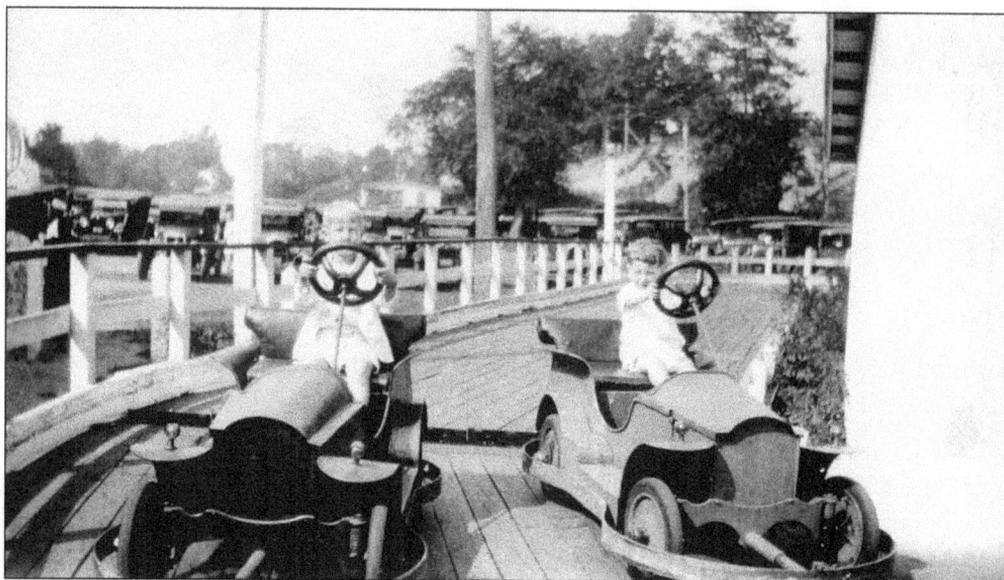

Riding in battery-operated Custer cars are Lester Anderson (left) and Wilbert "Bill" Veley from New Britain in 1928.

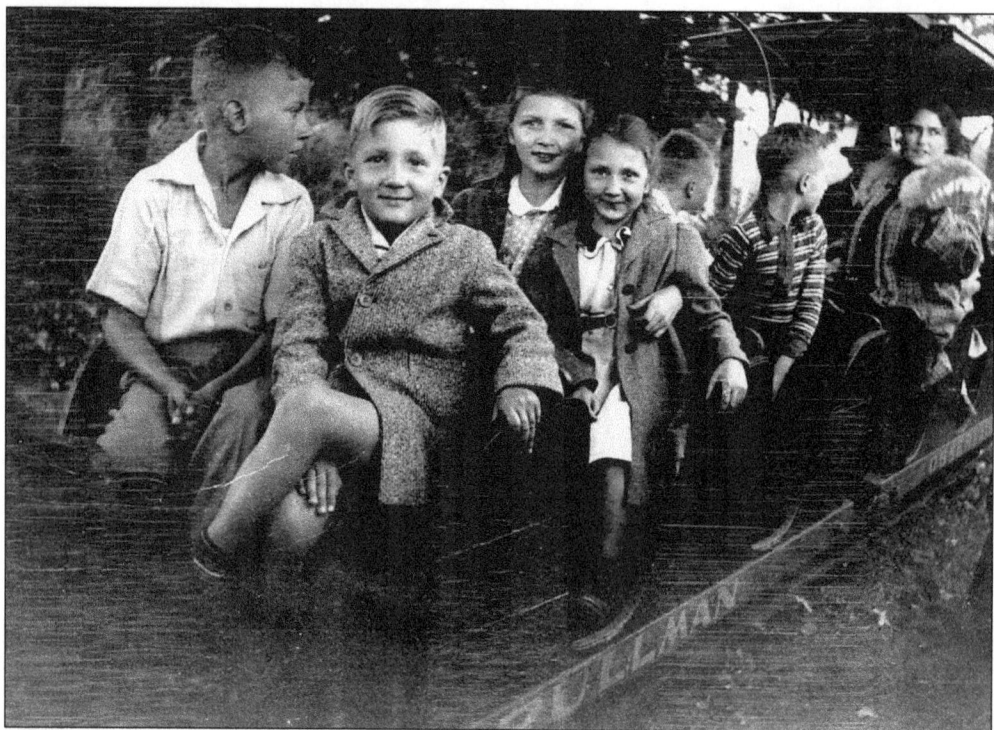

The children are enjoying this ride on October 19, 1941. Sitting in the front are Richard Hines (left) and John Hoffnagle. Behind them are Beverly (left) and Nancy Hoffnagle, and facing backward are David Hines (left) and Tim O'Donnell. They were all from Bristol.

Photographed in 1936, these three Bristol girls are enjoying one another on the dock. From left to right are Marion Swat McCabe Cunningham, Ruth Hayes, and Hazel Brown Sessions.

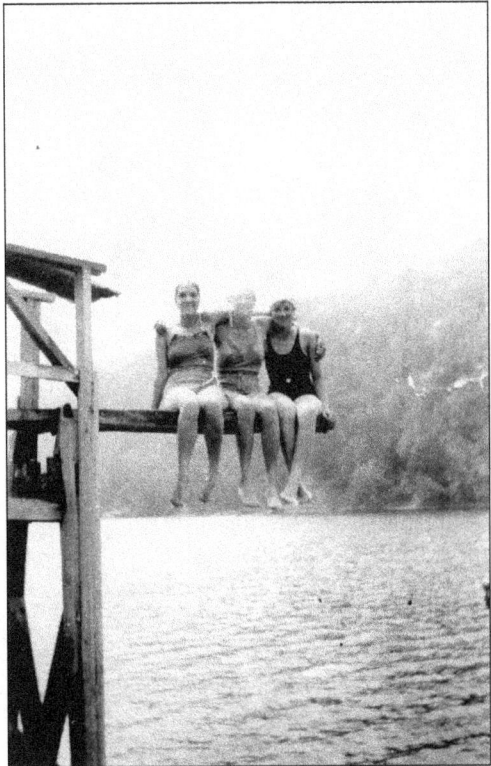

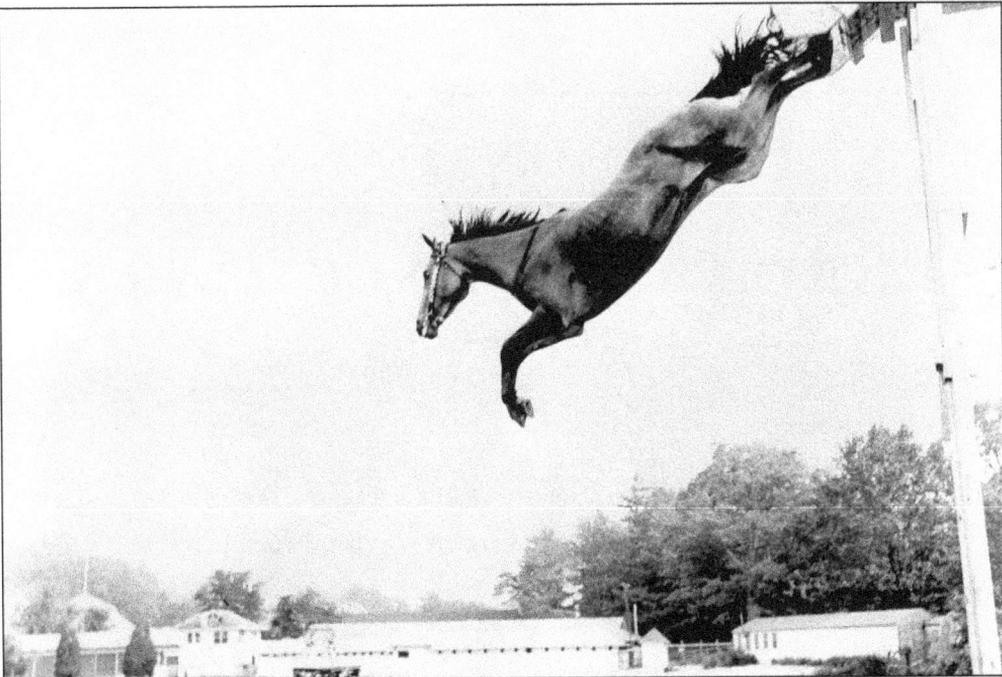

In 1904, the famous King and Queen horses did this same show. Reno Guerrette from Newington owned and trained this horse to jump from a platform. In the background is the shore with the casino and bathhouse.

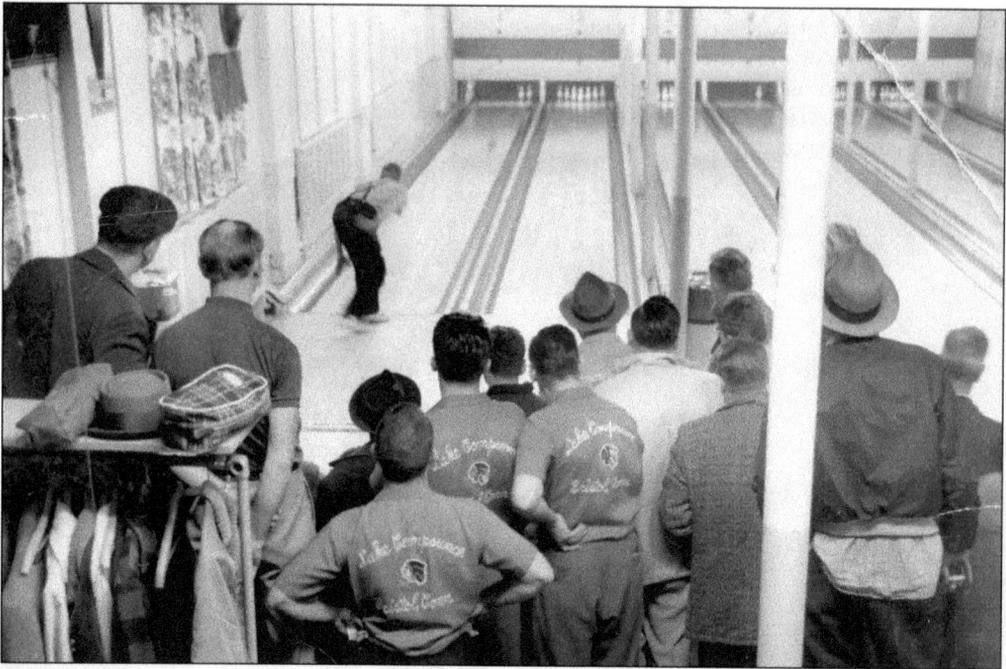

This is a picture of the Lake Compounce bowling team playing at the bowling alley at Lake Compounce. Roger Lemieux and J. Harwood "Stretch" Norton are among the bowlers on the team. The alley started with big pins and later converted to duckpins.

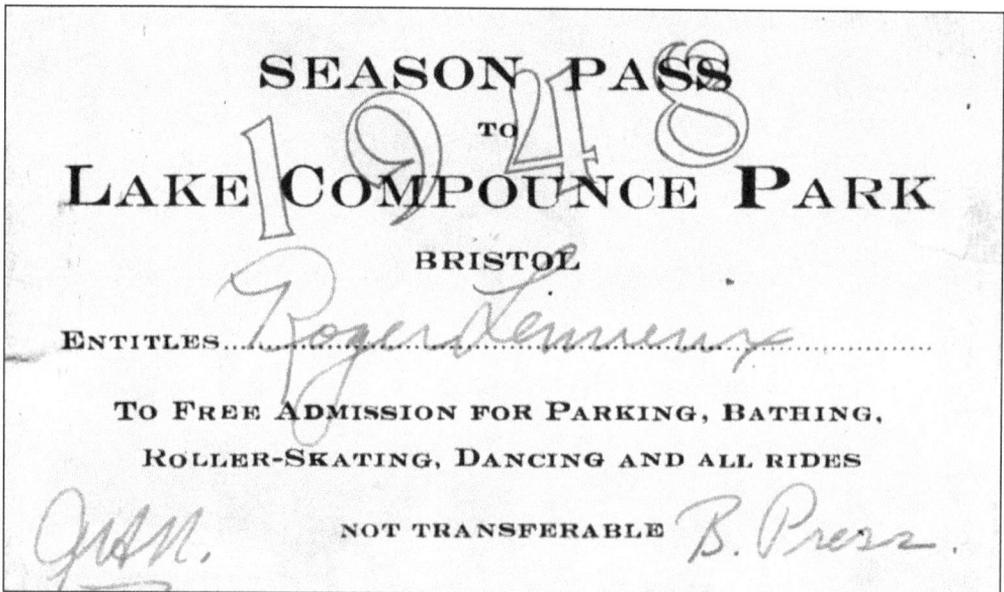

SEASON PASS
TO
LAKE COMPOUNCE PARK
BRISTOL

ENTITLES...........*Roger Lemieux*...........

To Free Admission for Parking, Bathing,
Roller-Skating, Dancing and all rides

NOT TRANSFERABLE

Besides bowling, Roger Lemieux was a reporter for the *Bristol Press* newspaper. He wrote a column called "The Bowlers Corner." He had a season pass to the lake to enjoy everything the entire park had to offer.

In this 1950 picture taken near the Wildcat roller coaster is the Klaneski family. From left to right are John Jr., Joan, Mary Ann, wife Mary holding Stanley, Jean, and husband John Sr.

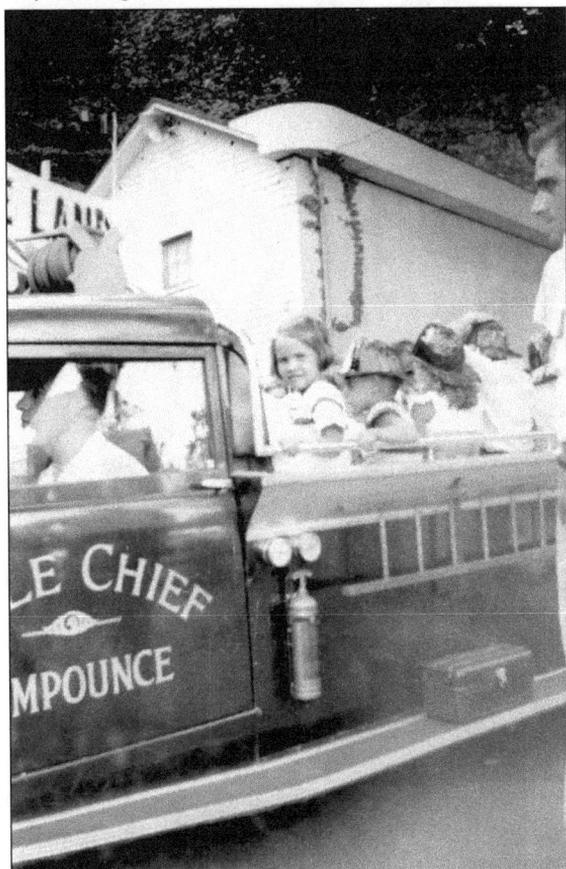

The *Little Chief Compounce* fire engine was made by the Fly-Harwood Company of Memphis, Tennessee, for Lake Compounce's Kiddieland. In 1950 when the season opened, Donna Marie Schissler Dickau is riding with other children on the right in front behind the driver.

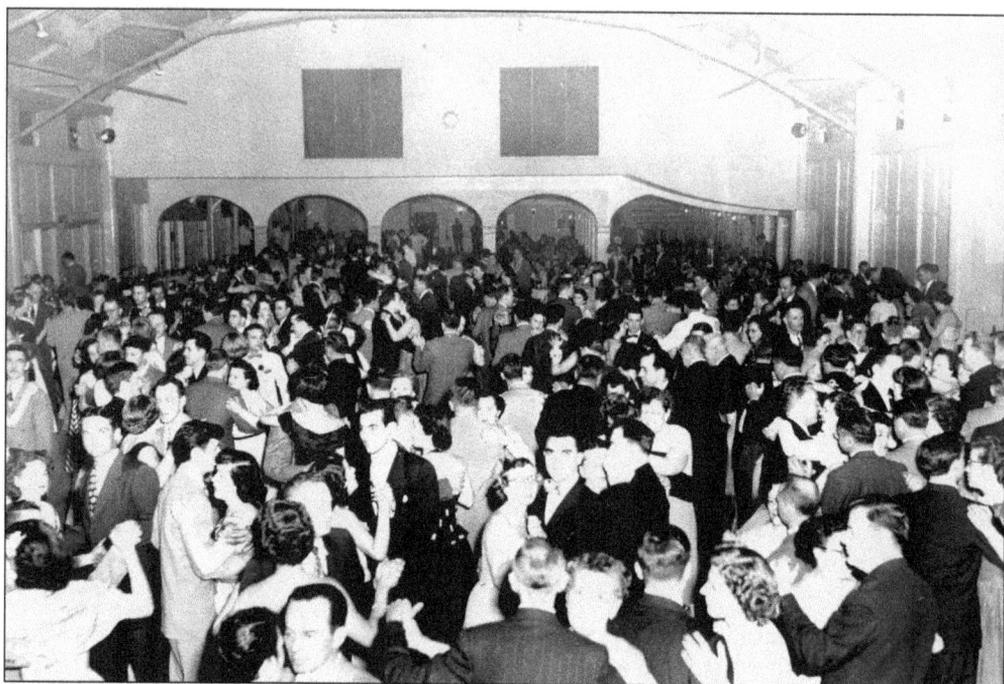

This 1952 picture was taken at the Bristol Policeman's Ball held in the Starlite Ballroom. In the middle facing the camera are Marie and Herb Hochstadt.

At the Elks Club of Bristol ball held in October 1954 in the Starlite Ballroom are Florence, Pat, and Jim Purcell, Sara and Al Budd, Mary ?, Ron Keith, Ceil and Edgar Hough, Mary Purcell, Jennie and Herb Benson, and Marie and Tom Purcell.

94

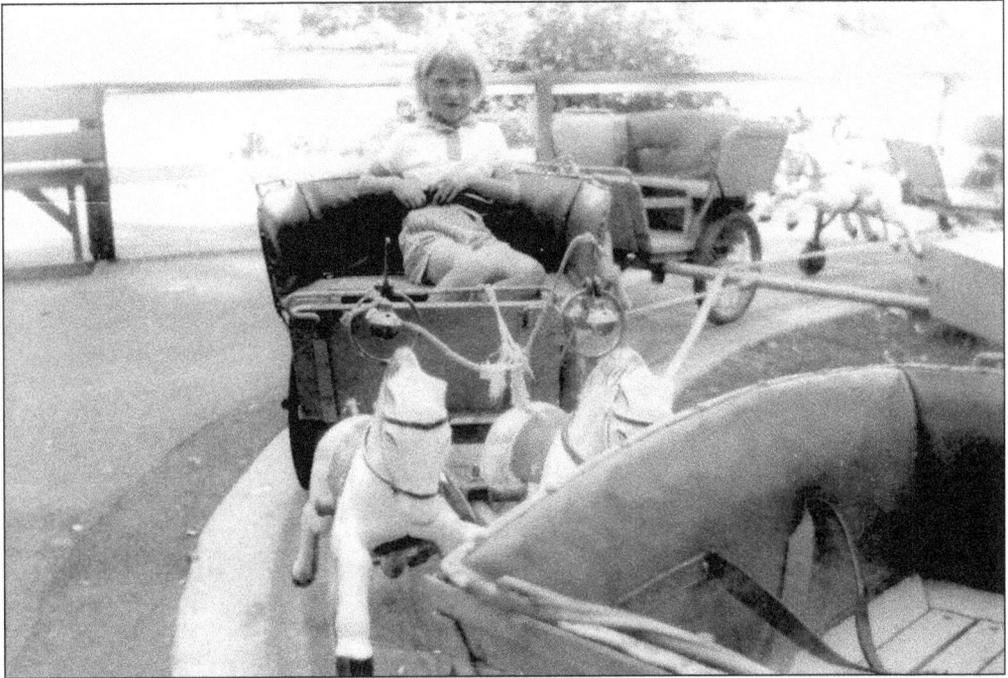

Rachael Fuller of Bristol is enjoying one of the rides from the Kiddieland area in 1961.

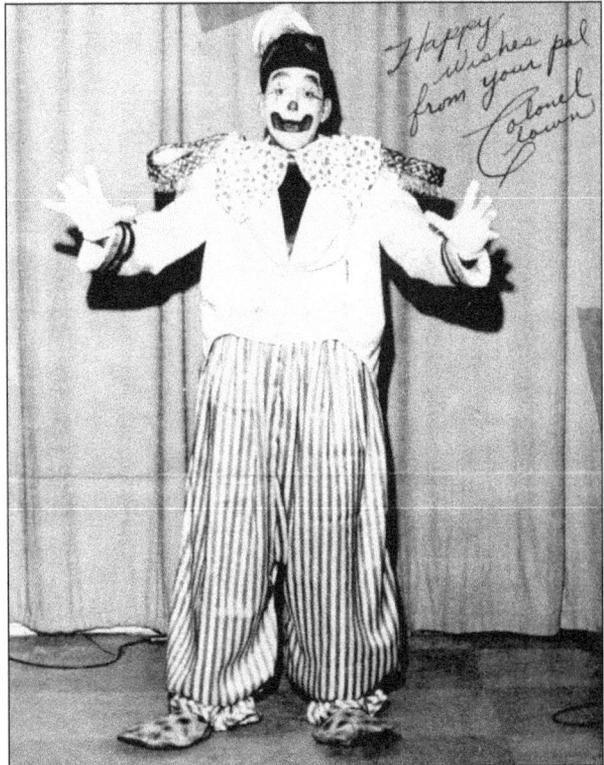

Joey Russell of Milford performed at Lake Compounce as Colonel Clown for more than 20 years. Colonel Clown also had a television show on Channel 30 called *T.V. Happiest Hour.*

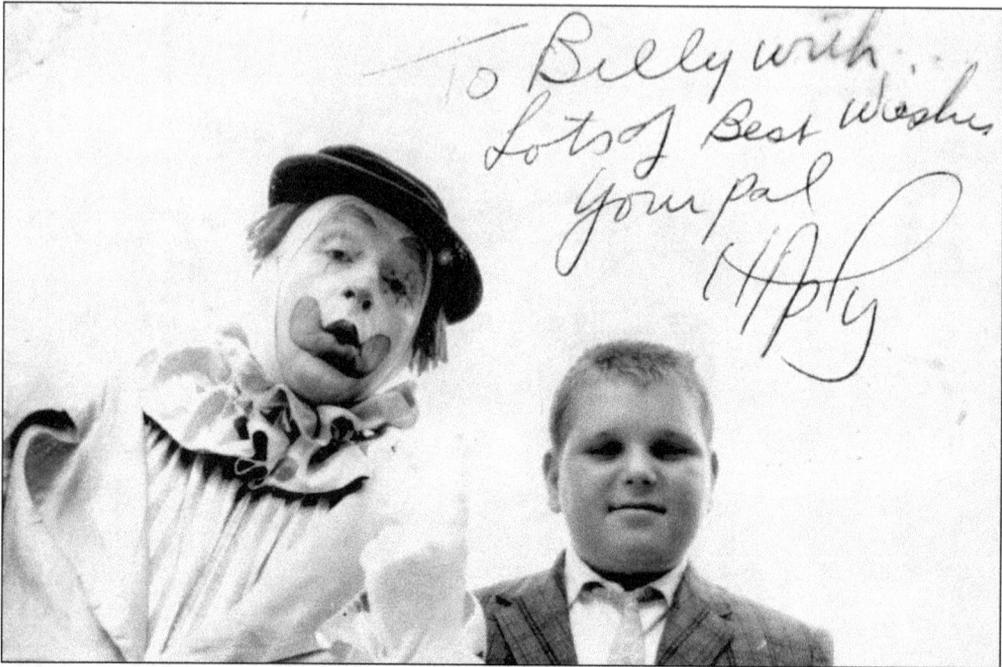

On the left is Colonel Clown with 13-year-old Billy Plaweski when Billy won the talent contest at Lake Compounce on July 8, 1962.

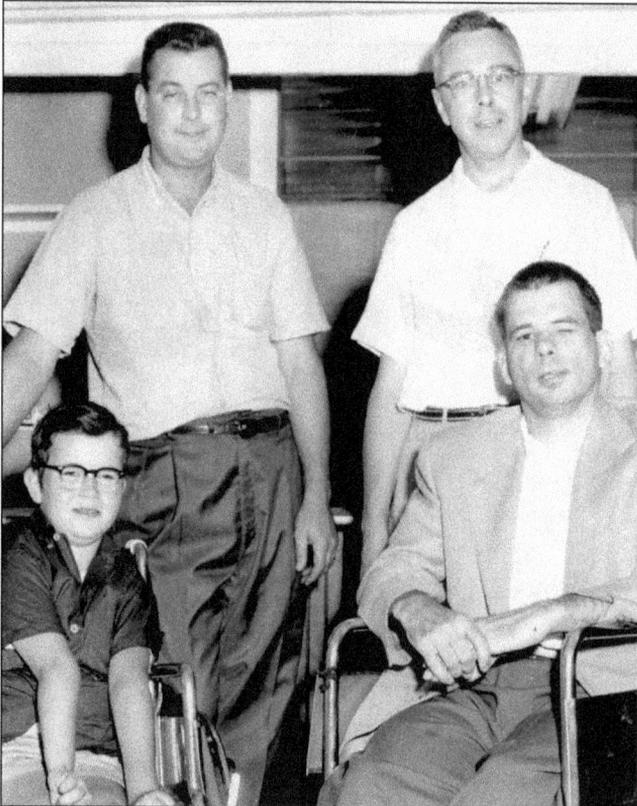

Starting in 1955, the Bristol lodge of Elks started having a day at Lake Compounce for handicapped children and adults who came from Bristol, Southington, Terryville, New Britain, Plainville, and Meriden. This picture was taken at the fifth annual event with 200 handicapped individuals attending. Standing are Kenneth Norton (left), son of Percy Norton, representing the management at Lake Compounce, and William W. O'Neill, chairman of the Elks Crippled Children's Committee. In front are Dickie Dyer (left) and Charles Martin Jr.

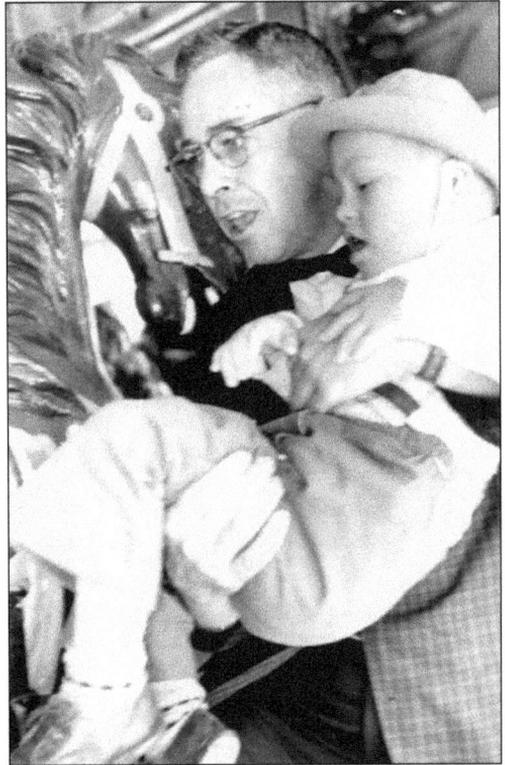

William W. O'Neill, chairman of the Elks Crippled Children Committee, is putting one of the children on a carousel horse at the fifth annual outing.

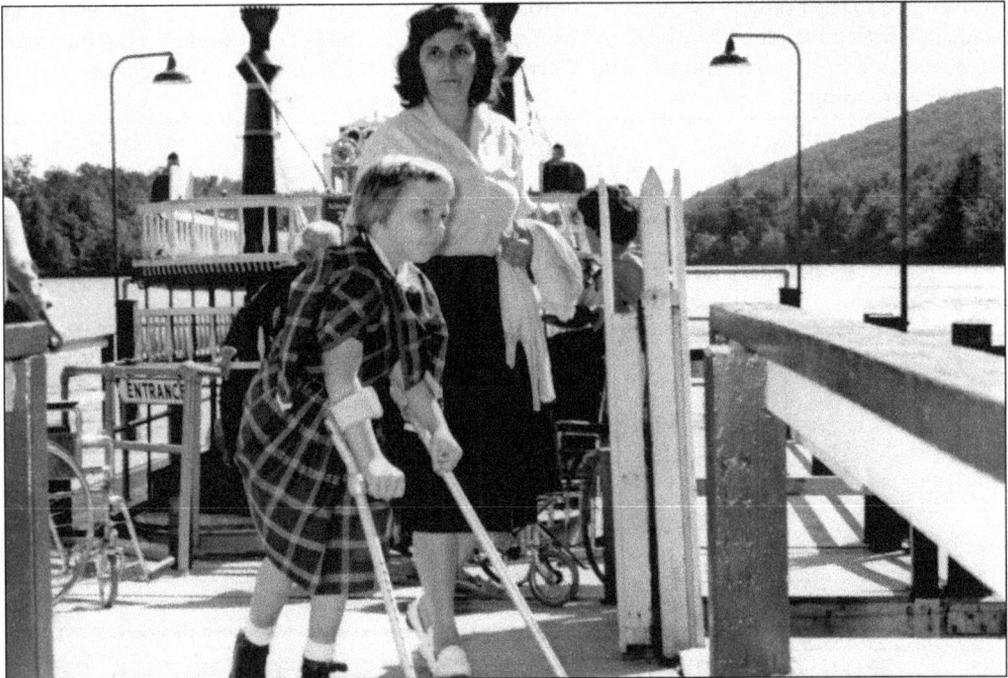

The women from the office personnel at New Departure of Bristol aided the girls and women who were handicapped. After the rides, a dinner was prepared and served for everyone in the dining room.

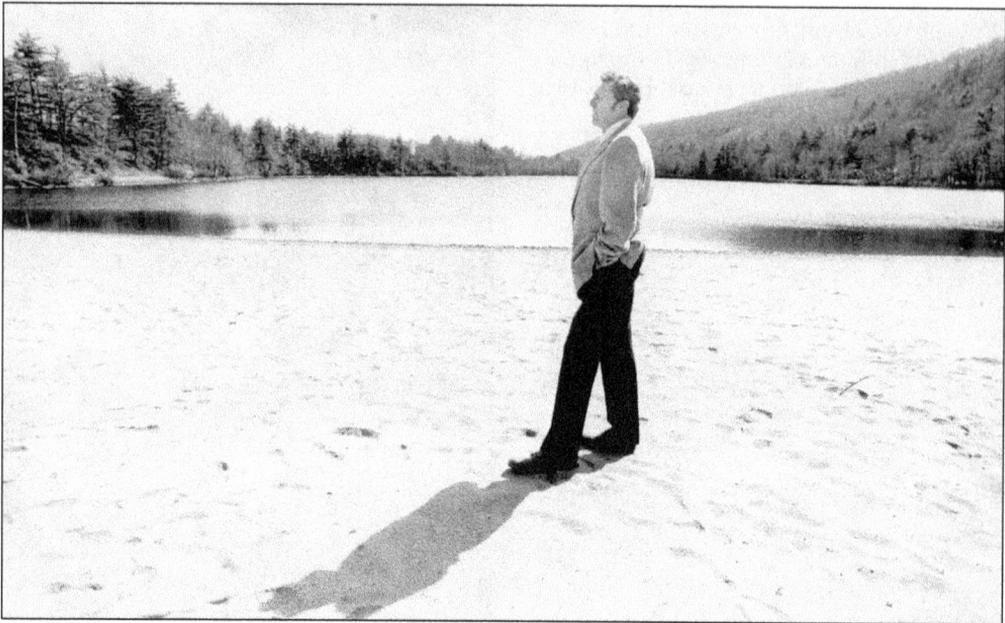

J. Harwood "Stretch" Norton, born on June 7, 1922, is the son of the late Julian Harwood Norton and Norberta Smith Norton. Stretch grew up in the same house his great-grandfather Gad Norton did. His father, Julian, put Stretch to work at nine years old. His job was collecting tags for the bathhouse lockers. He received his nickname when he grew four inches in one summer. He always enjoyed the big bands and the visits after the shows when the bandleaders would come to the house before leaving for their next show. Stretch went to Yale University and graduated with an engineering degree. Along with helping at the park, he worked as an engineer for Associated Spring. He and his wife, Carrie, have four children. In the 1985 picture above, Stretch is standing by the shore.

PONY RIDES CAKE SALE WHITE ELEPHANT SALE

SODA

HOT DOGS

FAMILY PICNIC & RALLY
FOR
STRETCH NORTON
SEPTEMBER 21, 1969 — 2 P.M.
LAKE COMPOUNCE
Keep ticket for Door Prize

FREE BEER

RIDES

SPONSORED BY THE REPUBLICAN TOWN COMMITTEE

When J. Harwood "Stretch" Norton decided to run for mayor in Bristol, he had a family picnic and rally at Lake Compounce. He served as mayor of Bristol from 1969 to 1971.

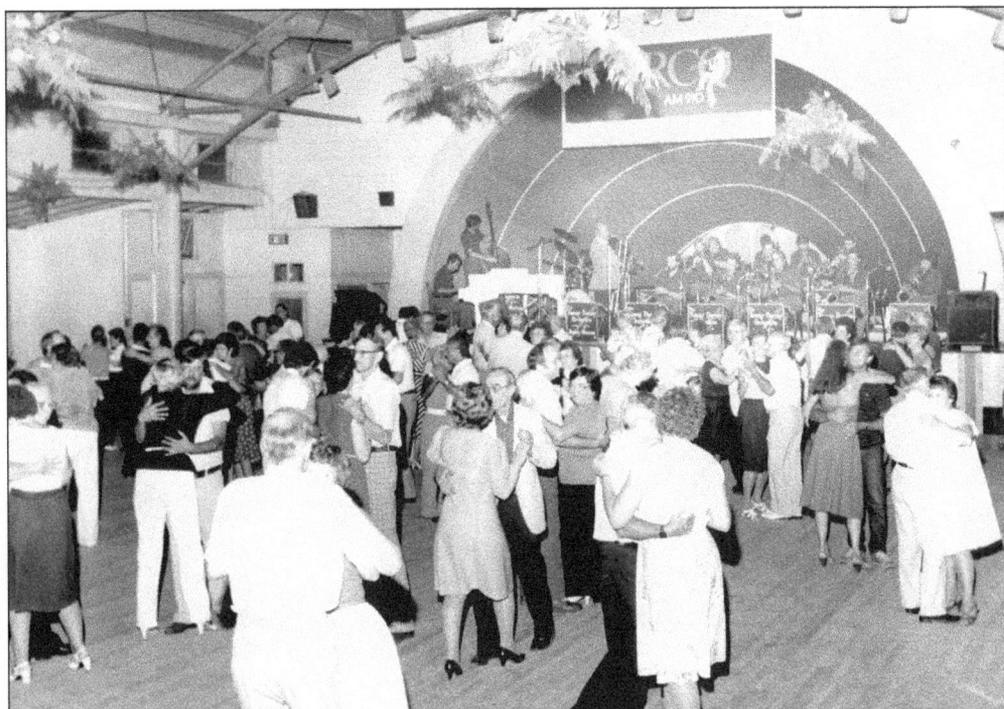

On the dance floor in the ballroom, this group of people is enjoying listening to Buddy Morrow leading the Tommy Dorsey band.

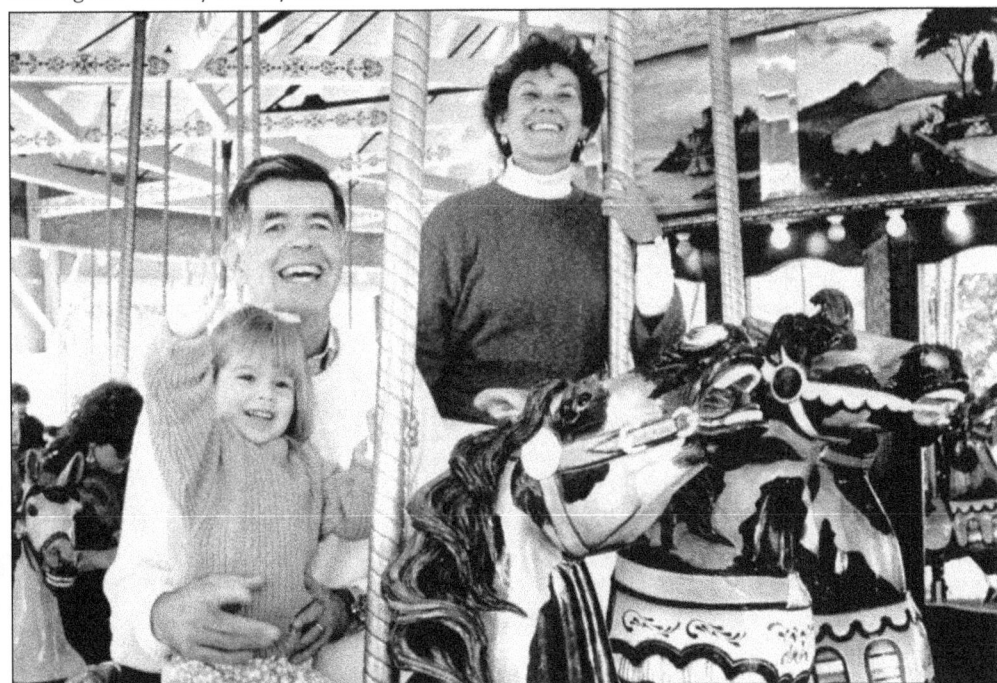

Jack and Carol Denehy of Bristol both worked at Lake Compounce as young adults. In this picture taken in 1986, when the park had reopened under Hershey Entertainment, they are enjoying the carousel with their three-year-old granddaughter Lindsay Vigue.

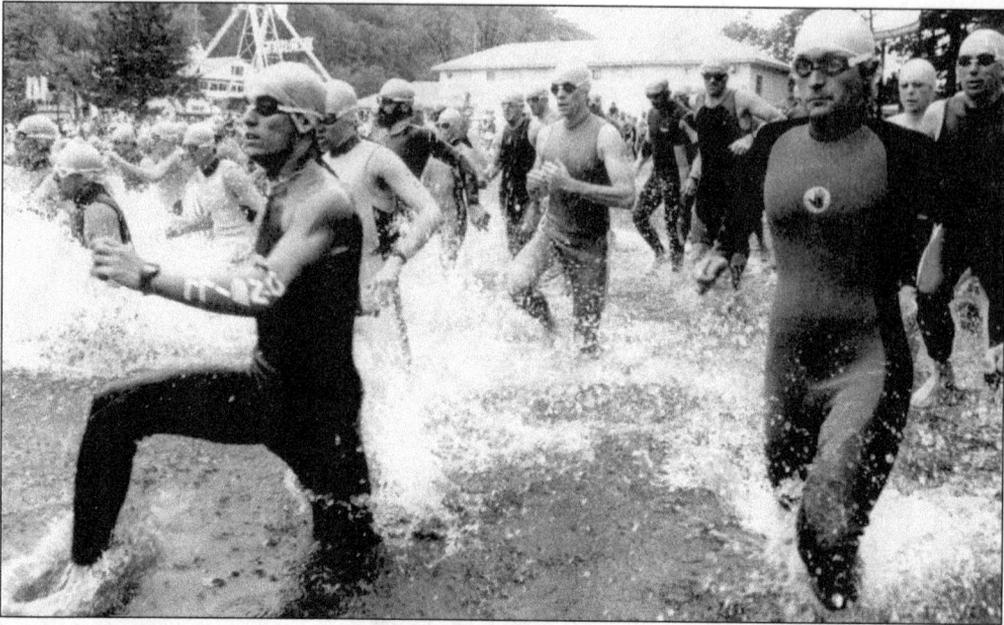

In this June 2, 1990, picture, swimmers are taking the plunge at the lake for the Tri Sports/Miles Home sprint triathlon championship that over 500 people competed in from around the United States.

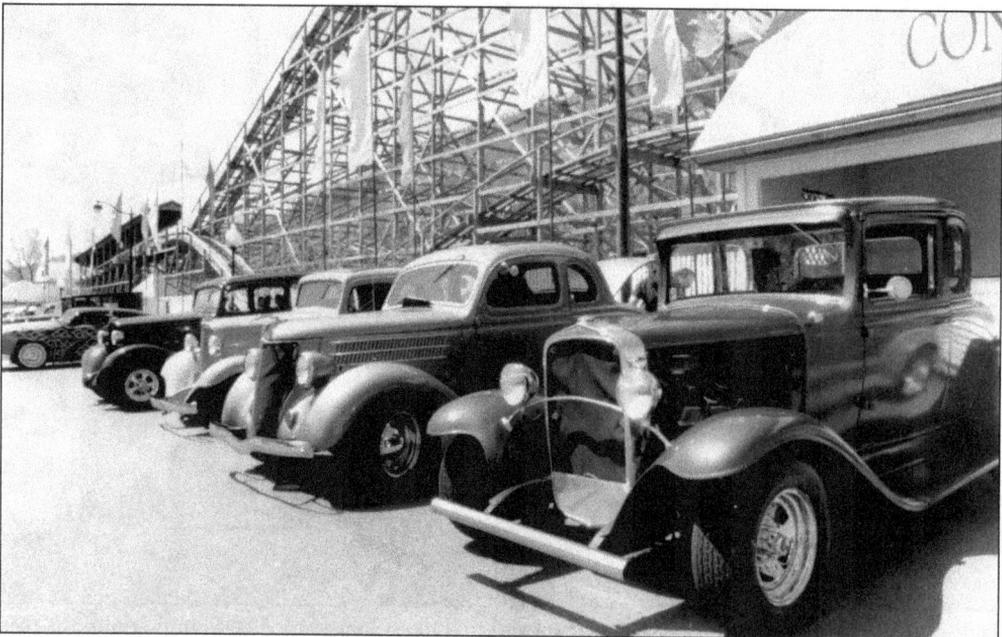

The Connecticut Street Rod Association started sponsoring a swap meet in 1969 at the lake. This picture is the 23rd annual swap meet that was held on Sunday, May 4, 1992.

Seven

A New Beginning

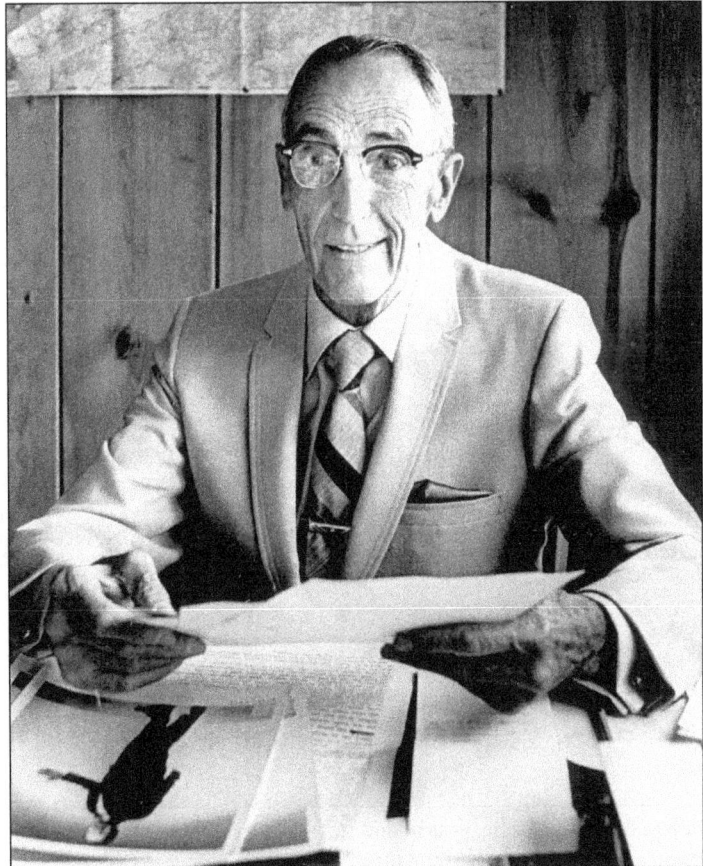

From 1851, Lake Compounce was owned and operated by Pierce and Norton Company Inc. On August 12, 1966, Edward G. Pierce, Isaac Pierce's grandson, sold his interests to the Norton family. The officers of the newly formed corporation were Julian Harwood Norton, president, Richard E. Norton, vice president, Christine French Norton, secretary, and Janet Norton Sonstroem, treasurer. This picture is of Julian on his 80th birthday in 1975.

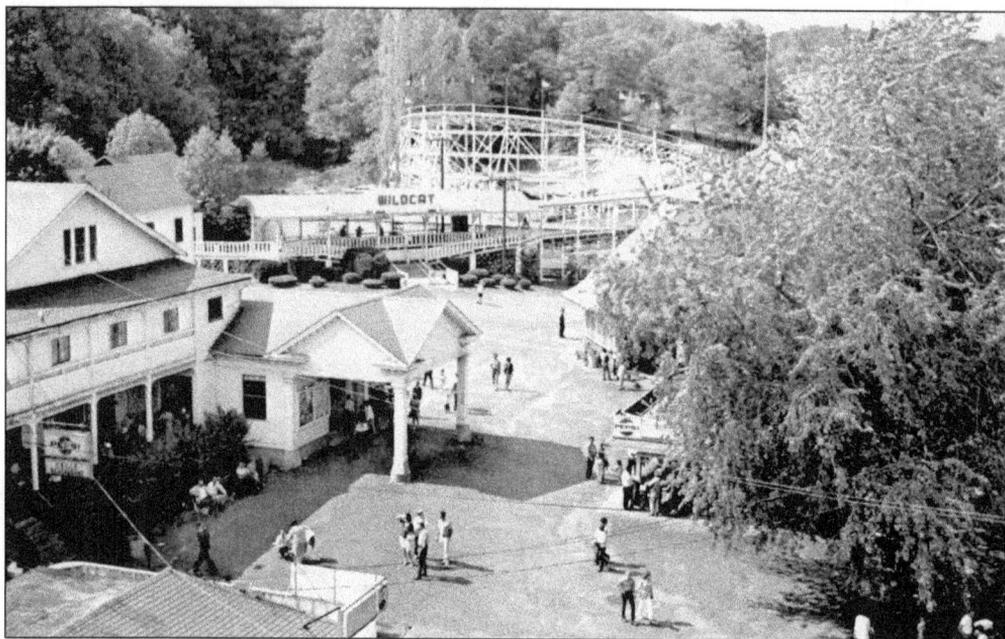

This 1970s picture shows the many changes to the original casino, built in 1895, on the left. The original 1927 Wildcat roller coaster ride is in the background.

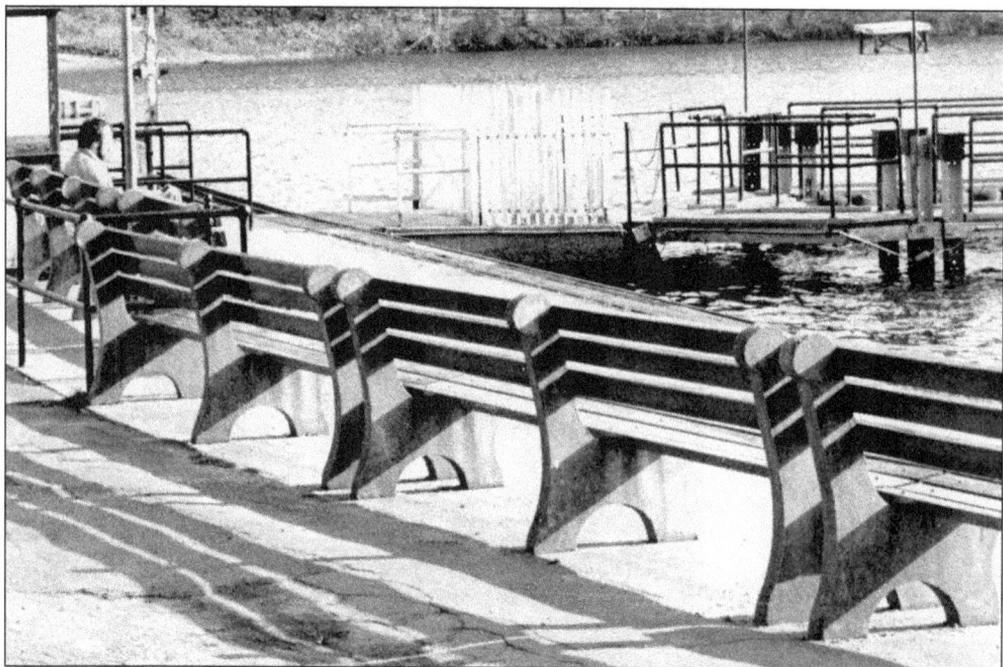

A row of park benches was added near the water. This view was taken on January 3, 1980, when the park was closed for the winter.

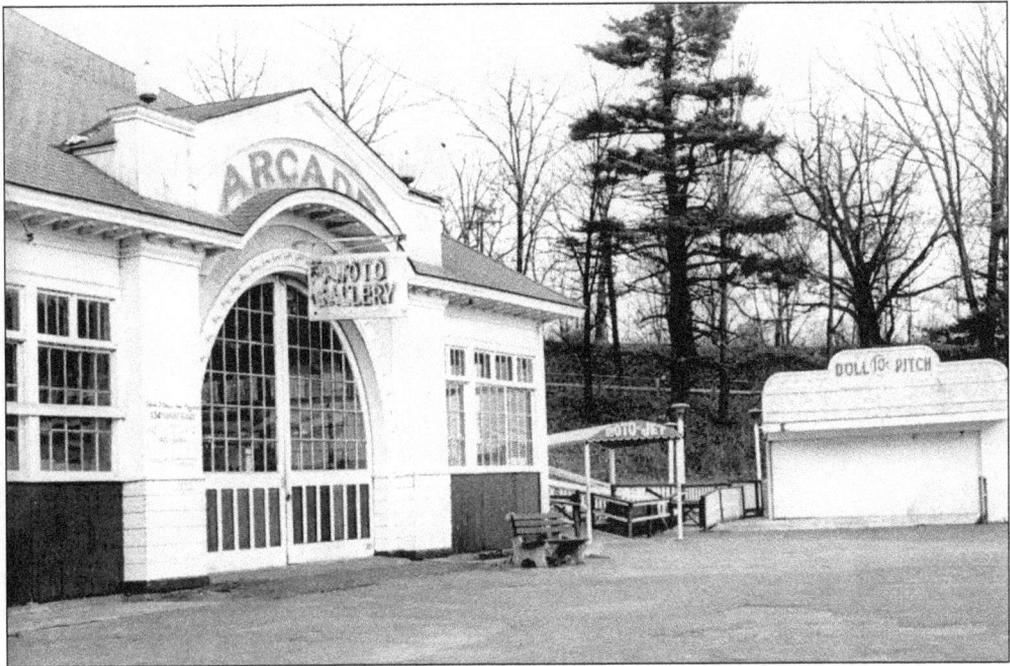

Taken on January 3, 1980, when the park was closed for the season, this image shows the arcade with a sign for the photo gallery over the entrance. The Roto-Jet amusement ride is on the right of the arcade. The Doll Pitch game of chance is next to the Roto-Jet.

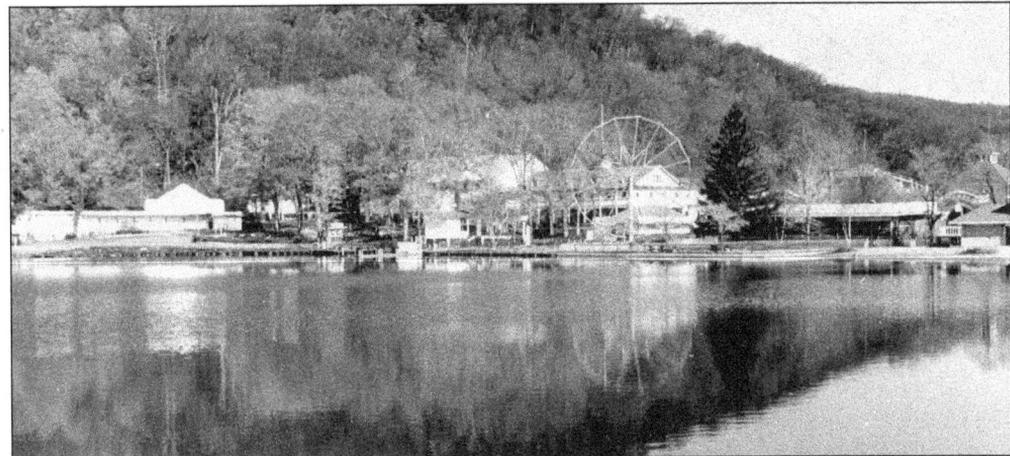

This May 5, 1982, view of the park was taken from the lake and shows the Ferris wheel still near the shore.

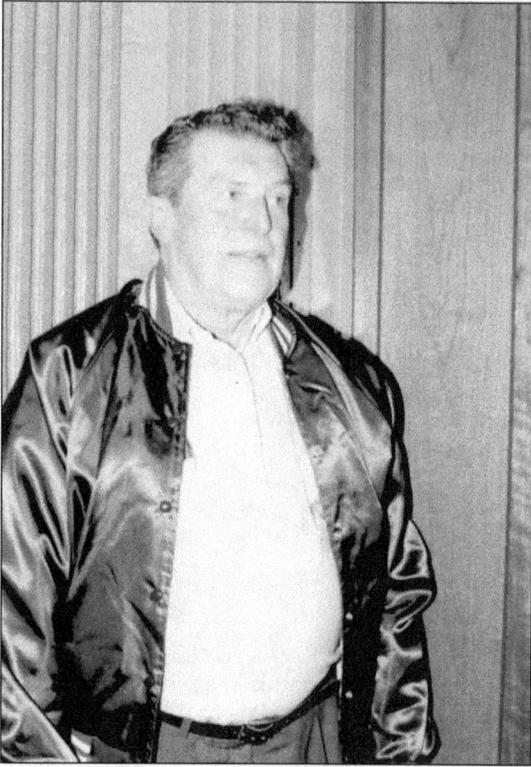

When Julian Harwood Norton died in 1975, Lake Compounce was taken over by J. Harwood "Stretch" Norton and his cousins. In 1985, it was decided by the Norton family to sell the park. This picture is J. Harwood "Stretch" Norton taken in 1985.

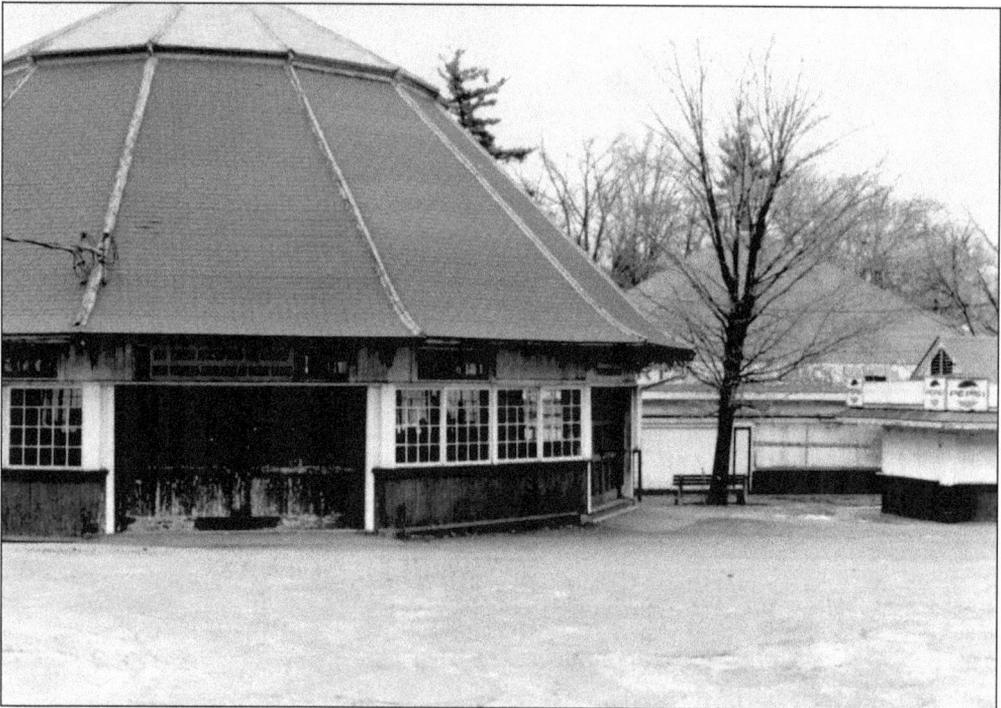

This picture of the carousel building was taken in the winter of 1985 when the park was still owned by the Norton family.

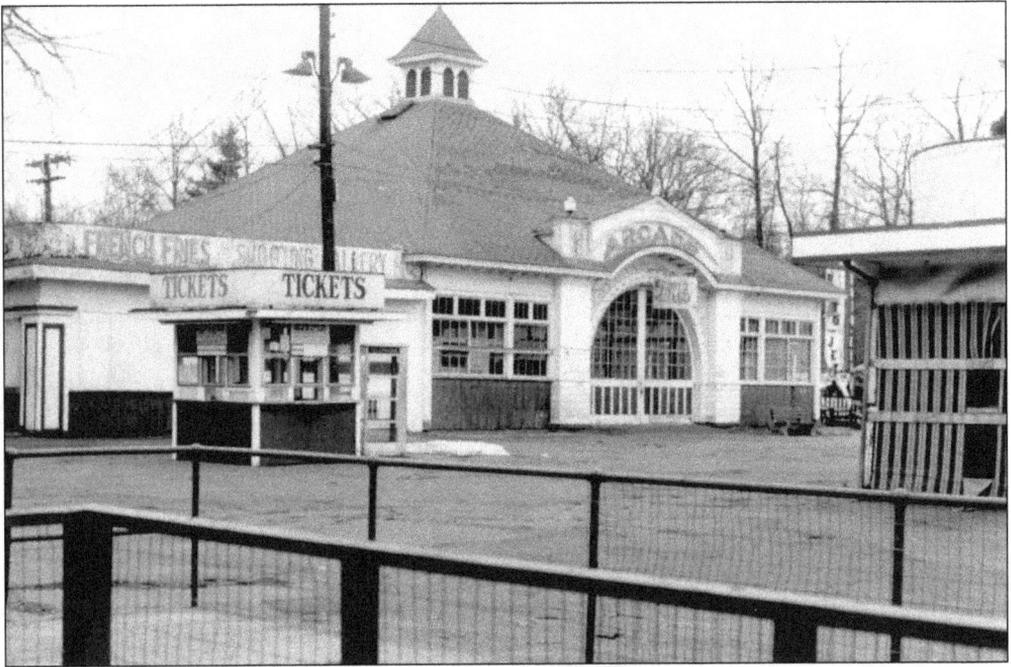

This is a picture of the arcade and ticket booth during the winter of 1985.

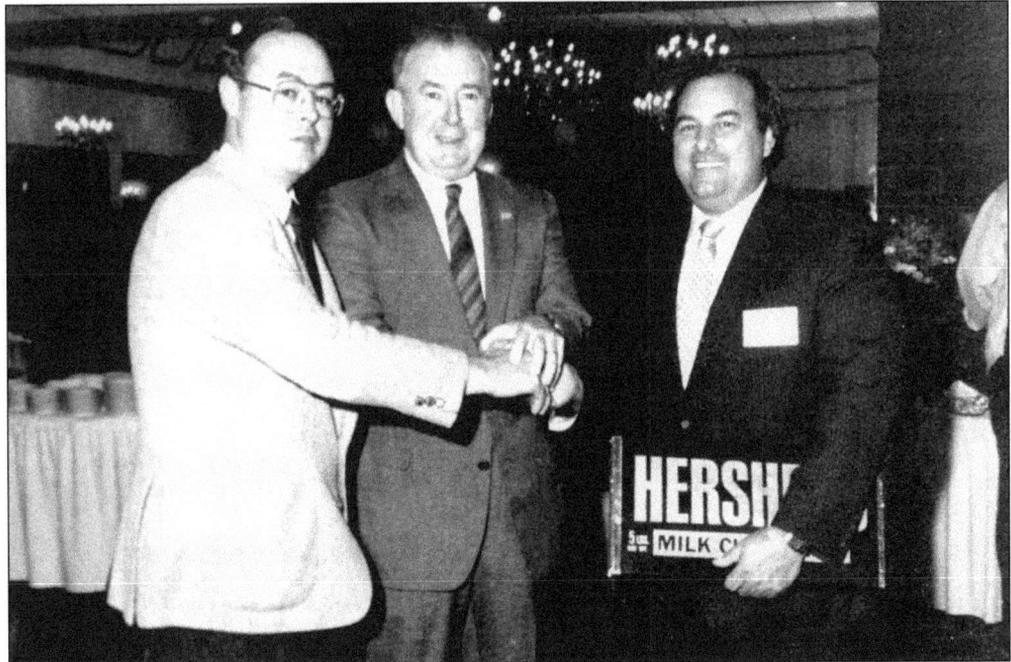

In 1985, the Norton family sold the park for $1.25 million to Bristol car dealers Stephen Barberino Sr. and his son Stephen Jr. and contractor J. D. "Chuck" Arute. The park opened that year just for one weekend. The Barberinos and Arute sold their majority ownership to Hershey Entertainment and Resort Company. In the picture above, taken in 1985, from left to right are Mayor John J. Leone Jr. of Bristol, Connecticut governor William O'Neill, and Robert Cusano, town councilman of Southington.

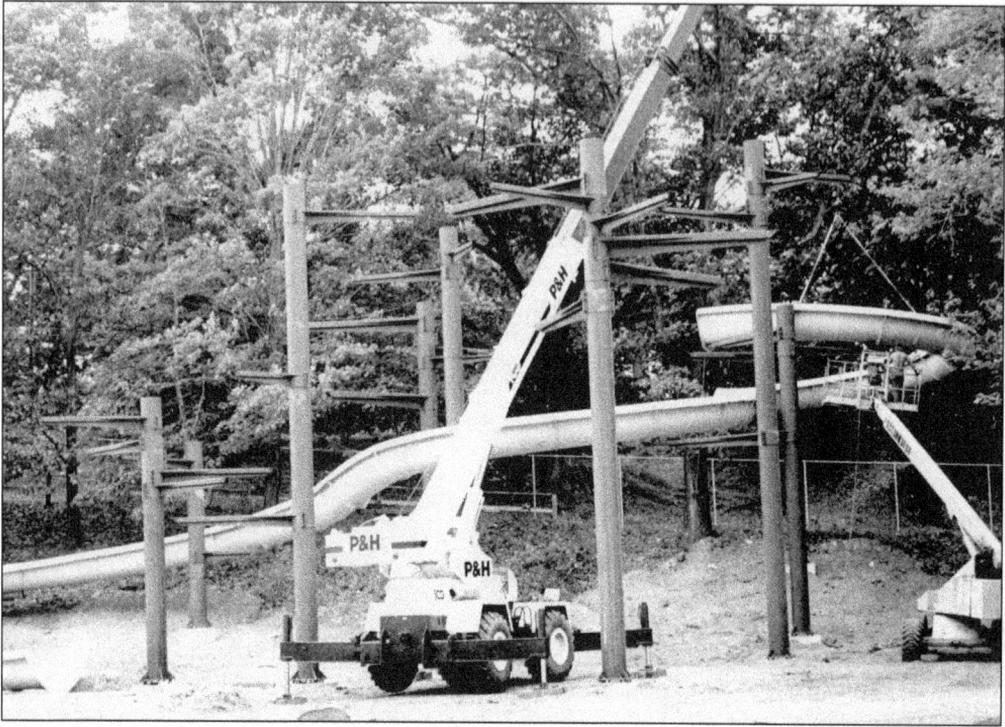

After purchasing the park, starting in 1985 Hershey invested millions of dollars to renovate existing amusement rides and add new ones. This picture shows the construction of the Huck Finn waterslide.

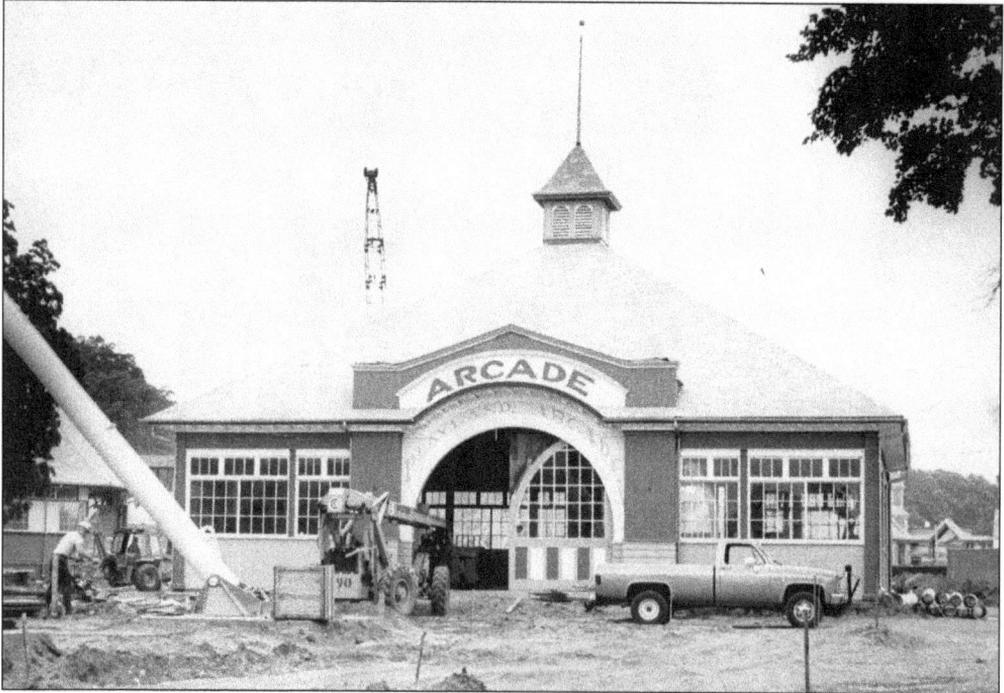

The arcade is getting refurbished with new windows and a new roof during the spring of 1986.

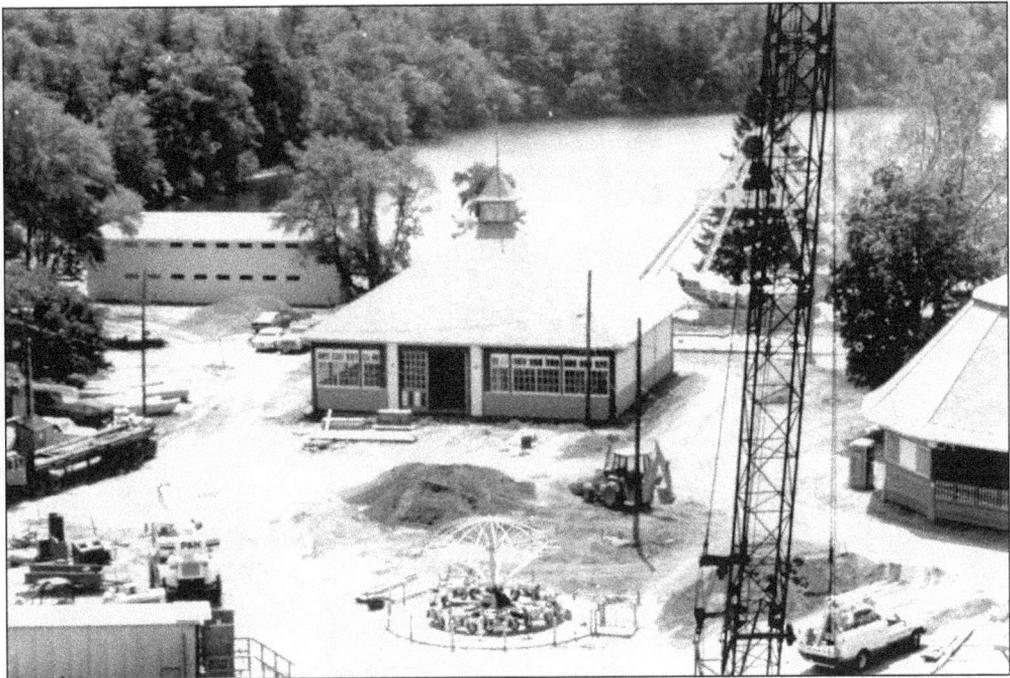

In the spring of 1986, Hershey had the entire park either under construction or being refurbished. This picture shows the bathing house on the left, the arcade at center, and the carousel on the right, all restored.

This 1986 view from the lake shows on the far left the casino that dates back to 1895. The new Pirate ride is in the center, and the bathing house is on the right.

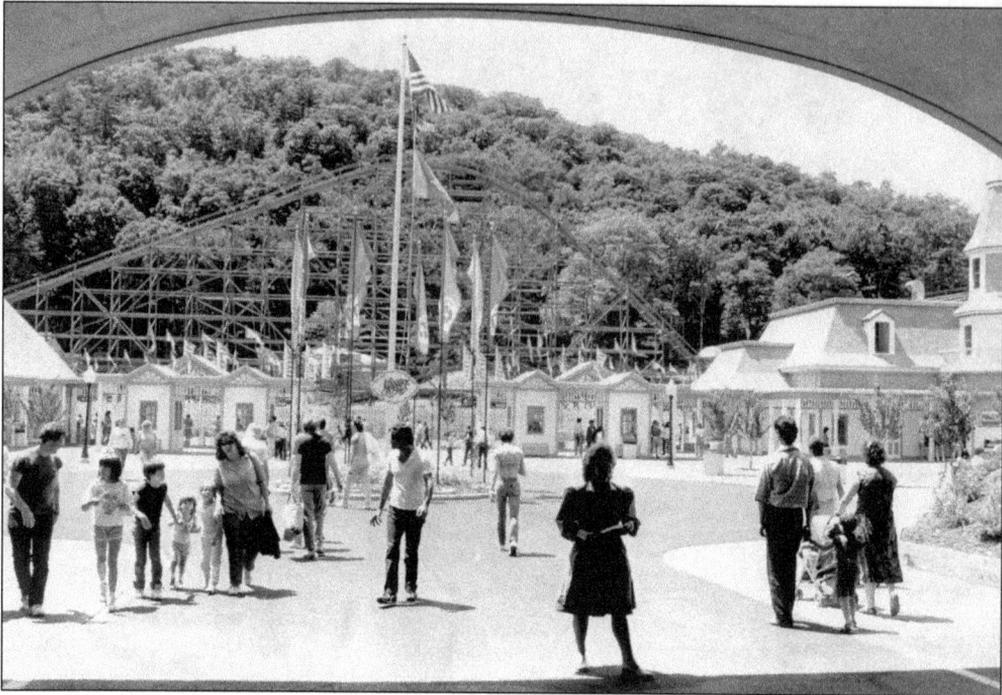

Photographed in 1986, this is the new entrance that Hershey built to get into the park with ticket booths in the background. Prior to Hershey owning the park, there was no entrance fee to get into the park.

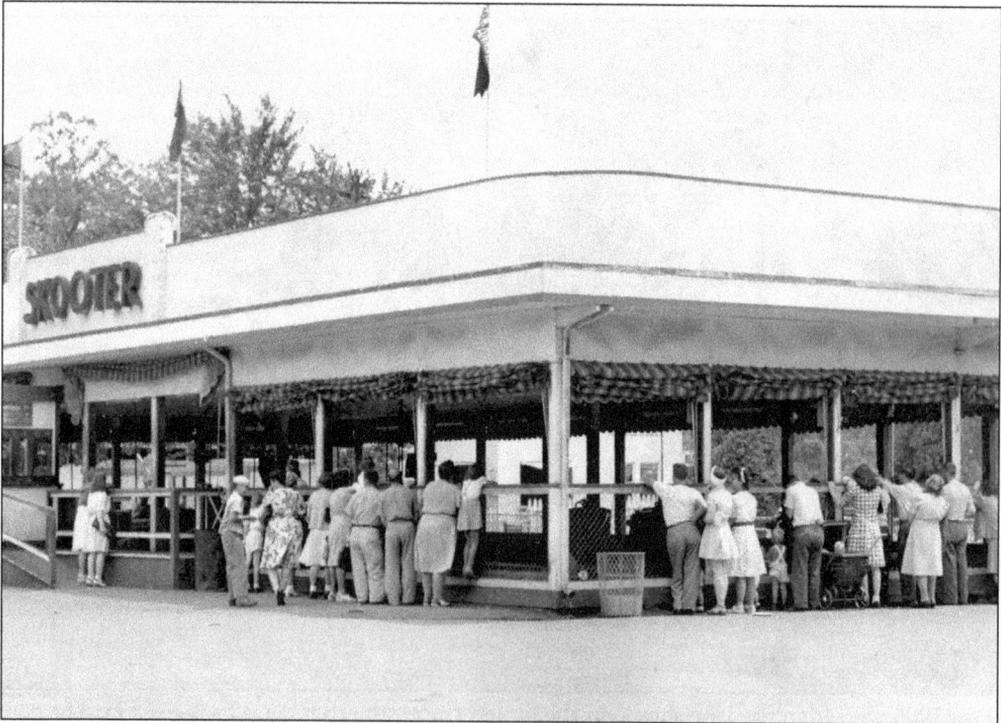

In this building was a bumper car ride called Skooter that was always popular with children.

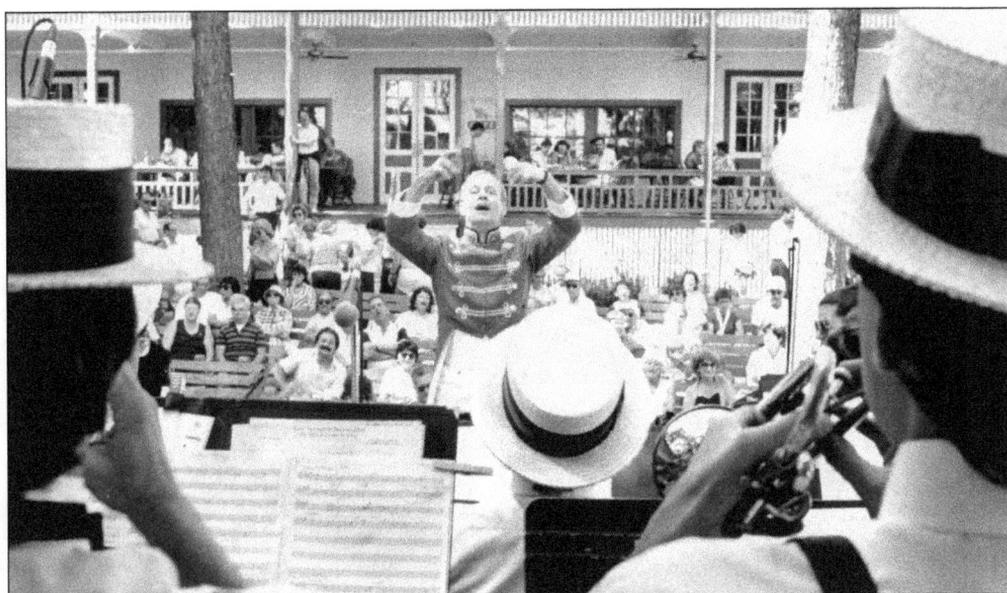

July 5, 1986, was the opening of the new Hershey Lake Compounce Park. In the picture above is an outside performance with the original casino built in 1895 in the background.

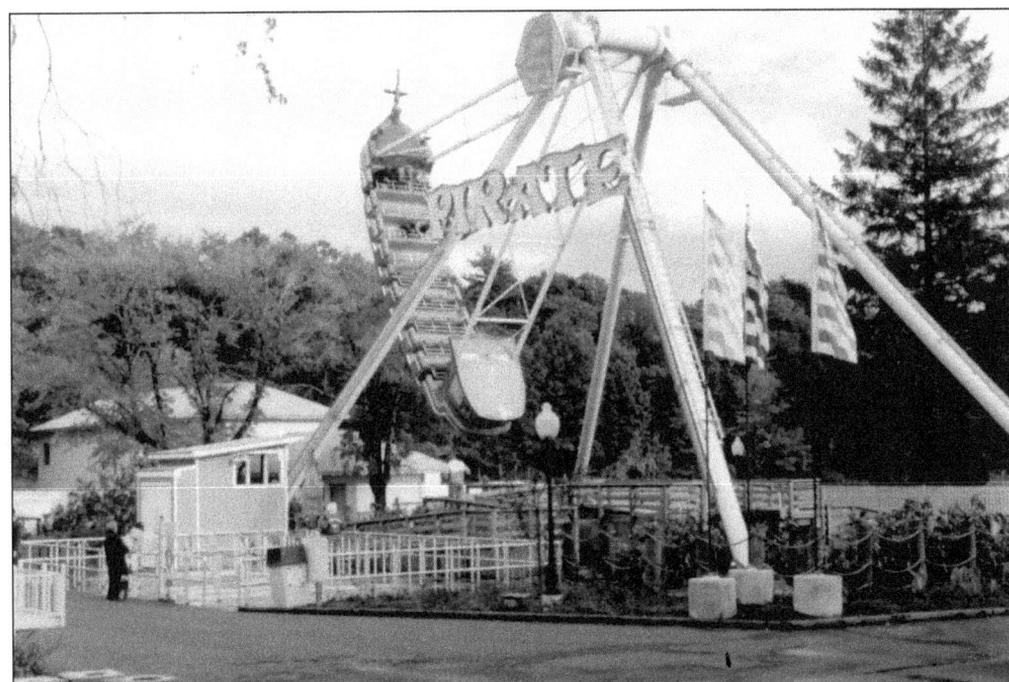

A new ride called Pirate, built by Huss Manufacturing of West Germany, is a boat that swings like a pendulum back and forth. The boat can accommodate 54 passengers.

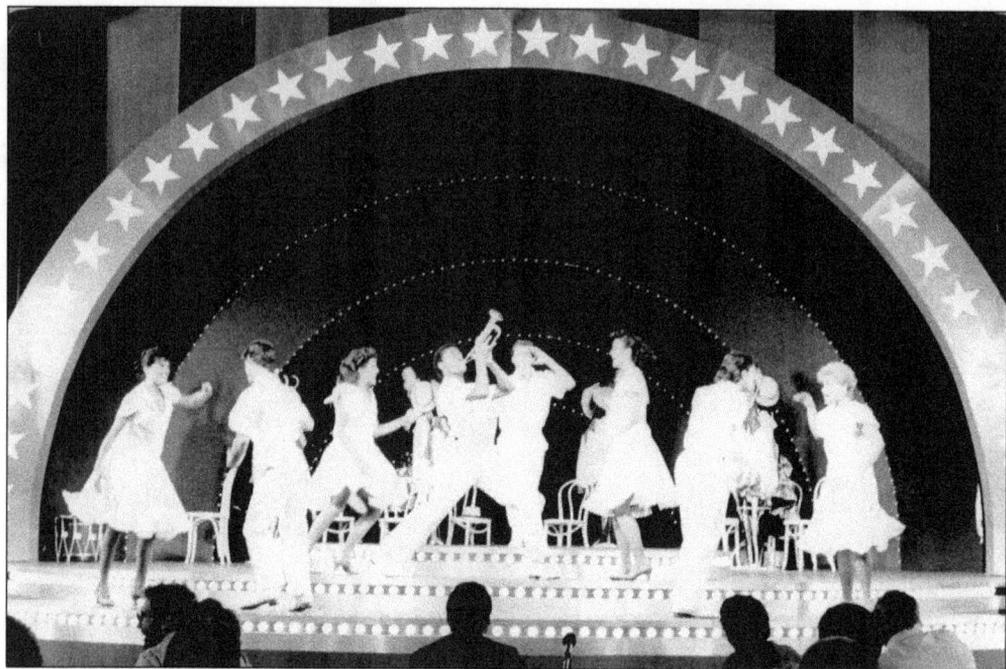

The Salute to Liberty Show started the season opening of Hershey Lake Compounce on July 5, 1986. Sponsored by the *Hartford Courant* newspaper, the show celebrated the last 100 years of American music. This picture shows the performers on the same stage that the big bands played on in the 1930s and 1940s.

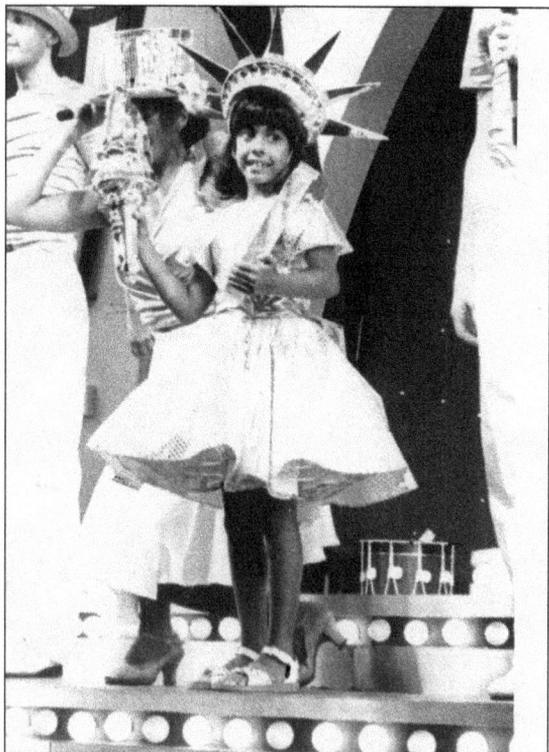

Most of the talent for the Salute to Liberty Show was local talent. The performance was done five times a day, seven days a week.

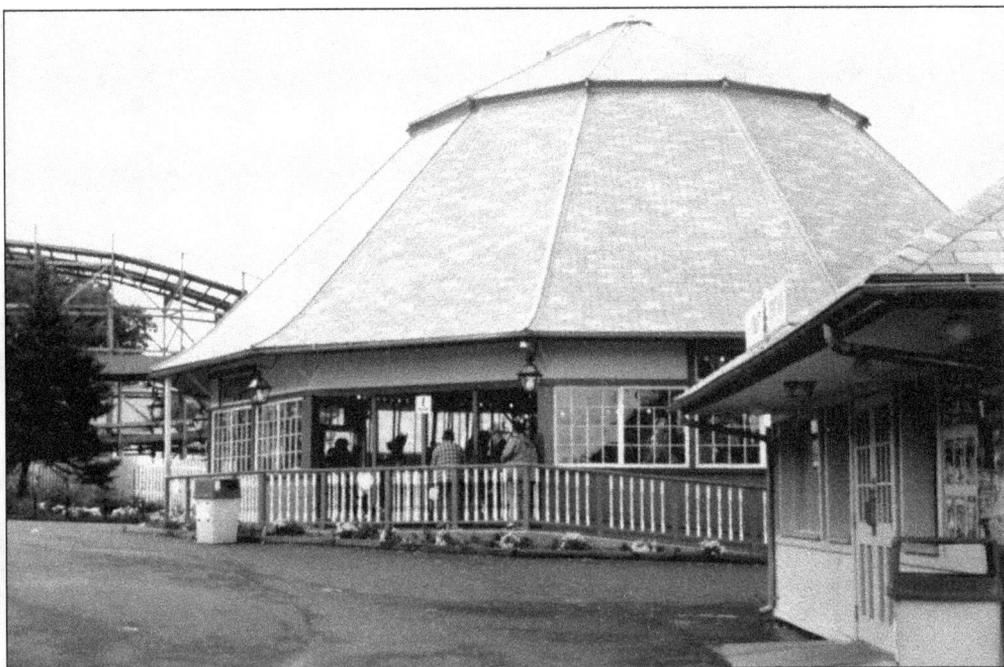

The carousel building is all restored back to its original look with the Wildcat roller coaster on its left in 1986.

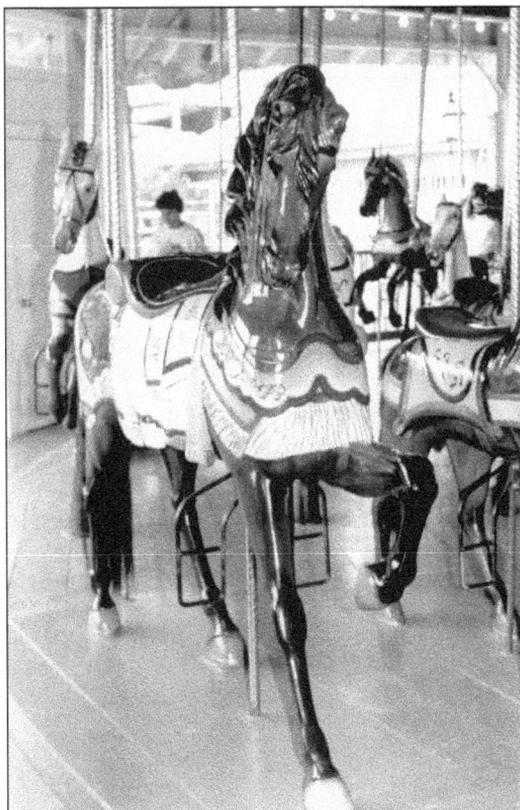

One of the carousel horses was restored back to the original condition it was in in 1911 when the carousel was purchased by Lake Compounce.

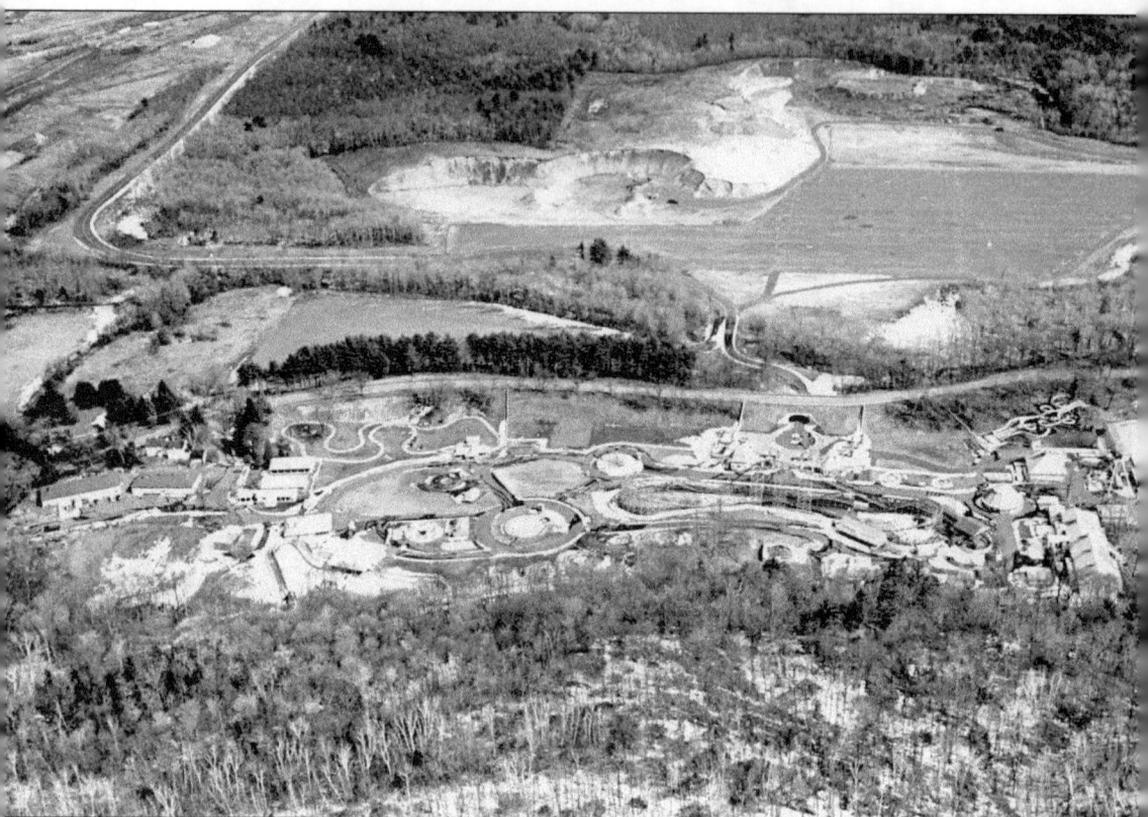

In the winter of 1987, Hershey decided to sell the park. In the spring of 1987, Joseph Entertainment Group of Milwaukee, Wisconsin, bought the park from Hershey. It renamed the park Lake Compounce Festival Park. This aerial view was taken on March 26, 1988.

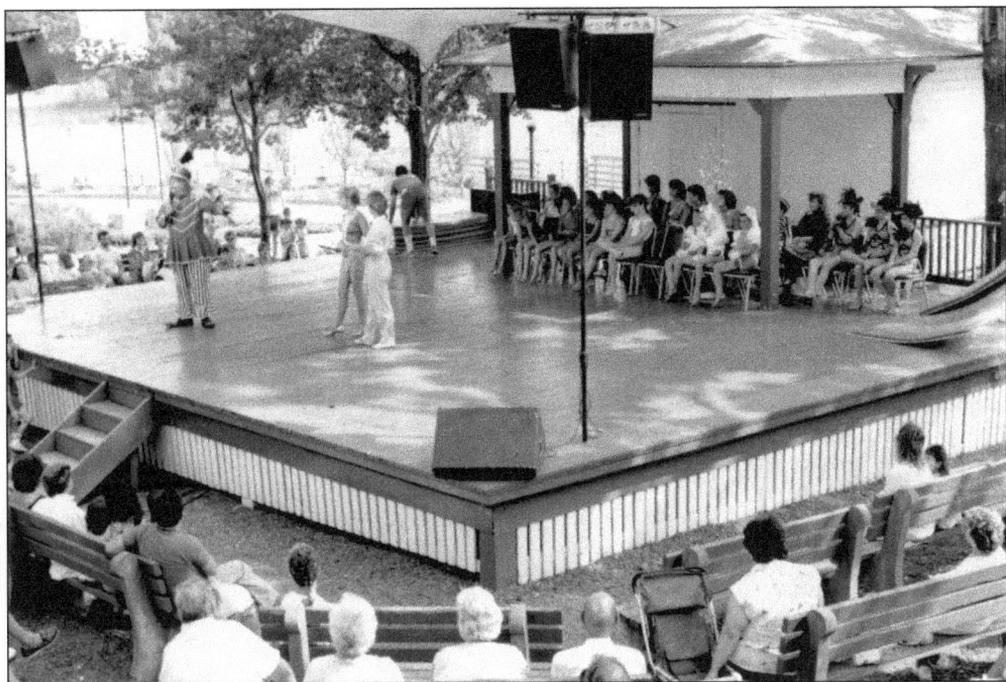

On August 27, 1988, the Colonel Clown junior talent show was brought back during Memory Weekend. In this picture are, from left to right, Colonel Clown (Joey Russell), Beth Rondinone of Haddam, and show producer Dorothy Malavas.

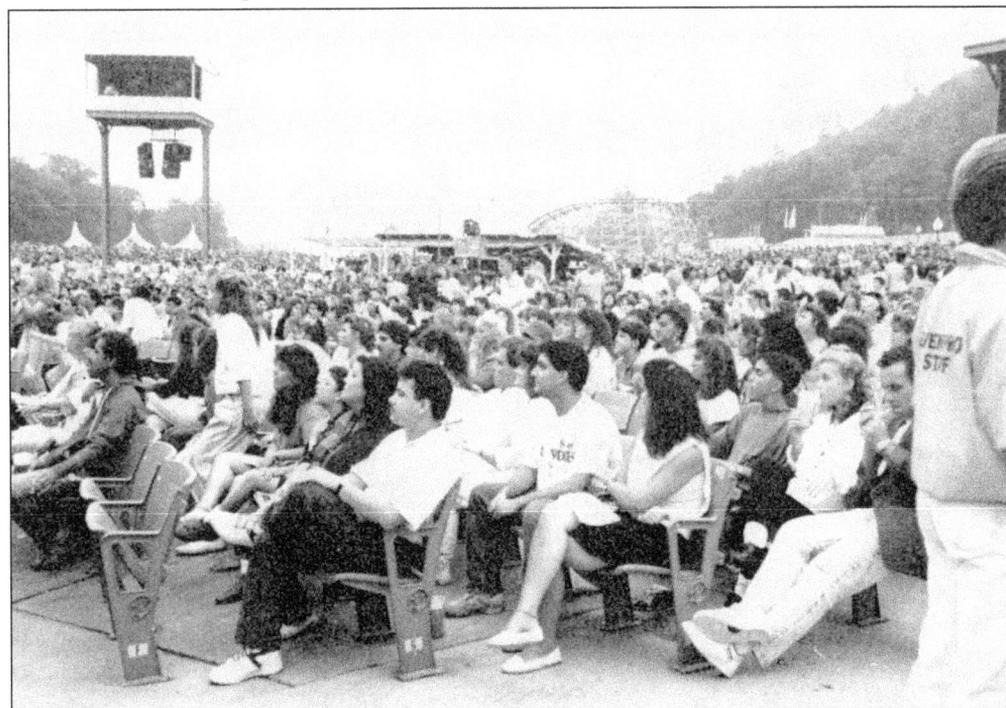

Along with the amusement rides, Joseph Entertainment Group filled the concert area with a 20,000-person seating capacity. This 1989 picture was taken during one of the concerts.

Permanent benches on the left provide a place to sit and enjoy the day or have food from the concession stands on the right. In the back on the left is the casino in this 1990 picture.

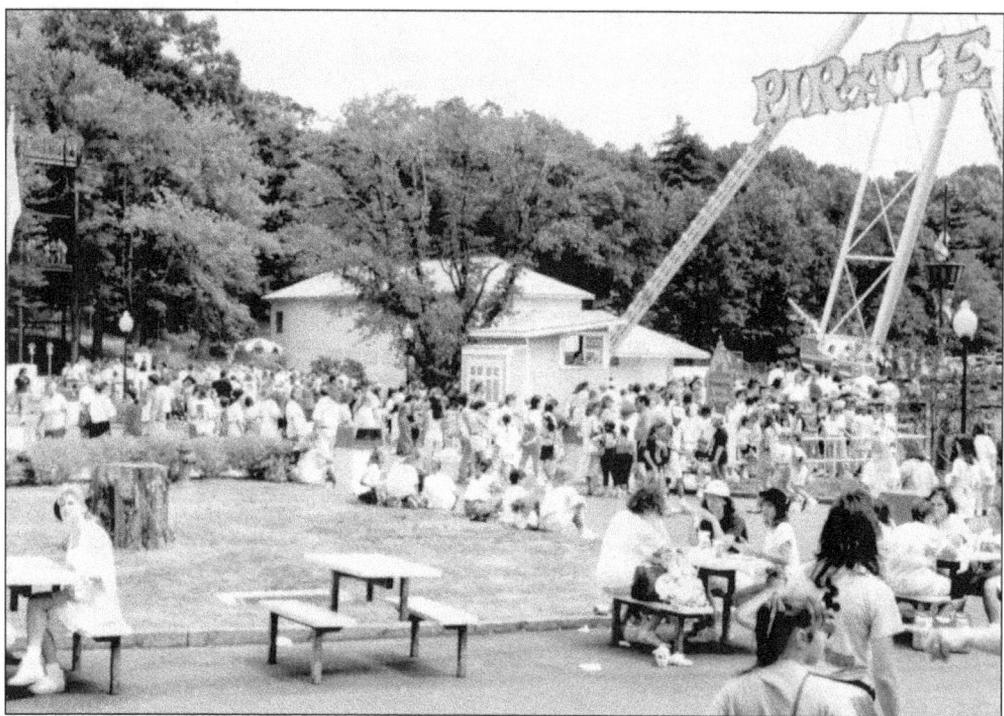

The crowd is enjoying a day with the Pirate boat ride on the right in 1990.

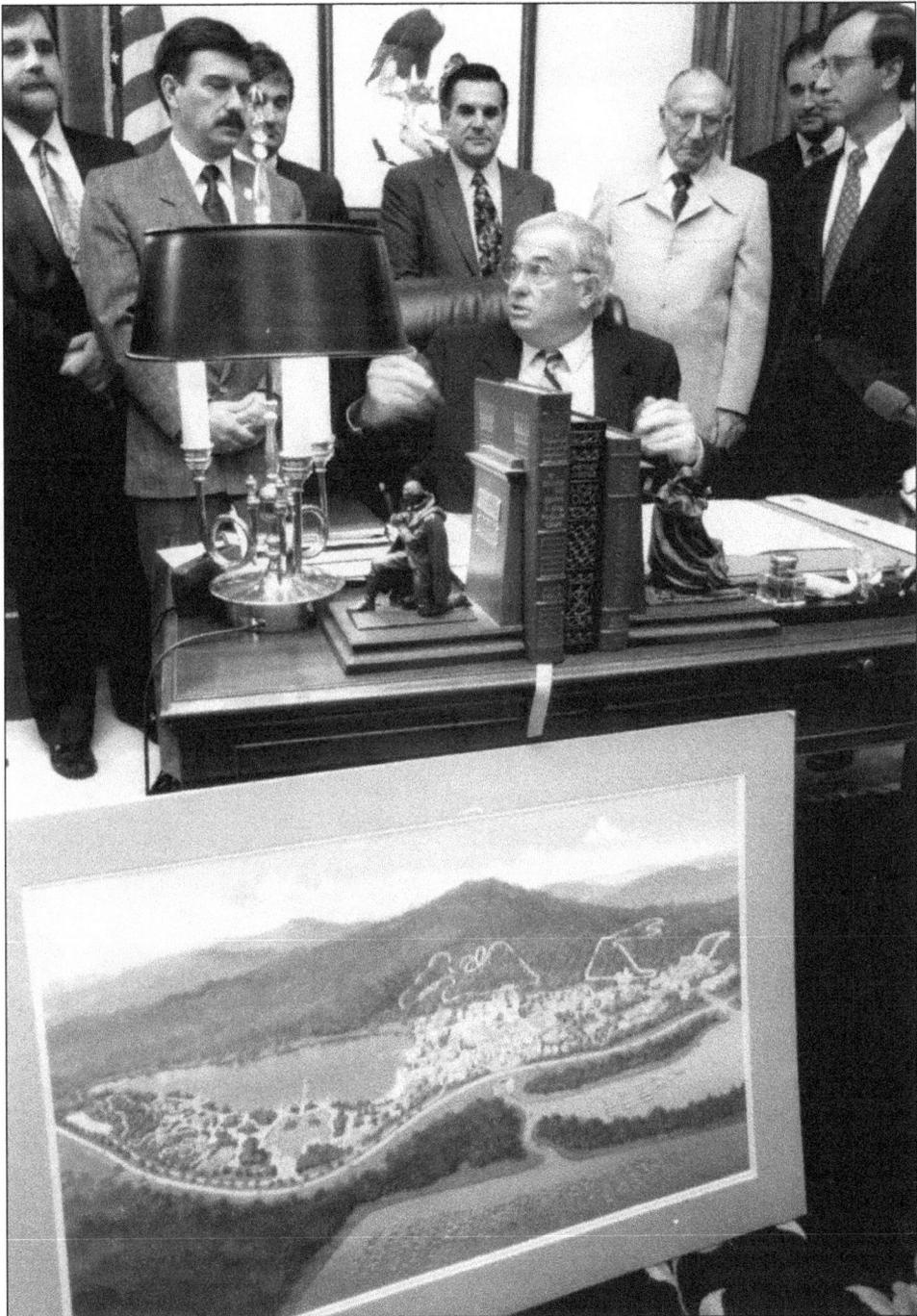

In 1991, Boston Concessions was running the park after Joseph Entertainment Group went into bankruptcy. In 1992 and 1993, the park was closed except for Labor Day to keep the record of continuous operation, and in 1994, Funtime Parks of Ohio promised to make Lake Compounce a theme park. On December 7, 1994, the State of Connecticut pledged $18 million as an economic development grant. In this picture, Gov. Lowell Weicker is signing the grant. On the bottom is a drawing of plans for the new Lake Compounce design.

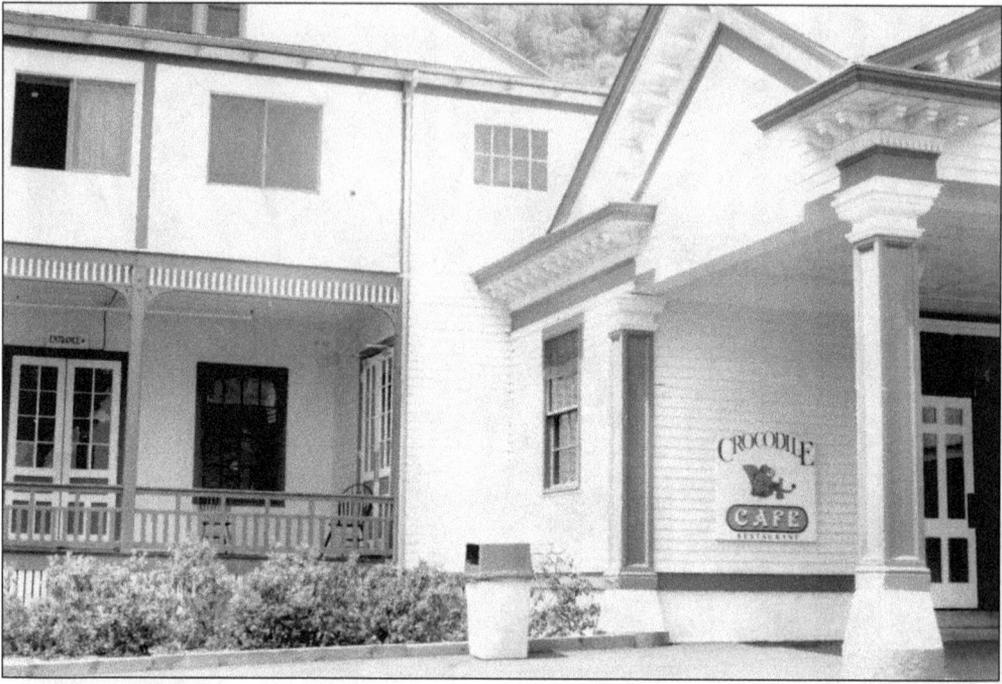

The casino was redone with the new Crocodile Club Café named after the Crocodile annual dinners that were held in this building.

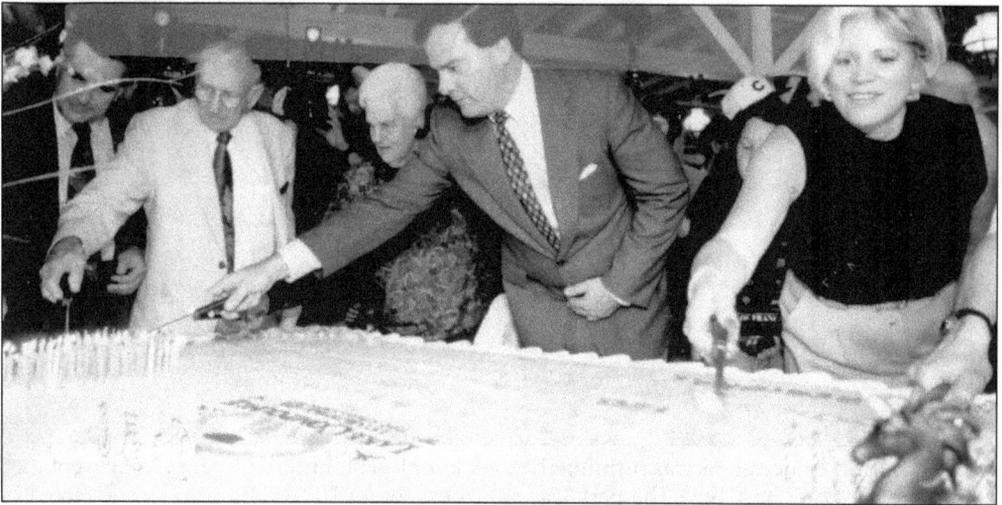

In 1995, Funtime Parks was bought by Premier Parks, which was not interested in Lake Compounce. The Barberinos now owned the park. In this picture celebrating the 150th birthday of Lake Compounce, from left to right are Stephen Barberino Jr., Stephen Barberino Sr., Florence Barberino, Gov. John Rowland, and Dorothy Barberino on June 15, 1995.

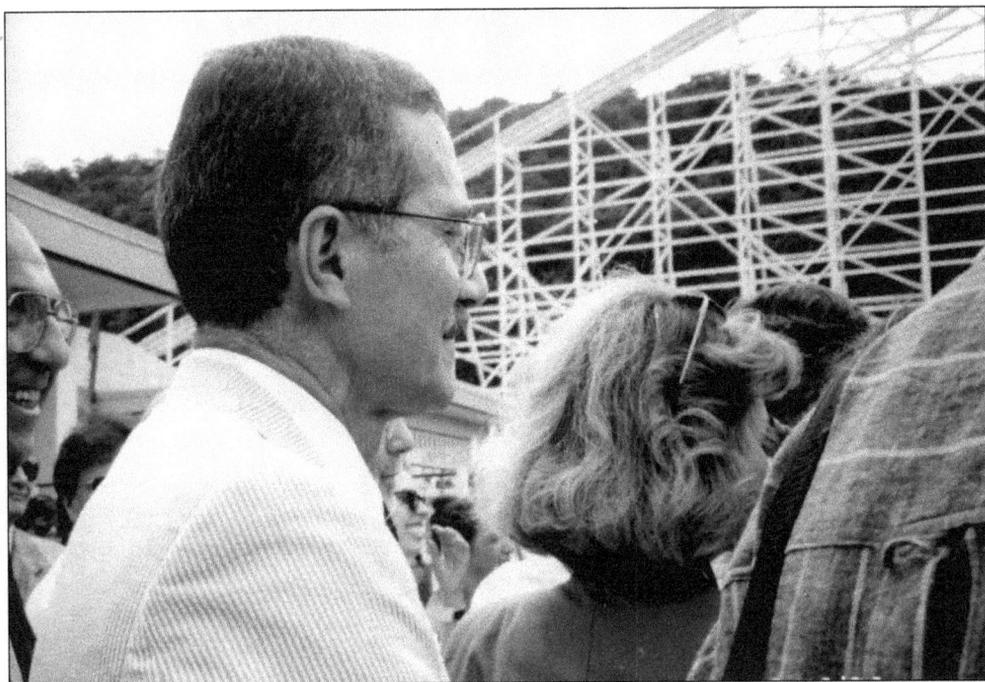

At the 150th birthday on June 15, 1995, and the reopening of the park is Mayor Frank Nicastro Sr. near the Wildcat roller coaster.

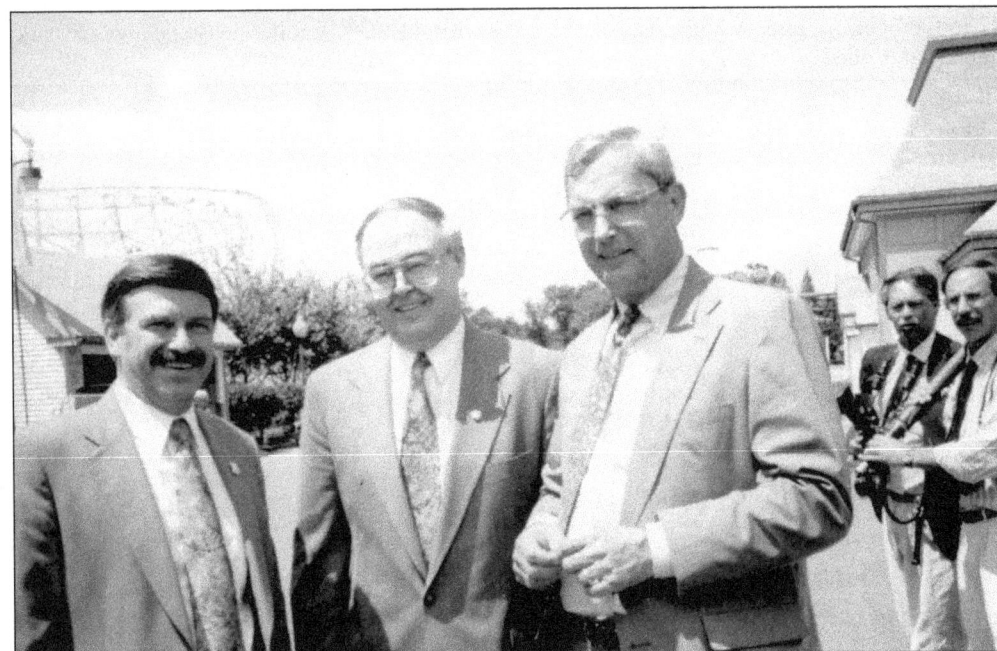

From left to right in this picture are Tom Calapietro, John Leone, and Rick Glover as they enjoy the park along with other guests at the 150th birthday celebration on June 15, 1995.

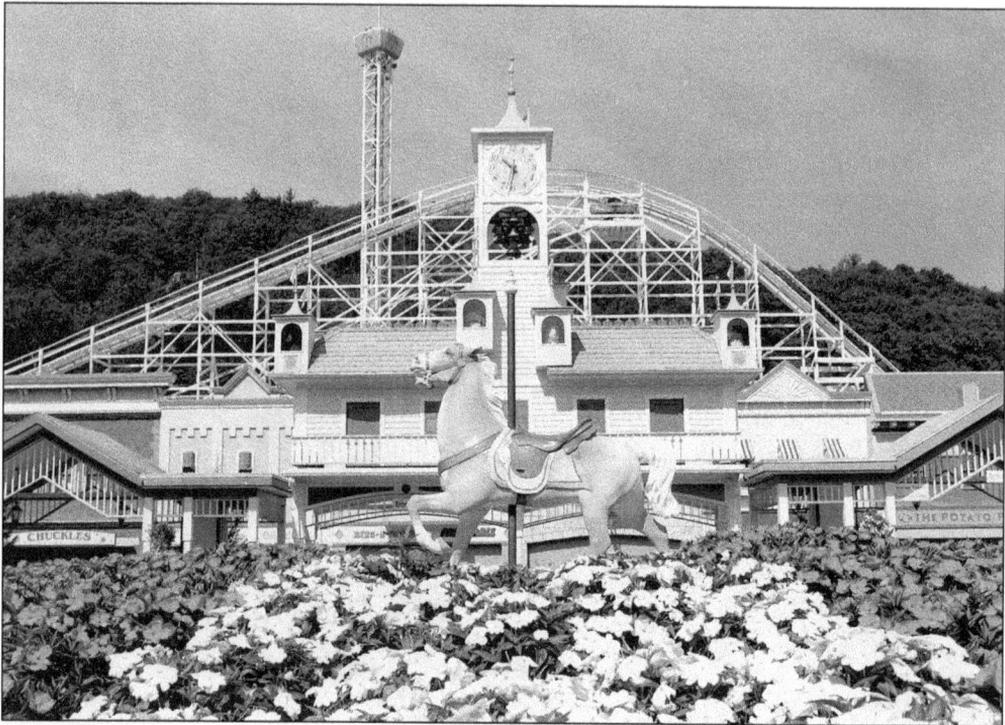

In April 1996, the Kennywood Entertainment Company of Pittsburgh, Pennsylvania, owners of two theme parks and an action park, became the managing partners working with the Barberinos to operate the park. Kennywood later took over the ownership of Lake Compounce. Now known as Lake Compounce New England Family Theme Park, the park is open from May 12 to October 31. The park consists of 332 acres with 44 rides, 4 roller coasters, a water park, and 2 water rides.

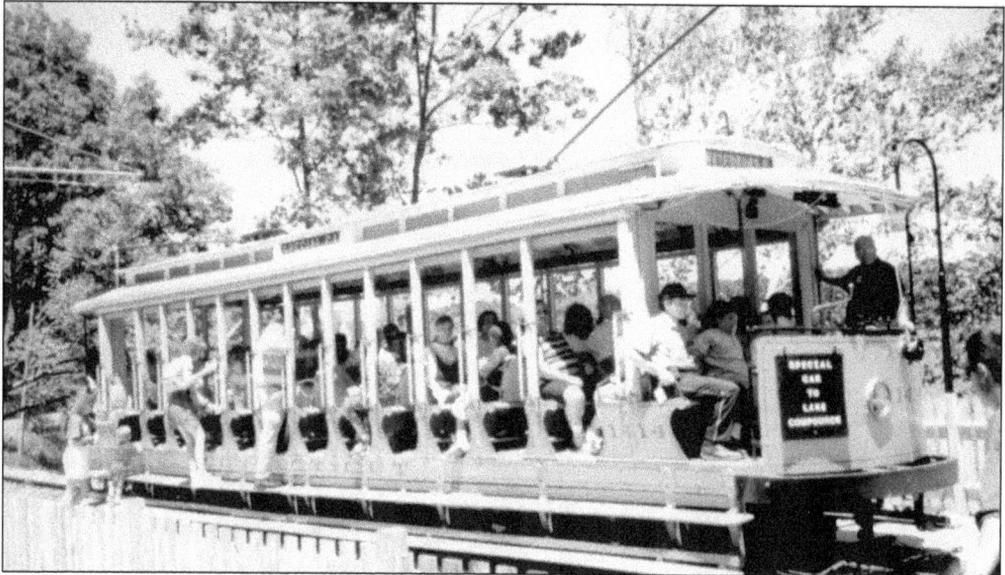

The lakeside trolley was refurbished in 1997. It holds 75 passengers and brings people from one end of the lake to the other.

The 1927 Wildcat is one of the oldest continually operating wooden roller coasters. It was rebuilt by Hershey in 1985 and restored under Kennywood. Seen here is the track for the cars.

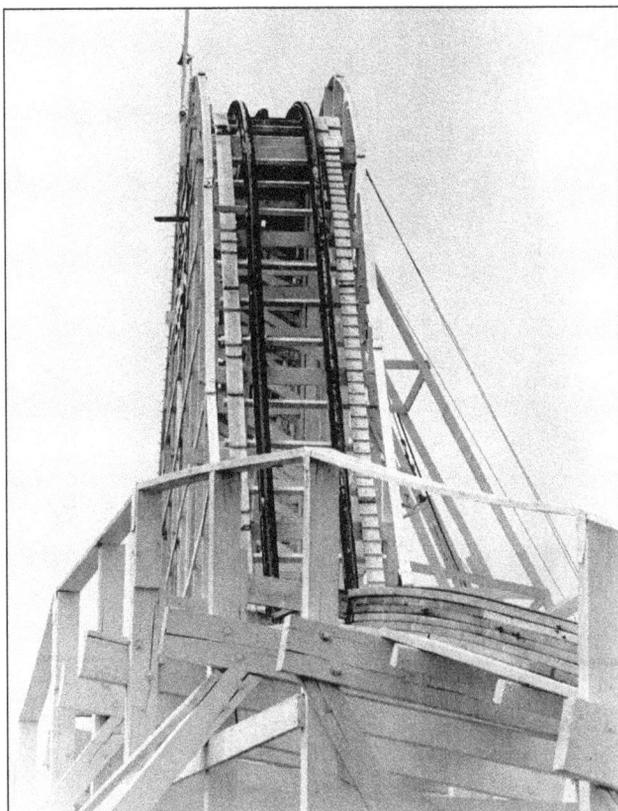

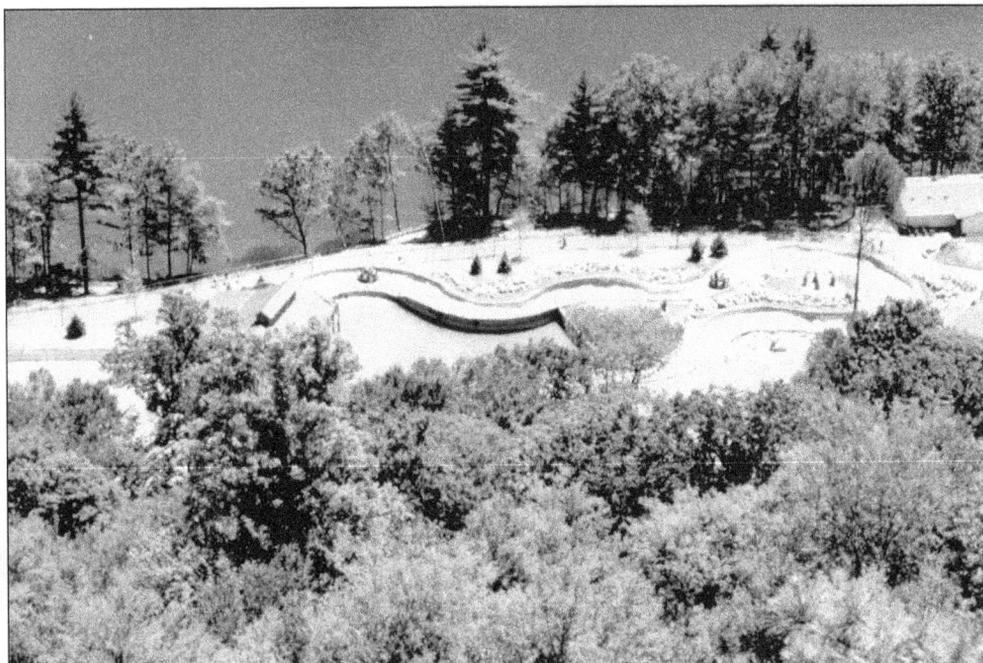

This 1997 aerial view shows a new ride called Thunder Rapids, a raft ride installed near the picnic area.

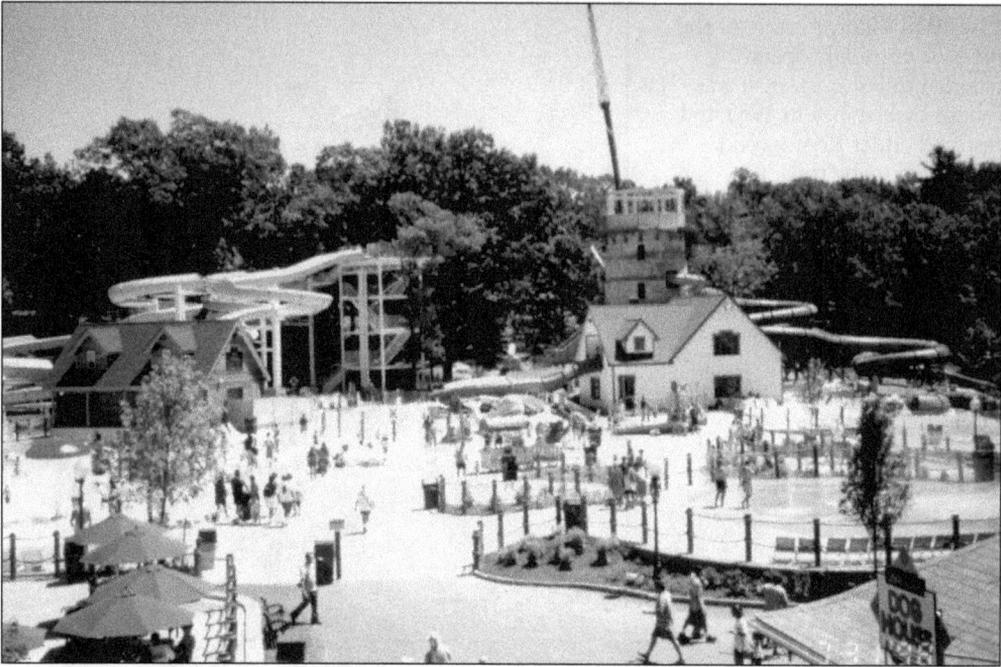

In 1998, Splash Harbor, the new family water park, opened. It is very popular with all ages during the warm weather.

Cyle the Crocodile is one of the entertainers who walk through the park having fun with all the children.

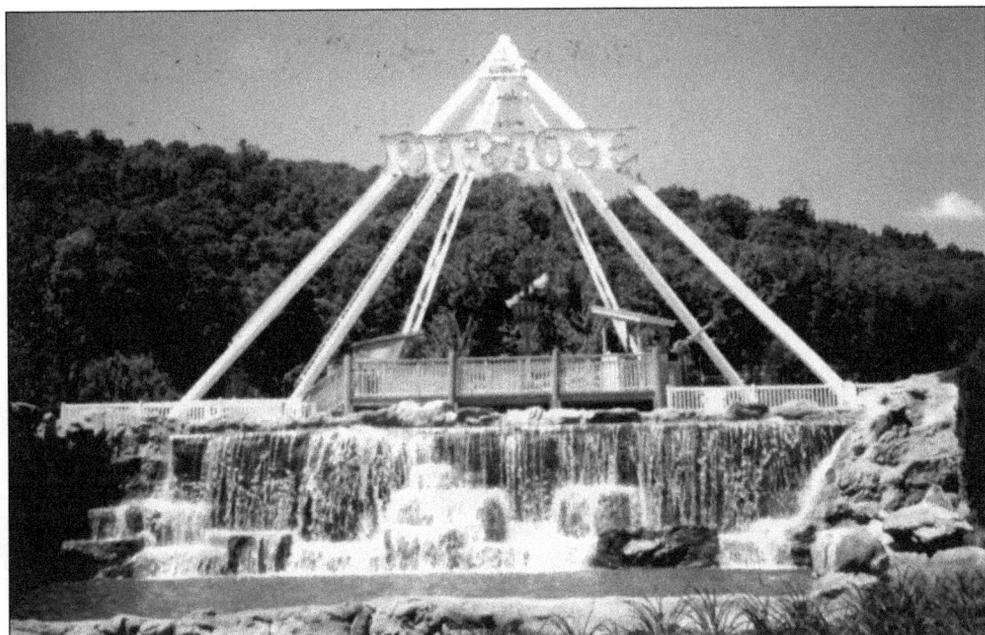

The Pirate ride was moved from the shore area to this new location. A waterfall was built when it was moved here in 1998.

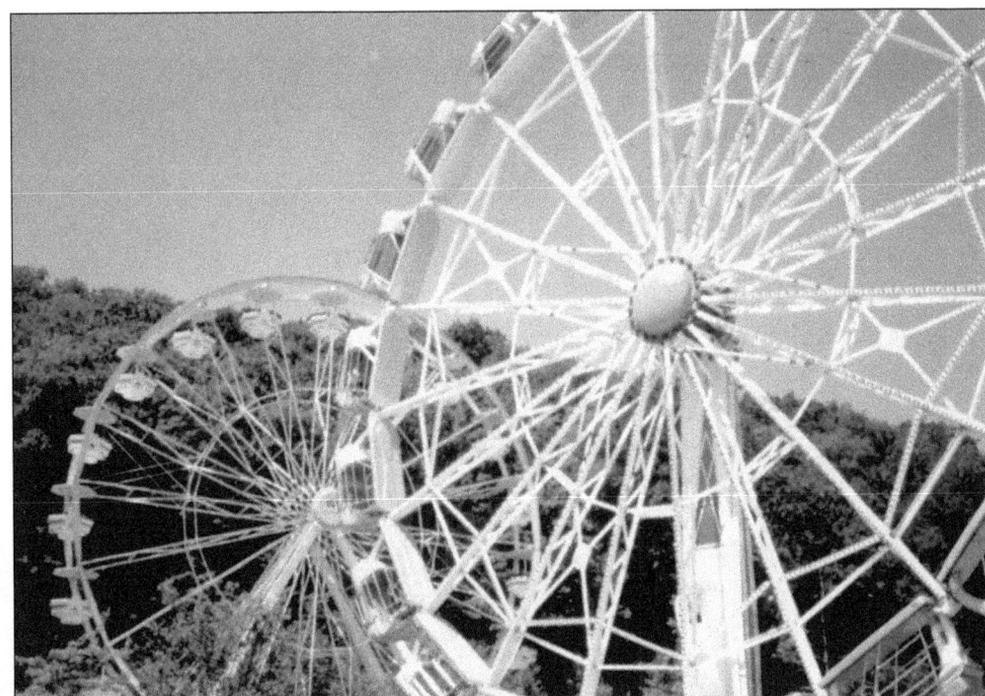

The Ferris wheel on the left opened in 1997, and a newer one called the Enterprise is on the right in this picture.

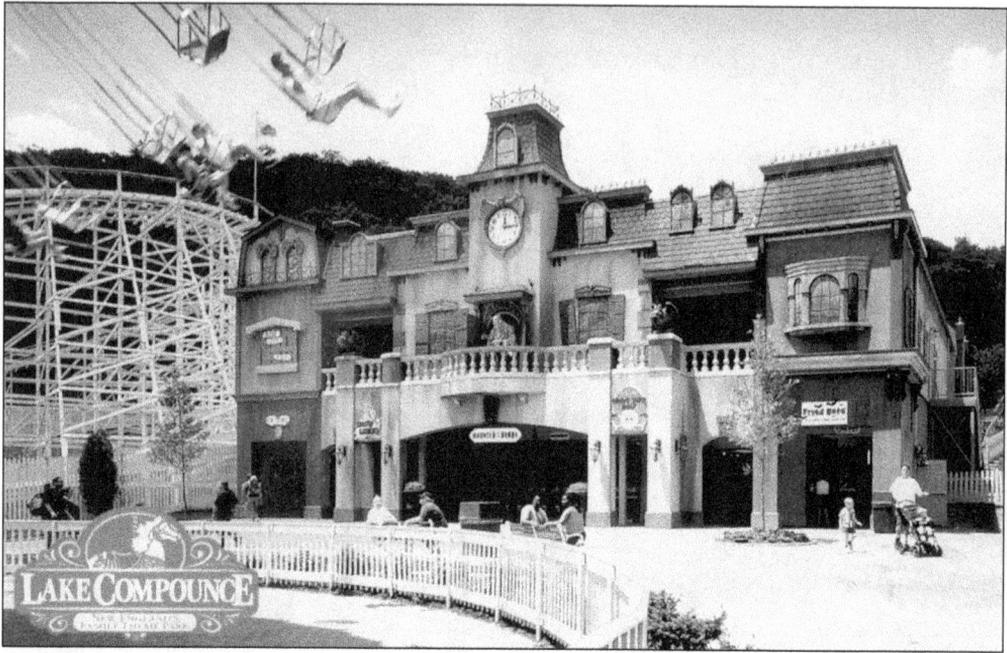

The Bleakstone Manor, a haunted house, becomes part of the Haunted Graveyard during the month of October.

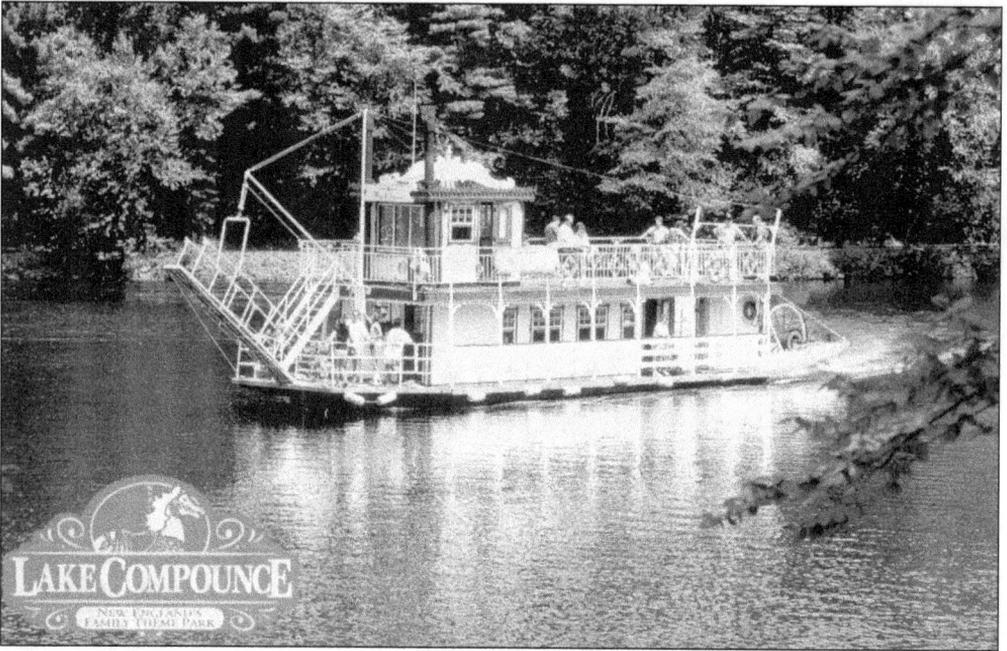

The *Mark Twain* sternwheeler that took passengers on a ride across the lake was replaced in 2007 by the *Compounce* cabana boat.

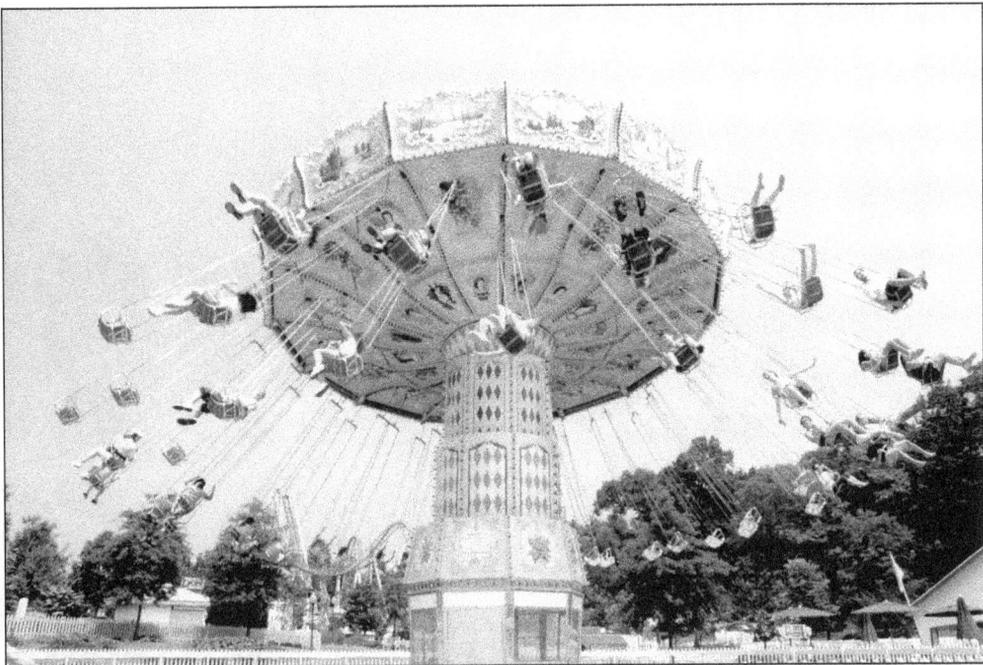

The Wave Swinger was one of the new amusement rides added in 1986 when Hershey owned the park.

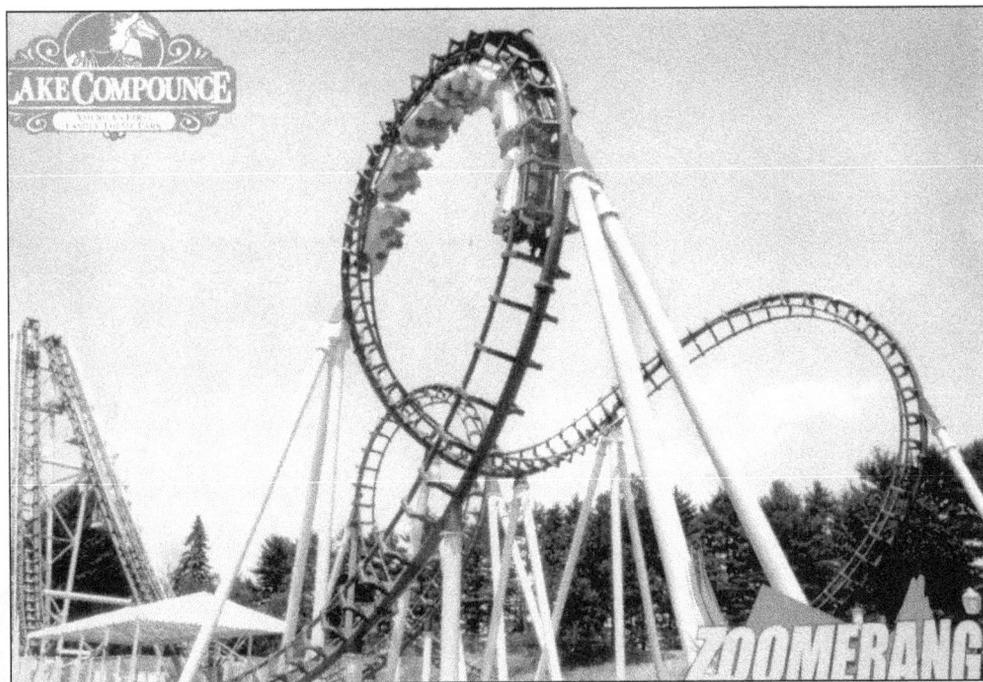

The Zoomerang, a Vekoma boomerang shuttle coaster, was one of the first rides added by Kennywood in 1997.

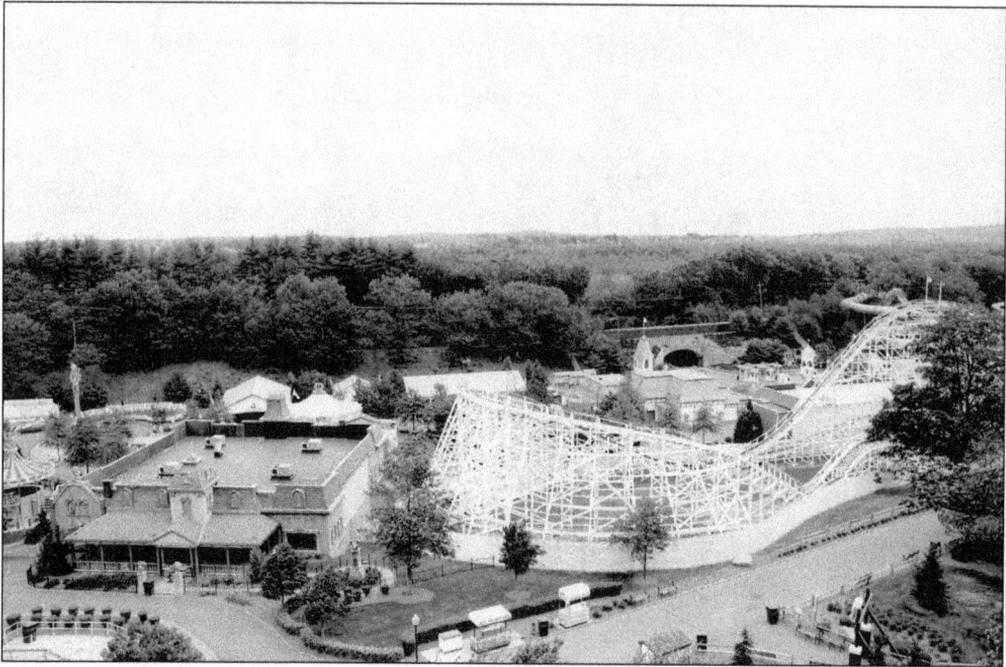

This view shows the Wildcat roller coaster with the tunnel entrance to the park in the background that Hershey built in 1986.

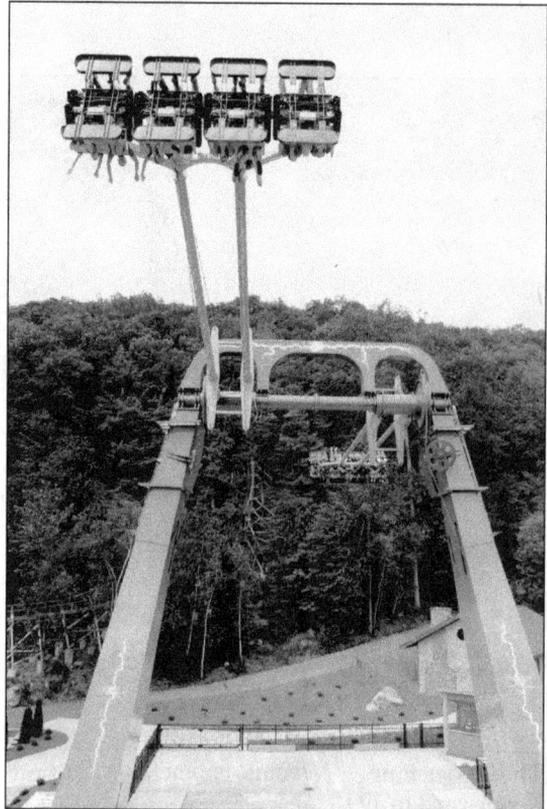

Thunder N' Lightning, an S&S Power screaming swing ride, was a new ride added when Lake Compounce opened its season in May 2006.

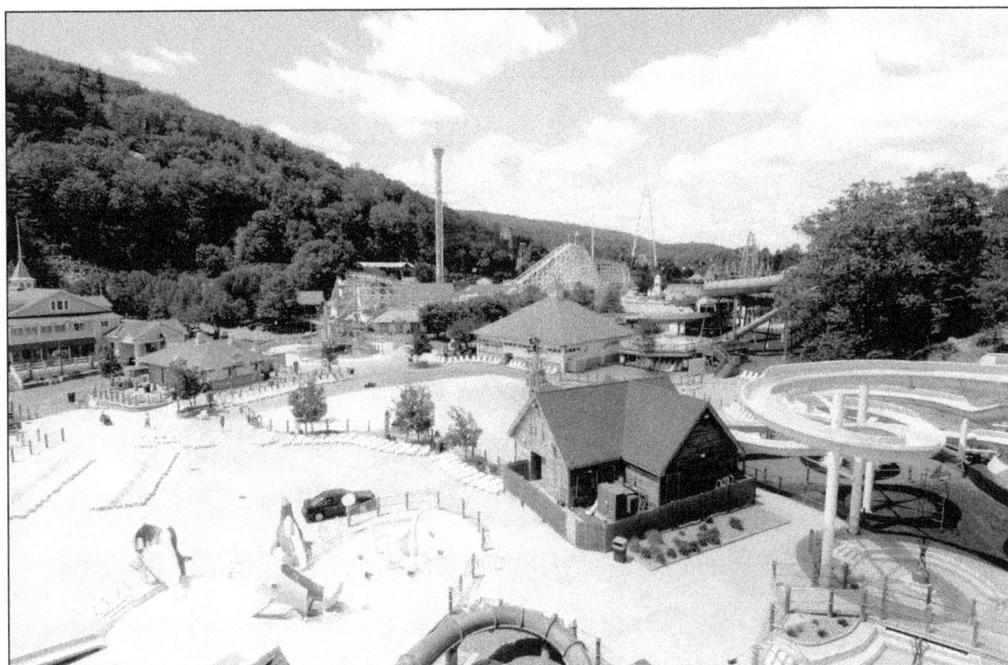

Splash Harbor was added in 1998. This water park has several slides, a wave pool, and a lazy river. Kennywood's future plans are to double the size of this water park.

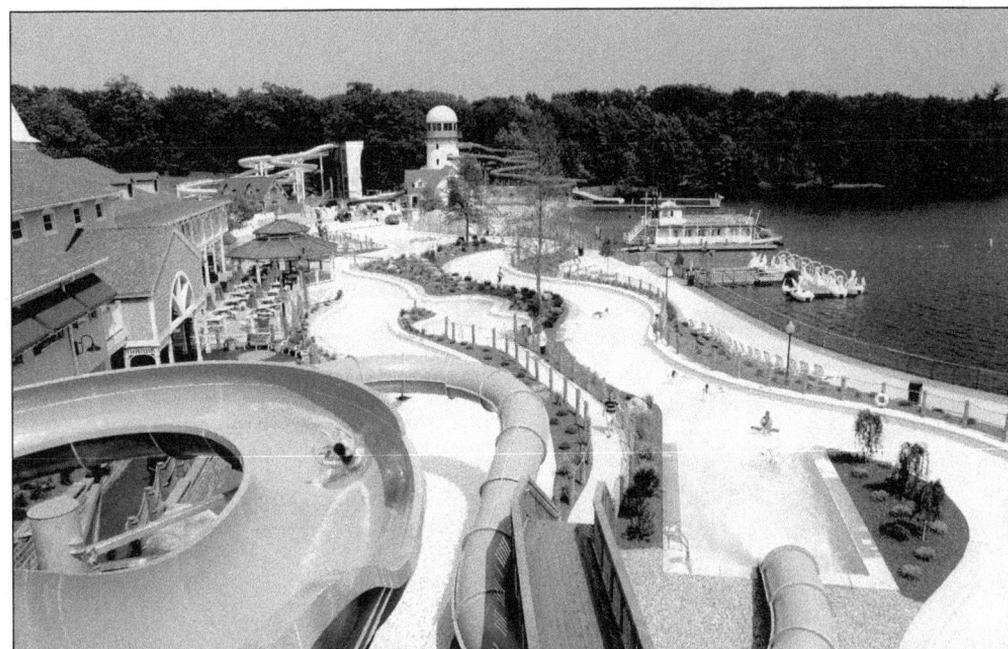

Anchor Bay, a water ride, was added to Splash Harbor in 2005. The ride consists of a lazy river with an optional waterslide.

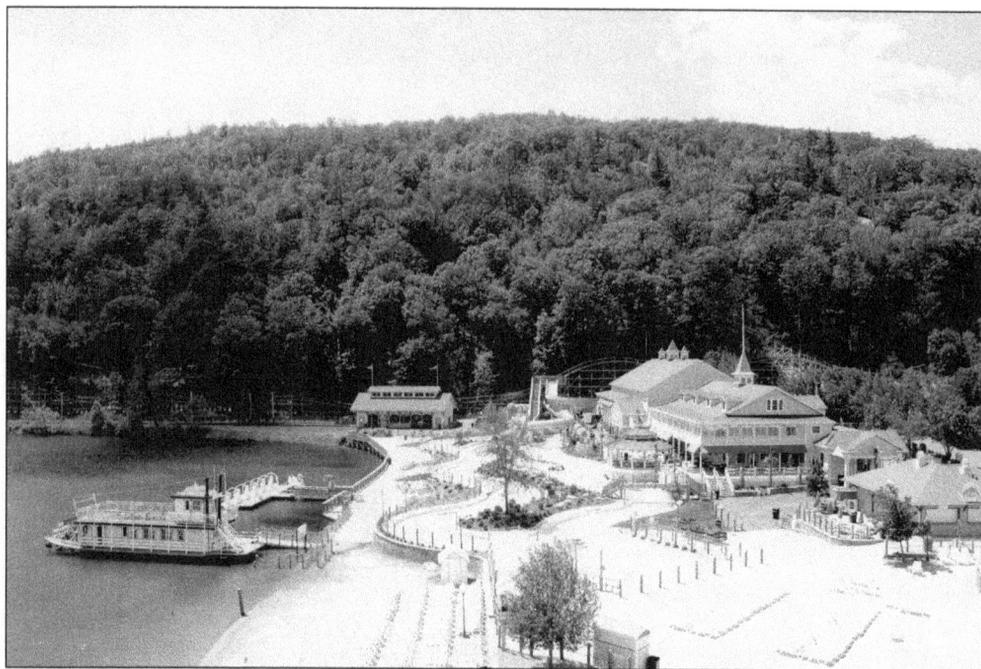

This view taken in 2007 shows the many changes since Kennywood purchased the park in 1996.

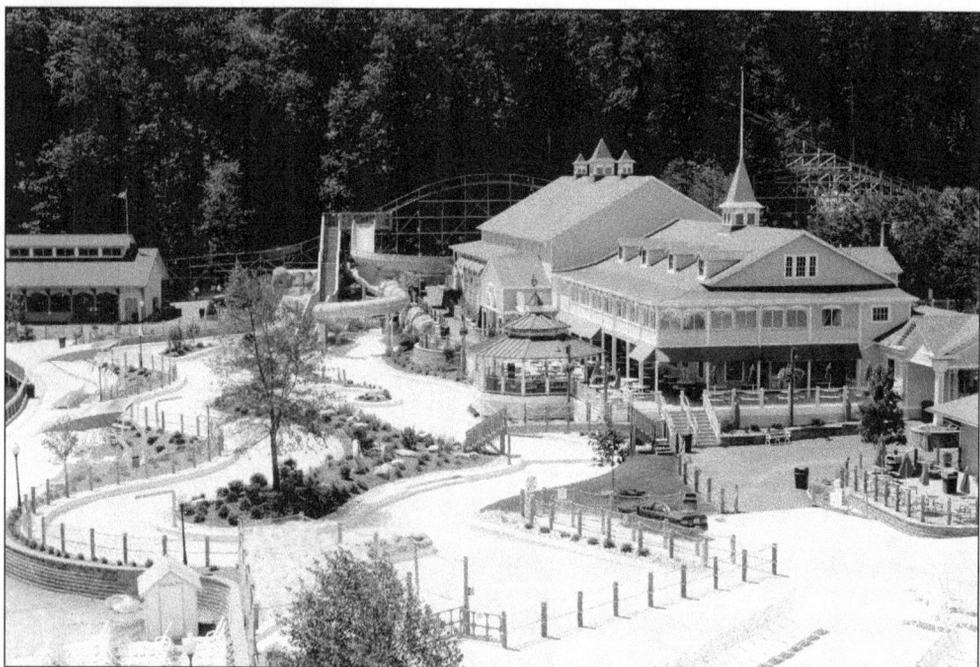

On the right in this 2007 picture is the original 1895 casino with a new look among its surroundings.

The area above, known as Main Street, has a Victorian look to the buildings. This area is near the main entrance to the park.

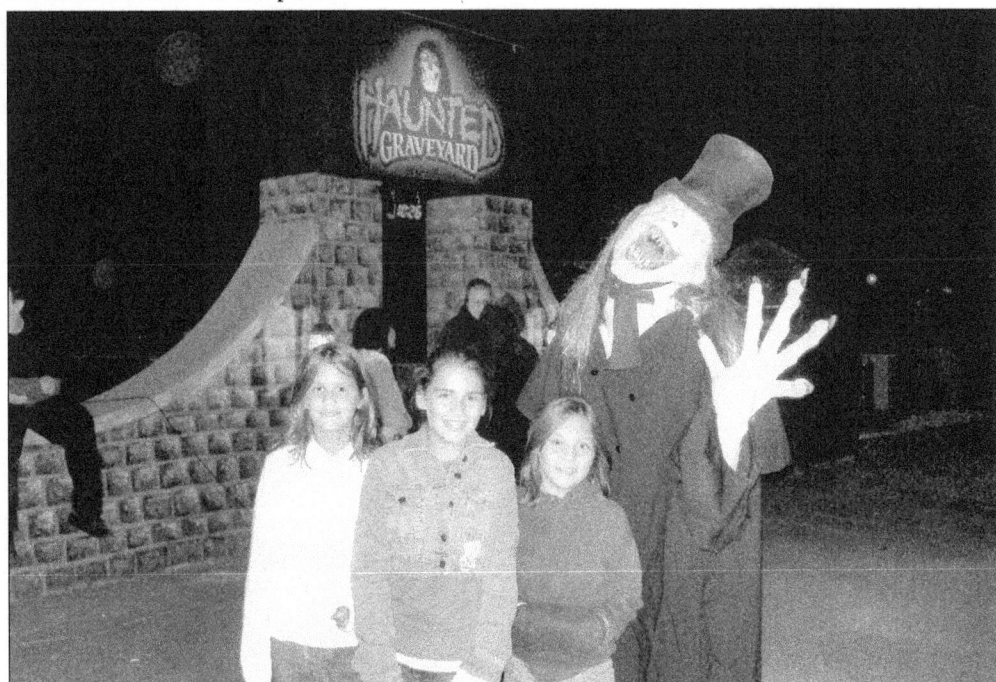

The Haunted Graveyard, produced by Graveyard Productions, became part of Lake Compounce in 2001. Decorations are put up along with special effects and placed on the rides and near the buildings. A portion of the proceeds are donated to juvenile diabetes research. In this picture are, from left to right, Lizzy Blackman, Holly Molinaro, Catherine Flannigan, and one of the Haunted Graveyards characters.

Visit us at
arcadiapublishing.com

www.ingramcontent.com/pod-product-compliance
Lightning Source LLC
Chambersburg PA
CBHW050644110426
42813CB00007B/1912